DRAWING
COURSE

MIKE WILKS

Author of

THE ULTIMATE ALPHABET

This book has been published to accompany a television series prepared in consultation with the Continuing Education Programme Committee. The series was produced by Richard Foster.

Book design by Sara Nunan, Bridgewater Design Ltd. Illustrations on pages 12 & 13 (bottom right) by Varna Haggerty, and on pages 40, 41 & 43 by Danny McBride. The photographs on pages 45, 48–9, 58–9, 70–1, 74–5, 78–9, 82–3, 90–1 & 96 were specially taken for the BBC by Guy Rycart.

PICTURE CREDITS

DRAWING

COURSE

MIKE WILKS

Author of

THE ULTIMATE ALPHABET

BBC BOOKS

CONTENTS

1
BACKGROUND

2
PRINCIPLES

3
MEDIA

Published by BBC Books,
a division of BBC Enterprises Limited,
Woodlands, 80 Wood Lane, London W12 0TT
First Published 1990
© Mike Wilks 1990

ISBN 0 563 21506 2

Set in Baskerville by Central Southern Typesetters, Eastbourne, East Sussex
Printed and bound in Great Britain by Richard Clay Ltd, Bungay, Suffolk
Colour separations by Dot Gradations Ltd, Chelmsford, Essex
Jacket printed by Belmont Press Ltd, Northampton

4
EXERCISES

5
THE WAY FORWARD

6
ARTISTS AT WORK

'IT IS IN MY OPINION NOT USELESS IF YOU PAUSE IN THE REALISATION OF PICTORIAL FORMS AND LOOK AT THE SPOTS ON THE WALL, AT THE ASHES OF THE HEARTH, AT THE CLOUDS OR IN THE GUTTER: ON CAREFUL OBSERVATION, YOU WILL MAKE WONDERFUL DISCOVERIES THERE, WHICH THE GENIUS OF THE ARTIST CAN TURN TO GOOD ACCOUNT IN THE COMPOSITION OF HUMAN AND ANIMAL BATTLES, LANDSCAPES, MONSTERS, DEVILS, AND OTHER FANTASTIC THINGS WHICH YOU CAN USE TO YOUR ADVANTAGE. THESE CONFUSED THINGS AWAKEN THE GENIUS TO NEW INVENTIONS, ALTHOUGH ONE MUST HAVE LEARNT WELL HOW TO DO ALL THE PARTS, ESPECIALLY THE LIMBS OF THE ANIMALS AND THE FORMS OF THE LANDSCAPE, ITS PLANTS AND ITS STONES.'

Leonardo da Vinci,
Treatise on Painting

1

BACKGROUND

INTRODUCTION

WHEN I WAS A STUDENT I WISHED THAT SOMEONE COULD HAVE GIVEN ME TEN GOLDEN RULES ON HOW TO MAKE ART. All I would then have had to do was to learn them thoroughly, put them into practice and the result would have been a masterpiece. Unfortunately, there *are* no ten golden rules: all art is made the hard way – with skills patiently acquired, techniques experimented with and a few guidelines diligently applied. What I hope I can do is to explain these guidelines clearly, offer some basic advice, generally review the options open and point the aspiring artist in a useful direction. The rest is up to you.

The scope of this book is necessarily broad and covers many techniques and media. While I have a good working knowledge of all of these techniques I do not consider myself especially skilful in any save one – pen-and-ink drawing – and it is on this, together with painting, that I have concentrated over the years. I have found that I have been able to achieve more and express myself better by consciously limiting the media I work in. This is the same for all artists and comes about quite naturally. You too will find that as you progress you will gravitate towards one medium, although if you are starting out you would do well to try all of the media outlined here and indeed any others that you come across. After some time you will naturally be attracted to one in particular. This, in my opinion, is the one to cultivate and from which to develop.

Everyone can draw. We each did it as a child and we still do it today. Handwriting is in fact the commonest form of drawing, and when we write we are exercising the same fine degree of control

over a pen as is needed when making a drawing. We also learnt to write in a similar way to learning to draw. At first we looked carefully at the shape of the letters and copied them. Later we were able to create small compositions from these shapes in the form of words, which in turn led to sentences and ultimately to the highly complex arrangements of lines, curves and squiggles in the essays that we all wrote at school. It is the same with drawing. First we must master some basic skills (writing) and later apply a set of guidelines (grammar). From then on we make the composition gradually more and more complicated (sentences growing into paragraphs), until we end up with a finished drawing (the essay). Then, just as we each have a distinctive handwriting – something we did not strive to make distinct but whose uniqueness came about quite naturally without conscious effort – a personal style of drawing will emerge. To the novice the fact that his or her drawing does not look like anyone else's is a fault, while to the experienced artist this is seen as a positive benefit and something to be cherished.

This book contains what I believe to be a sound basic course in the art of drawing. I have sketched out a very brief history of art and a similarly brief explanation of just what is going on when we look at something. The course will provide an outline of all the basic techniques and introduce the media suitable to employ them. It explains the fundamental guidelines for the use of composition, proportion, form, colour and perspective and invites you to put this knowledge to practical use with eight exercises. Some people will already be familiar with much of this information or will feel that they wish to begin drawing immediately, in which case they should turn to that section. They may then choose to return to the sections on guidelines and principles and to re-examine their work in the light of them. Each of these exercises can be tackled with each of the eight media presented, making a total of 64 projects should you wish to go this far. But as you will naturally gravitate towards certain subject-matter and certain media the course will have the scope and duration that you choose. The course is circular in shape: exercise eight can equally be seen as exercise one, and so with a switch of medium the cycle resumes. The book concludes with 'Artists At Work', a section devoted to six contemporary artists which features one of their recent works, and quotations explain their views and attitudes to their work. Attitude and commitment are other major elements in the infinitely complex equation that makes a work of art.

There is a paradox to be confronted by any author setting out to write a book about how to draw, besides the obvious one of communicating something quintessentially non-verbal with the use of words. It is that drawing can only be learnt, never taught. So, in

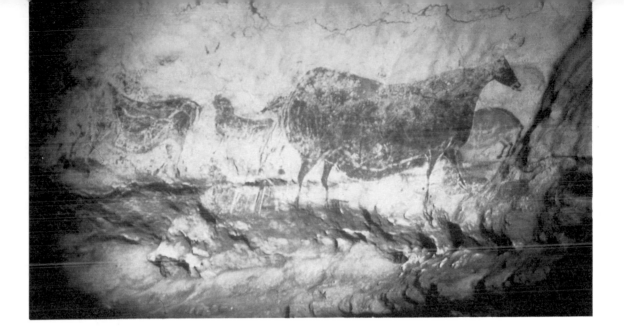

essence, this is a 'How to Teach Yourself How to Draw' book and its true value must lie in its ability to offer advice and direction and, I hope, communicate some of the joy that I have found through my work. Bear in mind that even for professional artists the act of creation is always a new and magical experience and that one's ability to perceive is perpetually being honed to an ever finer edge. In a very real sense, for each one of us who engages in this field of activity, each time we draw is the first time and, like anything new, a source of wonder and excitement.

These images from the caves at Lascaux near Montignac in central France are among the earliest surviving works of art. The marks were probably originally made with charcoal and have been coloured with various natural earth pigments. Artistic conventions such as outlines and silhouettes are still used today.

A *VERY* BRIEF HISTORY OF THE ART OF DRAWING

ART WAS ALREADY MANY THOUSANDS OF YEARS OLD WHEN HISTORY BEGAN TO BE RECORDED. It has been practised in an unbroken line right up to this day and will continue for as long as mankind finds wonder in the universe.

Drawing is the oldest and simplest way of creating an image, and the first drawing was probably made with charcoal, which is still used today. This was already an ancient drawing tool around 30 000 years ago, when someone living in what is now Lascaux in central France picked up a piece of burnt wood and drew hunting scenes on the walls of a cave. These marks were later made permanent with a black pigment, probably manganese, and coloured in with ochres. Cave walls are extremely durable, but as the same is not true of most drawing surfaces there is little remaining evidence from the hands

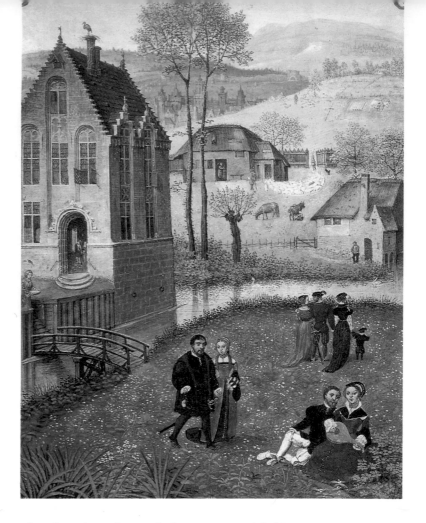

April, a detached leaf from an illuminated calendar made in Bruges around 1540 by the Flemish miniaturist Simon Bening, displays his incredible eye for detail and provides an insight into the everyday life of that era. The original measures only 152 mm × 102 mm (6 × 4 inches) and would have been made with water-colour or gouache applied to vellum with a fine brush.

of early artists who worked on more perishable material, and this has left gaps in our knowledge. The oldest surviving drawings made on fragile material are those on papyrus recovered from the tombs of the Egyptian Pharaohs. These only survived because of the dry climate and the fact that they were out of circulation, as it were. The oldest papyri date from 2600 BC and are essentially records of the Pharaohs' lives and deeds drawn in hieroglyphics – pictures representing words. Although no one can be absolutely certain, it is doubtful if at that time these were considered art as we understand the term today, and they were probably preserved because of their religious significance.

The same might apply to the stunning works of art that are found in medieval manuscripts. By the Middle Ages hieroglyphics had been superseded by the alphabet, and words and pictures had become separated. The 'illuminations' to these manuscripts literally shed light, in both senses of the word, on the texts. In Europe between the fourteenth and sixteenth centuries there was a dazzling explosion of artistic activity that we know today as the Renaissance. The word means literally 'rebirth' and this period was characterised by the

rejection of medieval values and the readoption of those of classical times. From this period there emerged such geniuses as Leonardo da Vinci, Raphael, Bellini, Van Eyck, Titian, Michelangelo, Dürer and Holbein. It provided the impetus that took art up to the birth of Modernism in the late nineteenth century by way of such movements as the Baroque, Rococo and Romanticism.

Modernism attempted to break with all precedents and is characterised by the gradual paring-away of anything perceived to be superfluous, such as any attempt at illusion in picture-making. At its best this can be seen in the works of Van Gogh, Picasso, Matisse and Duchamp. This quest for a new aesthetic resulted in the birth of a plethora of 'isms' – Impressionism, Cubism, Futurism, Dadaism, Surrealism, Expressionism, Minimalism and Conceptualism. It also introduced abstract art and successfully blurred the boundaries between everyday life and art. Modernism is now seen as a historical period and artists are beginning to be freed from its constraints. It is once more legitimate to create works using such old-fashioned tricks as the illusions practised by the old masters as well as anything else thought useful from the arsenal of Modernist ideas.

Art is of course universal and in true relativistic fashion its centre is to be found everywhere. I view it from the vantage point of a European, but I am the first to admit that achievements as great as those of Europe have come to us from other cultures. Heartbreakingly beautiful works of art were produced in China during

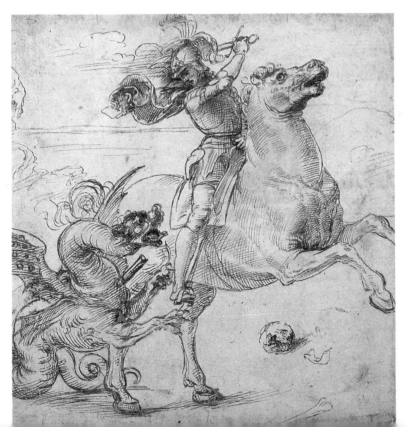

This image (above) entitled **The Stallion and the Wind's Future Wife** *was made by the German-born Surrealist Max Ernst in 1925 and uses the technique of frottage that he pioneered. These marks were made by rubbing over a textured surface and then elaborated into this strange and wonderful image.*

(Left) This is a preliminary study by Raphael for his painting of **St George and the Dragon,** *which today hangs in the Louvre. It most probably utilised a quill and bistre ink and was drawn in Florence around 1505. Note the use of the hachure lines that describe the form of the subject.*

the Ming and Sung dynasties, in Japan during the Momoyama and Edo periods and in India under the Mogul emperors. Art history tends to classify works into schools and movements and is thus apt to ignore anything that does not fit into these artificial pigeon-holes. I personally find the work of naïve artists and so-called 'Outsider Art' (or 'Art Brut' to give it its proper name) profoundly fascinating and I would encourage you to seek out examples of work from this far end of the psychological spectrum.

A SIMILARLY *VERY* BRIEF EXPLANATION OF SEEING

WHAT WE CALL 'SEEING' IS THE DETECTION OF LIGHT BY THE EYES. This is then turned into electrical impulses and passed on by nerves to the brain which makes sense of it all. Technically, light is a tiny part of the electromagnetic spectrum emitted by the sun that includes at one end long radio waves of 10,000 metres and descends through radar, infrared, ultraviolet and X-rays to tiny gamma rays measuring 0.0000000000000001 of a metre. We perceive this small visible portion of the electromagnetic spectrum as white light; with the aid of a prism this can be broken down into a spectrum of colours from extreme red at a wavelength of about 760 nanometres (760 billionths of a metre) to extreme violet at about 380 nanometres. This visible spectrum is a continuous scale which is conventionally broken down into seven colours – the familiar colours of the rainbow – red, orange, yellow, green, blue, indigo and violet.

It is a paradox that light, as well as being formed of waves, also has the property of being tiny discrete particles of energy called photons. Light in the form of waves/photons radiates out in straight lines from its source and is the fastest thing that exists in the universe, with a speed of about 300,000 kilometres per second (186,000 miles per second). Visible light is basically composed of three primary colours, red, green and blue, and everything is coloured with various combinations of these three. In simple terms, the selective atoms forming the skin of a tomato, for example, reflect the red light and absorb the green and blue, while those of grass reflect the green and absorb the red and blue. Black will absorb all of the light which falls on it and white will reflect it in equal proportions.

We are each equipped with a set of extraordinarily sensitive organs in the form of eyes capable of detecting light and colour. The human eye is in fact so sensitive to light that it can detect a candle burning

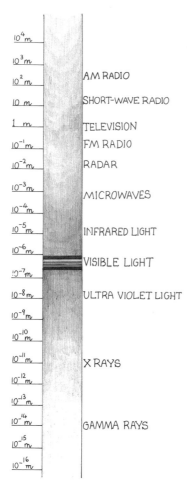

The electromagnetic spectrum encompasses long radio waves right down to tiny gamma rays, and only a small fraction of this is evident as visible light. Within this a trained eye is probably capable of discerning about 9 000 000 separate colours placed in contrast to one another.

12

The world around us is coloured by the atoms on the surface of objects selectively absorbing and reflecting the three primary colours of light – red, green and blue – in various proportions. A red object absorbs the green and blue light but reflects the red, which is what we experience when we see it, although in practice traces of the other primary colours will be present.

16 kilometres (10 miles) away. Light enters the eye through the transparent cornea and is focused by the lens on to the retina at the back of the eye. In front of the lens is the iris, which expands and contracts to control the amount of light passing through the pupil. The retina is sensitive to light and sends messages to the brain via the optic nerve. The retina contains receptors for light and colour called respectively rods and cones. The rods work in low-light conditions and are responsible for detecting light in shades of grey (scotopic vision) while the cones work in daylight and do the job of detecting colour (photopic vision). It is only at the centre of our field of vision, where the rods and cones are packed very tightly together and where our sense of sight is therefore most acute, that we have colour vision. The brain then fills in the missing pieces, as it were, with memory derived from the constant scanning of the eye, giving the impression of colour over our whole field of vision. All of this information is received upside down and the brain inverts it so that things appear normally.

Our eyes are not only capable of discerning form and colour but, by virtue of being set slightly apart, they can perceive depth. This ability is called stereoscopic vision and locates what we are looking at in space. It was obviously of great advantage to our distant ancestors when they moved about by swinging through the trees. Thus, at relatively close distances, we are always looking around corners and can perceive simultaneously both sides of a sheet of paper held edge-on in front of our face. This stereoscopic vision only works at ranges up to about 100 metres. The fact that the world around us exists in three dimensions of space and one of time is one of the basic problems to be tackled when making two-dimensional pictures.

This is a rather bald description of what happens when we look at something but goes no way to explaining the sensation of seeing, which belongs to the province of the brain, or the mysterious power of art to move a person to joy or tears.

Light that enters the eye is focused by the lens on to the retina, which contains our light receptors known as rods, which function in poor light and register images in tones of grey, and our colour receptors known as cones, which function in daylight. This information is turned into electrical impulses, which are passed on to the brain via the optic nerve.

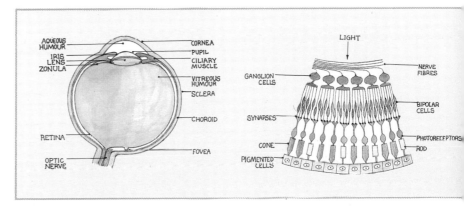

THE IMAGINATION

*An unusual and disturbing juxta-
position of ideas, so close and yet
so far apart, was used by the
Belgian Surrealist René Magritte
to create this startling and
original image (above) entitled
The Red Model, painted in 1935.*

*Superbia (Pride) by Pieter
Bruegel the Elder (1525–69). This
is an allegory using fantastic
imagery that would have been
easily understood by the people of
sixteenth-century Flanders as a
warning against indulging in one
of the seven deadly sins.*

WHILE SCIENCE HAS SUCCEEDED IN EXPLAINING SOME OF THE MECH-
ANISMS INVOLVED IN SEEING IT HAS SO FAR GONE ALMOST NO WAY TO
UNVEILING THE MYSTERIOUS FACULTY OF IMAGINATION. Albert
Einstein believed imagination to be more important than knowledge,
and what he perceived as truth in science must be at least as true for
art. Imagination is unique to man and is, in my opinion, our most
underestimated quality and fundamental to all scientific, techno-
logical and artistic advance.

A little over 150 years ago photography was invented. At the time
many people predicted the end of painting and drawing and thought
that in the near future all art would be made with the camera. Look-
ing back, it is now obvious that far from signifying the end of 'hand-
made' images photography freed art from the drudgery of merely
recording appearances and gave it a new vigour. This has meant
that artists can now concentrate on exploring new and exciting ways
of depicting the world outside or can look in an altogether different
direction, where the camera cannot penetrate, and record the inner
world of the imagination. There have always been rare individuals
who have explored this inner world, but because they have practised
their art separated by space and time and because of the insistence
of art historians to put individual artists together in particular
locations, schools and epochs, they have hitherto been categorised as
artistic mavericks. The anonymous artists who illuminated medieval
manuscripts used their imagination to the full in depicting the
prospects of the damned, and this tradition was carried on into the

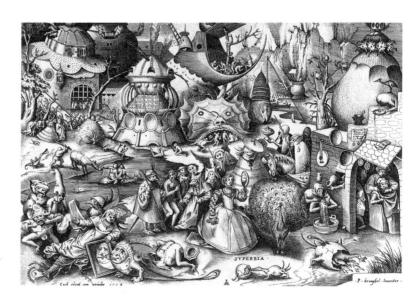

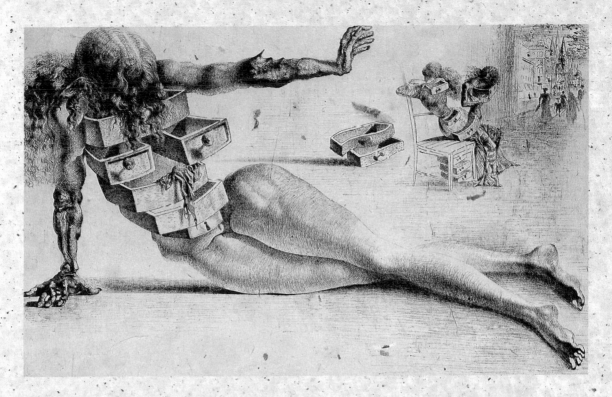

Renaissance by such artists as Bosch and Bruegel with their apocalyptic visions of hell. These were not simply works of the imagination but allegories that utilised a system of symbolism that would have been common currency to the people of that era but are obscure to the more 'sophisticated' society of today. Up until our own century such use of the imagination was rare. Imaginative artists of the past include Arcimboldo, Blake, Fuseli, Goya, Piranesi, Dadd, Doré, Moreau, Redon and Rousseau.

Sigmund Freud was perhaps the first scientist to take a good look inside the human mind, and he could have been talking about himself when he described Leonardo da Vinci as a man who woke up in the dark. With the birth of Surrealism in the 1920s there was at last an artistic movement that, acknowledging the teachings of Freud, felt able to use imagination as a subject. This is evident in the work of Ernst, Magritte, Delvaux, Di Chirico (who, strictly speaking, was a metaphysical artist), Tanguy and Dali. Surrealist imagery has since become commonplace and we have all become anaesthetised to its original power to shock and disturb. Recognising its power to reach deep inside our minds to the very seat of our desires, the advertising industry employs it relentlessly. This in no way lessens the vital importance of continuing to explore a universe that is, in all likelihood, as vast as the one we perceive outside ourselves, and thus contributing to an art and mystery that exists outside of time.

PRINCIPLES

HOW TO START (AND STOP) A PICTURE

A SHEET OF BLANK PAPER POSSESSES THE POWER TO INDUCE TERROR, PROBABLY BECAUSE OF THE SEEMINGLY INFINITE POSSIBILITIES IT PRESENTS, BUT THIS FEAR IS UNFOUNDED BECAUSE A GREAT MANY DECISIONS HAVE ALREADY BEEN MADE BEFORE THE DRAWING INSTRUMENT EVER BEGINS TO TOUCH THE PAPER. All sheets of drawing paper start off as a rectangle as this has proved to be the most versatile shape; the particular format you use will suggest itself by the choice of subject-matter. It is likely that if you are about to draw a landscape the long edge of the paper will be horizontal while for a portrait it will be vertical. These formats are called 'landscape' and 'portrait' irrespective of the image that appears on them. If you propose to draw a building, a still life or an animal then the question of format will depend on whether the subject is taller than it is long. Interesting results might be achieved by ignoring this advice but only if, and when, you feel confident enough to tackle more ambitious compositions.

 If it is to be a drawing of a landscape then there will probably be a horizon which will divide the sheet at some point, so a simple choice can be made as to the proportion of land and sky that you wish to include; this, in turn, is suggested by whether you choose a low or high point of view. Such a stark division will have the effect of cutting the sheet in half and this should be mitigated by having vertical elements of the composition bisecting the horizon. Look at your subject to define the other major horizontals such as the lines

These few simple lines (above) represent the major elements in the composition by Antonio Canal, known as Canaletto (1697–1768), entitled St Mark's Square seen from the Ascensione shown alongside. The plotting of such marks indicating the principal horizontals, verticals and diagonals represents a framework on which to build.

of distant hills, roads, the shadows cast by clouds, rivers and other bodies of water. Then study the major verticals such as tree trunks, buildings or upright rocks and plot them on your paper as a start. Another useful decision to make at this stage is whether you wish the drawing to fill the sheet or if you want to use white space to enhance the composition. In the final analysis there is no substitute for your instincts in making such decisions. Trust them – they seldom let you down.

For more imaginative compositions you will need some inspiration. This is a quality that everyone possesses and is not the sole province of supremely gifted individuals. I cannot tell you where to seek inspiration except to say that it is always there – just let it find you. It is naturally attracted to a mind in a receptive mood: Leonardo da Vinci urged his pupils to study the stains on crumbling walls to see the strange creatures and scenes that these triggered off in the mind, and most people have seen all manner of things in the shapes of clouds. Ancient Chinese artists used to provoke inspiration by deliberately splattering ink on to a surface, seeing what this suggested and going on to elaborate these chance marks into a finished

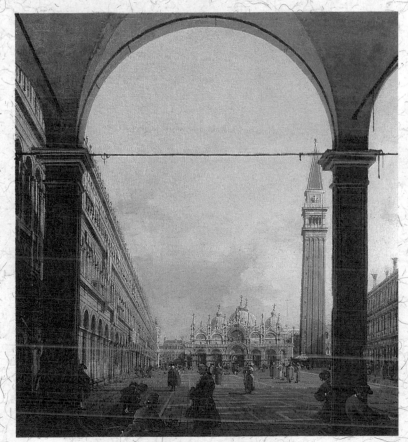

Study your subject and use thumbnail sketches such as these (above) to determine whether the composition is to occupy the whole drawing surface or else to use space in a creative manner to make a more interesting composition.

composition. A variation of this technique was later adopted by the Surrealists who called it 'decalcomania'. In the course of the average lifetime we each spend about 25 years asleep and when we sleep we all dream. This is an important and very real part of our lives and an amazingly rich source of material for imaginative compositions.

If you keep an open mind while you are drawing the image itself often suggests ways in which it might change. Always be prepared to exploit the happy accident as the chance smudge, stain or dribble can often be fortuitously turned into something worthwhile. Even when using an indelible medium such as pen and ink nothing is irrevocable, so that even if your mistakes turn out to be *un*happy accidents they can be modified or eradicated. Do not let the fear of making mistakes block your flow of creative energy.

Knowing where to stop a drawing is much more difficult than knowing where to start. To the experienced artist this moment is often self-evident, but it is much more common for the beginner to overwork a drawing than to underwork it. In a sense no work of art

This analysis of **The Madonna of the Meadow** *by Giovanni Bellini (1430–1516) demonstrates how the artist used the repeated motif of the triangle within his composition. This imparted a feeling of stability and the number three also has spiritual overtones in Christianity. There are more triangles evident than the main ones defined here.*

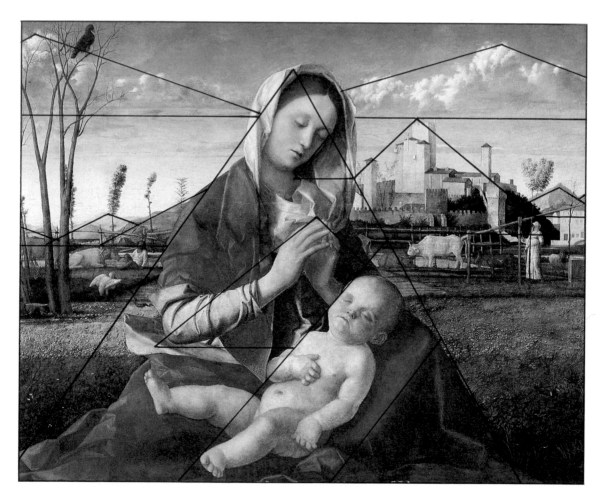

is ever finished but is merely abandoned; the trick is knowing just when to stop. The late drawings of Matisse display an incredible economy and convey their subject with the use of just a few lines, but in the end this is knowledge that must be gleaned the hard way and there will doubtless be a ratio of many overworked drawings before this lesson is truly learnt. If you keep this fact firmly in mind you should soon be able to sense just when overworking begins to be apparent and stop.

In the early stages of a work *doing* is much more important than strict evaluation – that comes later. A common fault of beginners is to look too closely at their effort at too early a stage and thus abandon it before it has ever really started. This over-critical quality was once a fault of mine and still raises its head once in a while. My solution has been to attempt to finish everything I start and later to destroy those works that do not come up to scratch.

COMPOSITION

BETWEEN BEGINNING AND FINISHING A PICTURE A WEALTH OF ARTIFICE MUST BE EMPLOYED; THE MOST BASIC ELEMENT OF ALL IS COMPOSITION. Composition is the invisible framework that lies underneath a picture and upon which it is constructed. There are many elements that constitute composition. The first is the mood we wish the work to convey this often dictates the over-all shape that the pictorial elements are made to assume. If we wish the composition to emphasise stability then we might construct it along the lines of a square or a triangle resting on its base. We know from common experience that cubes and pyramids are unlikely to move of their own accord. If, on the other hand, we wish to express instability then we can rest these same shapes on one of their corners. Triangular compositions can also serve as arrow-heads directing the eye either up or down, to the left or right.

A circular composition denotes both stability and movement as we know a wheel appears the same at rest as in motion. It can also convey a feeling of completeness. Strong diagonals will stress movement, which is seen at its simplest in the typographic cliché of printing a suitable word in italics such as *SPEED!* Strong horizontal stress, reminiscent of a placid body of water, conveys calm while jagged, abrupt shapes suggest tension and disharmony.

We can proceed further and organise the elements in the picture into a symmetric composition with its connotations of order or imply dynamism by employing asymmetry. The composition can be made to appear to tumble by making it top-heavy and we can impart a

The Destruction of Pile *by Mike Wilks (1947–). This elaborate pen-and-ink drawing of 1978 was created using a 'building-block' approach. The composition was deliberately crowded to impart a claustrophobic mood and the toppling feeling emphasised by perspective utilising many vanishing points.*

An image can be scaled up or down in size with the aid of graticulation. The original image is first 'squared up' and a grid of identical proportions with an equal number of squares constructed; the basic image is copied on to the grid square by square before being elaborated.

feeling of claustrophobia by deliberately overcrowding it or by letting the image actually rest against the edges of the picture area. It is possible to convey loneliness by isolating an element within space. By cropping elements in half we can also imply that the composition continues outside the edges of the picture, but this sophisticated approach should be handled with care by the inexperienced as it runs the risk of merely looking as if you have misjudged the size of your paper.

These are all only broad general principles and, although doubtless useful to the beginner, anyone with skill in drawing could produce examples that used these same ideas to express their exact opposites. This ability of art constantly to overturn our preconceptions and stand the world on its head is a never-ending source of delight. In fact, we can look at the composition of a picture in two ways. There is the traditional way of imagining the picture-plane as a window through which we glimpse another world and also actually to look at the surface of the picture and to focus attention on the pattern value of the marks recorded there. Both approaches are equally valid.

The compositions of my own pictures tend to be complex and contain many elements which require a great deal of organisation. My usual method of working is to draw individual elements, usually highly simplified, on separate pieces of paper and then to transfer them, item by item, on to the surface where I will make the finished work by tracing them through with the aid of a light-box. I have found this 'building-block' technique ideal, but this is time-consuming and makes the task of organising the composition beforehand extremely important. This is a fairly sophisticated procedure and is only of substantial use when working, as I do, from the imagination. When drawing from life, however, there is a ruse that can prove useful for the beginner.

All of us are familiar with taking a photograph. We use the view-finder for composing the picture by moving the image around within it until we feel that it is in just the right place before releasing the shutter. We can do the same for drawing. First, cut out two L-shaped pieces of card and place them together so that they form two sides of a frame. By manipulating them we can make a rectangle of any proportion which, when looked through at arm's length with one eye, is used to isolate the image that we wish to record. With the aid of this simple device we can decide on precisely what we wish to include in the drawing, where its boundaries will fall and the proportion that we wish to use. Then place the mask in the bottom left-hand corner of your drawing paper and project a diagonal line through its corners on to the paper. Any rectangle that is made

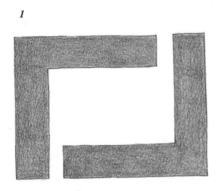

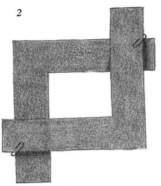

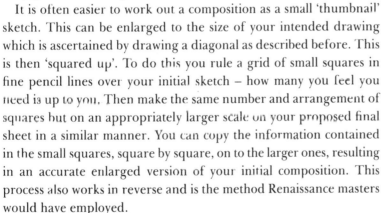

sharing this diagonal will have exactly the same proportions as the aperture of the mask. This viewing device is fine for the beginner but should be discarded as soon as you feel confident about judging this with your own eye. After an initial period it will prove to be more of a hindrance than a help. We do not see the world restricted by the edges of a viewfinder and our two eyes are of disproportionately greater advantage than one.

It is often easier to work out a composition as a small 'thumbnail' sketch. This can be enlarged to the size of your intended drawing which is ascertained by drawing a diagonal as described before. This is then 'squared up'. To do this you rule a grid of small squares in fine pencil lines over your initial sketch – how many you feel you need is up to you. Then make the same number and arrangement of squares but on an appropriately larger scale on your proposed final sheet in a similar manner. You can copy the information contained in the small squares, square by square, on to the larger ones, resulting in an accurate enlarged version of your initial composition. This process also works in reverse and is the method Renaissance masters would have employed.

There is no obvious starting point in a picture as there is in a book, symphony or film, and therefore the eye needs to be drawn into the composition and given a place from which to begin to explore it. Any composition needs an element to arrest the eye and there are certain things that we are all naturally attracted to, such as the human figure, circles, anything unexpected or out of the ordinary and also anything that contrasts boldly against its surroundings. In everyday life we usually express more interest in things closer to us: the bolder something is drawn the nearer it will seem to the viewer, the fainter it is drawn the further away it will seem.

This element of contrast can play an important role in your composition. To enhance a rounded shape juxtapose it with an angular

A viewing mask can sometimes prove useful for the novice. This is made from two L-shaped pieces of card (1) that can be manipulated and subsequently fixed with paper clips to create a rectangle of any proportion (2). This is then used to isolate your subject (3). A diagonal line projected through the corners of the mask on to a sheet of drawing paper will determine the identical proportion at a larger size (4).

one, to emphasise brightness surround it with darkness and so on. Colour can be used to spectacular effect by isolating an area of vivid colour within an over-all field of sombre ones. Whatever is odd or unusual in relation to the main body of the picture will be sure to stand out.

Another important principle of composition is the use of what is called 'consonance', the repetition of a shape, colour or theme to bind the picture together. For example, a circle might be repeated several times at different scales, positions and in different forms within a composition like the visual equivalent of an echo, or colours might be deliberately restricted to one end of the spectrum to unite the whole. There are any number of such tricks.

There are also many 'artistic devices' that are commonly used to good effect. One such is the idea of a frame within a frame where the area around the edges of a picture is used to represent the foreground with an aperture through it where more distant elements are depicted. You may also use strong uprights or horizontals to arrest the eye and prevent it from drifting out of the picture or use curtains at each side to suggest a stage and thus imply a sense of theatricality. Such devices were originated in the work of the old masters and you will be bound to find them everywhere.

There is no need either to feel restricted to standard rectangular drawing paper. Should your composition suggest the need for a square, triangular, diamond-shaped, circular or even an irregular format then feel free to adopt it. It is also quite feasible to join more than one sheet of paper together to create extra long or tall compositions. In art, success is the only rule.

Lastly, you can either plan out your composition thoroughly, which risks losing any spontaneity, or you can rely on the magic of the moment to carry you through, and thus risk ending up with an ill-disciplined mess. Perhaps the wisest approach, and the one I try to employ, is to work out the basic design of the picture allowing enough latitude to allow you to incorporate any new ideas that present themselves. Art, if it is to be anything, must contain the element of magic, and the alchemical recipe for this is in the end unique to each and every artist.

PROPORTION

THE NEXT STEP TO BE CONSIDERED IN THE MAKING OF A DRAWING IS PROPORTION. Proportion is the way in which one part of the work relates to another and all of these to the whole. Exactly what each of us perceives as harmony in proportion is bound to be different.

*A much-used artistic device is the frame within a frame, as used here in this sketch after Salvador Dali's painting of 1925, **Girl Standing at the Window**.*

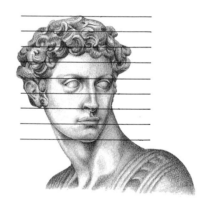

The adult male head was subject to a classical ideal, being divided into eight units. Michelangelo Buonarroti (1475–1564) adhered to them rigorously in his sculpted head of Giuliano de' Medici, Duke of Nemours, from which this drawing was made. This was obviously an idealised portrait and it is unlikely that such proportions are found in reality.

What is pleasing to one person's eye can seem dissonant to another, so we must each arrive at our own point of view. In any event constant exposure to new art as well as to art from other cultures continually redefines our ideas of just what is right and wrong in this area. There is, however, an excellent starting point and a common basis in the classical ideals of proportion. Probably the most beautiful works of art ever made featuring the human figure were the sculptures produced in ancient Greece during the classical period. At this time there were generally accepted ideals that artists were expected to follow, and these were expressed as a set of rules govern ing the proportions of the human figure. In broad terms, the adult male body was divided into eight units with the head occupying one, a distance of two more to the waist, one for the pelvic area and the legs the remaining four, divided at a mid-point by the knees. The female body, being smaller and displaying less muscle, had seven units, with the head again taking up one. Try to find a reproduction of a classical statue and measure these proportions for yourself with a pair of dividers. When these sculptures were intended to be set high up on a building these proportions were cunningly altered so as to take into account the phenomenon of foreshortening to make them appear correct when viewed from below.

The human head was likewise subject to such a set of rules with a division into a further eight units. The distance to the hairline was two units from the top of the head with the centre line of the eyes a further two units down at the mid-point between crown and chin. The nose occupied the next two units, the base of the lips rested on the seventh with the point of the chin completing the eight. The top point of the ears was said to be on the same level as the eyes, with the lobes coinciding with a line projected round from the base of the nose, which continued to the back of the head to define the lower limit of the hair. These proportions are *ideals* and as such are a useful starting point, but anyone who has done even a little drawing from life will know that they bear little relationship to reality, and nowadays artists rely on their eye alone. It is a useful exercise to compare these ideals with your own face.

When these classical principles were being rediscovered during the Renaissance, various artists tried to codify this knowledge into their own sets of principles. The best known works on this subject were by Leonardo da Vinci and Albrecht Dürer. Leonardo's work was never finished and was compiled from diverse manuscripts after his death by a pupil. In it he attempted to codify the entire human body into ratios and proportions (the lips were said to represent 1/112th of the surface of the body) and to demonstrate such things as the equivalence of the span of the outstretched arms to the height

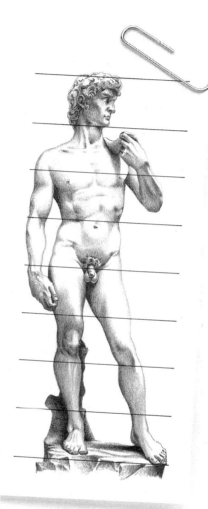

This drawing after Michelangelo's statue of David demonstrates the classical ideal of proportion as related to the adult male figure. The head is one-eighth of the body height and provides the basic unit by which it is measured.

of the individual. Dürer's work, called in English the *Treatise on Human Proportions*, included drawings explaining his concept of how the parts of the figure fitted together; he called this his 'anthropometric' system. This divided different types of bodies into various sub-proportions but still relied on the classical ideal of the male body measuring eight head lengths and went on to show sections through the body at each of twelve different levels. Both of these systems endeavoured to find modules from which to construct representations of the figure and to uncover an underlying divine harmony. In the twentieth century the Swiss-born architect Le Corbusier developed his own modular system of proportion which he used in designing his buildings to harmonise with human stature.

The Renaissance was also responsible for rediscovering the 'Golden Mean', a method of dividing a whole into two harmoniously related parts that was the basis of classical Greek architecture. It is still of great relevance today and is in common use. The idea behind the golden mean (or golden section, as it is also known) is simple in that the smaller part is made to relate to the larger part as the larger relates to the whole. With a little experience this becomes easy to judge with the eye alone and after a while becomes second nature. If, for instance, you were to take a rectangular piece of drawing paper, divide each side at its golden section and project a horizontal or vertical line from each of these, the point where they crossed on the sheet would be an ideal spot to place the central element in your composition.

Leonardo da Vinci strove to discover an underlying divine harmony in the proportions of the human body. In the famous image from which this was copied he demonstrates the equivalence of the span of the outstretched arms to the height of the individual.

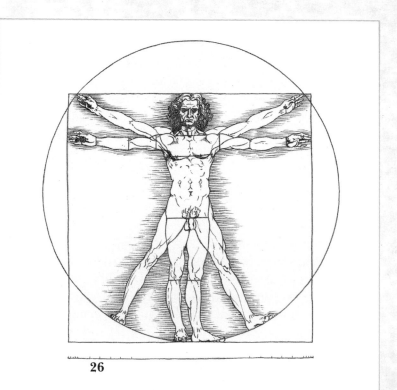

The golden section is a method of dividing a whole into two harmoniously related parts. The geometric method for arriving at this is first to draw a line of any desired length and then to divide it in half. With a compass placed at one end of this line trace an arc from this half-way point through 90° to form an upright (1) and then join this point to the other end of the base line to make a scalene triangle (2). Then, without altering the set radius, place the compass at the top of the upright and dissect the long leg of the triangle before placing it at the far end and projecting an arc from the point where this line is dissected to the base once more (3). This mark on the base line divides it at the golden section and the smaller part of the line has the exact ratio to the larger part as the larger part does to the whole – a ratio of roughly 8:13 (4).

You can then construct a rectangle using these proportions which will itself have a harmonious ratio of 3:5 (5). This rectangle can then be divided using the same principle **ad infinitum** *and each resulting division will also be a golden section. If you divide off one side of such a rectangle into a square and draw an arc of 90° from one corner and continue this procedure through the resulting smaller squares derived from increasingly smaller golden section rectangles the spiral assumes a logarithmic curve and is the true spiral to be found throughout nature (6).*

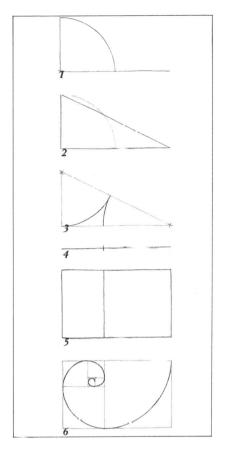

Another useful proportional tool used to create visually pleasing relationships are intervals derived from Fibonacci numbers. This sequence of numbers was first set down in Pisa in the thirteenth century by Leonardo Fibonacci as the result of a self-imposed mathematical problem concerning the rate at which rabbits reproduced. This states that after an initial sequence of two units the following numbers are the sum of the preceding two. Thus the sequence runs 1, 1, 2, 3, 5, 8, 13, 21, 34, 55, 89, 144 and so on. Intervals that bear this relationship to one another are seen to have an innate order and harmony and have since been widely used in art.

When it comes to plotting proportions observed from life the novice can use a simple measuring device as an aid. To judge the proportion of one element that you wish to draw in relationship to another you simply hold out your pencil, pen or whatever at arm's length – this is to ensure that all such measurements are always made at the same distance from the eye – and, looking through one eye, line up one end of the subject you are observing with the end of the drawing instrument. You then move your thumb along its length until it coincides with its other end, which might be, say, half a pencil-length.

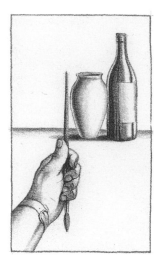
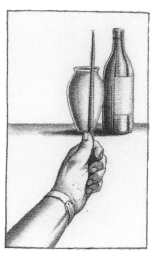
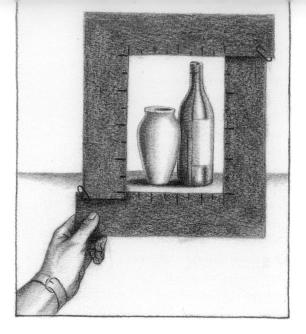

A simple way of assessing the proportions of observed elements is to use your drawing instrument as a measuring stick. Hold it at arm's length (above) and slide your thumb along it until it coincides with the measurement that you wish to make. Repeat this procedure for your second measurement to determine the relationship of one to the other.

Gradations marked along the inside edges of a viewing mask (above right) can be used by the novice as a guide to estimating proportions.

You then repeat this procedure to make your second chosen measurement, which might be a quarter of a pencil-length, and you have an observed ratio of 2:1, which can then be plotted on your drawing. The proportions of all other elements in your composition can be thus determined and after a little practice it becomes a simple matter to assess this with your eye alone.

Another common aid is to mark regular gradations along the edges of a viewing mask and to estimate with your eye where various elements of your subject coincide with them. Manufactured versions of this drawing aid are available which have a grid printed on a transparent surface, but as they are only of any real help initially it is not worth seeking them out unless you really find such help indispensable.

There are other approaches to proportion that bear no relationship to these ideas but which might none-the-less prove useful. One is sometimes called 'psychological' proportion. This simply means that some subjects assume greater importance to the observer because of the way they feel about them. For instance, if you spot someone you know in a crowd of strangers then this recognition imparts a greater subjective importance to that person than to the rest of the crowd. If you were then to make a drawing of this you might portray that particular person as you in fact perceived him or her – in more detail, in a bolder line or larger than the rest, even though objective observation might tell you otherwise.

Exaggeration and distortion are similarly useful. We are all familiar with the way a cartoon can capture the likeness of a person even though the features are grossly exaggerated and out of all proportion. The image becomes more like the person than any photograph could ever be and when done well seems to capture some essence of the personality. I do not suggest going to the extremes of a cartoonist,

who practises an art which is a specialisation all of its own, but distortion and over-emphasis can often be used to convey the way you feel about your subject. You might feel that a giraffe is so tall that you have to exaggerate the length of the legs and neck to convey successfully a true sense of 'giraffeness'.

Any such use of emphasis is permissible and is one of the many advantages that a drawing has over a photograph, which in any event, is a much simpler and quicker method if you wish merely to record the appearance of something. The camera has no faculty of perception; this does not mean that art cannot be created with it, but it can only register patterns of light and shade and cannot think or feel about what it is momentarily looking at. Human perception takes place over a period of time, sometimes many hours or even days for some drawings, and as a result experiences vastly more of what it sees than any camera.

The ancient Egyptians used a stylised approach to representation where figures were depicted as if seen from several different viewpoints at once. No attempt at perspective was made and the image seems to exist in a shallow space as if sandwiched between two sheets of glass.

PERSPECTIVE

A KNOWLEDGE OF THE PRINCIPLES OF PERSPECTIVE IS INDISPENSABLE TO ALL ARTISTS AND IS OF PARTICULAR IMPORTANCE IF YOU WANT TO CREATE THE ILLUSION OF DEPTH. There are two main approaches to the depiction of perspective. The first is known as 'conceptual' perspective and is most commonly seen in the drawings of children and ancient or primitive cultures. This is used to depict the world not as it is seen but as it is known to exist. Therefore an Australian Aboriginal drawing of a lizard will show its interior as well as its exterior – something that cannot be seen with the eye alone but relies on the experience of cutting it up. Interestingly, unlike the Western way of representation, such a work of art will represent *all* similar objects and not just one in particular.

An ancient Egyptian drawing will portray people according to the status that they had rather than recording their actual measured stature. Thus a Pharaoh is shown several times larger than his courtiers who are in turn depicted larger than their slaves. These figures are all highly stylised, being composites made up of elements seen from different viewpoints. Heads are always shown in profile but with the eyes drawn as if viewed full-face. The torso is shown as if seen from the front, but the lower body from the side. Another common feature of

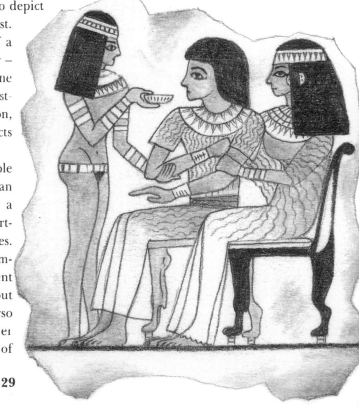

29

conceptual perspective is that objects are shown from the point of view that best expresses their shape, irrespective of how they would appear relative to the other objects in the composition. This idea, which in one respect bears some relationship to the way we actually perceive things, was used by the Cubists in the early part of the twentieth century. It is a perfectly valid way of viewing and recording the world around us and nowadays such things as diagrams and 'exploded' technical drawings, which are intended to impart information in as unambiguous a manner as possible, will utilise at least some of this conceptual approach.

This personal way of recording the world served mankind for thousands of years and was only supplanted in Western art by another, more strictly controllable way of depicting space as recently as the Renaissance. This new approach, which was variously called 'perceptual', 'geometric' or 'linear' perspective, is what we tend to think of when we use the word today, although both conceptual and perceptual approaches have their own value and are in current use. It is

The Masked Ball, *1979, by Mike Wilks. This pen-and-ink drawing uses a very basic representation of perspective with elements simply overlapping each other to create the illusion of depth.*

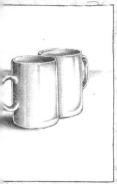

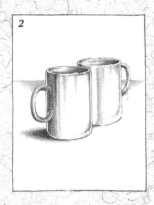

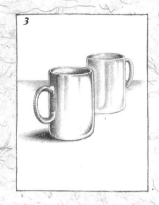

interesting that neither way of looking is perfectly true: perceptual perspective must be modified with a measure of conceptual perspective before things begin to appear as they really are. Just how much you wish to borrow from each one is a question of personal taste and is one of the elements that make each artist's work unique. From now on I will use 'perspective' to signify *perceptual* perspective. In this sense, perspective is the sleight-of-hand practised by artists to create the illusion of three-dimensional space on a two-dimensional surface such as a sheet of paper.

Perspective is an artistic invention first set down by the Florentine architect Filippo Brunelleschi during the early fifteenth century. The study of perspective was considered so important that it was later described by Leonardo da Vinci as the 'bridle and rudder of painting'. Perspective does not exist in reality. What we actually perceive in nature, by virtue of our stereoscopic vision, is the separation of objects in space. We understand from common experience that things that are nearer to us appear large and that they diminish in size proportionately the further they are away. In fact, an image will be halved in apparent size as its distance from the viewer is doubled. This progressive diminution will be apparent if you were to attach a sheet of acetate to a window-pane and trace off what you see; you will be amazed at how tiny things actually appear. The simplest form of perspective utilises the basic observable fact that one object placed in front of another will obscure part or all of the one behind it, and that two objects of a similar size will appear larger or smaller than each other depending on their relative distance from the observer. It is quite possible to create ambitious works of art using this principle alone. If objects are depicted in this way and we wish to suggest that they are close or touching then the simple fact of the one behind being partially obscured by the one in front is usually sufficient. If we wish to convey the illusion of a shallow space separating the two then a cast shadow or reflection can be drawn together with a slight diminution of the relative size of the rear

One object being partially obscured by another can be used to convey an illusion of shallow separation in space (1). A cast shadow or reflection and a slight diminution of size for the further object gives the impression of greater separation (2), while an impression of further depth is achieved by a more pronounced diminution in size and a paling in tone of the rearmost object plus a bolder treatment of the foremost. This, together with the incorporation of a subtle halo, seems to separate it further (3).

An image will halve its apparent size as its distance from the observer is doubled. Thus the Magritte shown here below on the right is twice as far away as the Magritte on the left.

object. To achieve the effect of greater spatial separation we need to reduce further the apparent size of the far object and to increase correspondingly the emphasis placed on the near one by treating it in a bolder manner. If the rear object is also rendered in reduced tonal intensity and a subtle pale 'halo' created around the front object then the illusion is complete.

This progressive paling of tone and colour and blurring of detail as it recedes from the viewer is known as 'aerial' or 'atmospheric' perspective. It comes about because the atmosphere is not completely transparent but is full of moisture and tiny specks of dust and other similar material, which has the effect of creating a haze and scattering the light that passes through it. The short wavelengths of blue light are scattered the most and as a result all colours tend towards this end of the spectrum as they recede from the observer. This is most evident in the colour of the clear sky and in such things as the blue-greyness of distant mountains. The use of aerial perspective is evident in Oriental art and was known to ancient artists but was subsequently lost until its reintroduction into Western art at the time of the Renaissance. It was perhaps used to greatest effect by Turner and later by the French Impressionist painters. Aerial perspective is especially useful to the artist in creating landscapes and where there is an absence of other devices to give the eye clues to depth and distance portrayed.

Another way of portraying distance is to borrow an effect from photography. When we use a camera it is necessary to focus the lens on the object we wish to record; if this is near to us it results in the background of the photograph being hazy and indistinct, or the opposite if we are photographing something more distant. In fact, this is not the way that we see, because when we direct our attention to an object in the foreground what we see in the background is not out of focus but is simply not being observed. When looking at a scene our gaze will repeatedly scan over the foreground, middle-ground and background and we will perceive it as a totality built up in our brain from many discrete views. This is not possible with the frozen image made by a mechanical device such as a camera which must of necessity have its attention, as it were, directed by the photographer. By rendering the foreground or that part of the composition to which we wish to draw attention more distinctly, bolder or in more detail, we can achieve this same effect.

This particular method of working can be seen in the paintings of an artist like Vermeer, who is believed to have used a camera obscura in creating his pictures. The name means 'dark room' and the artist's version was a box equipped with a lens which focused the image that was being observed on to a ground-glass screen, where the artist

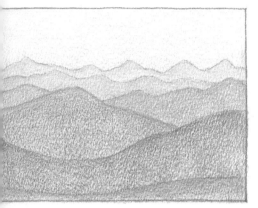

The fact that the atmosphere is not completely transparent means that objects become less distinct and bluer the greater the distance they are from the observer (above). This is known as 'aerial' or 'atmospheric' perspective.

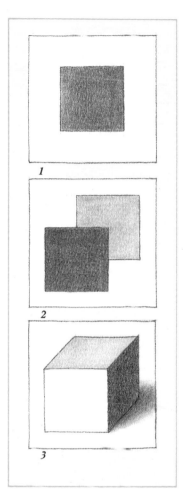

1

2

3

The picture plane can be regarded in three different ways. It can be reinforced and used to represent a flat plane upon which marks are made (1), it can be partially penetrated and seen as a shallow space where only flat objects can exist as if trapped under a transparent sheet (2) or totally penetrated and considered as a window through which we glimpse another three-dimensional world (3).

could trace it on to a sheet of drawing paper. This two-dimensional area, which is bounded by the edges of the sheet of drawing paper, is called the picture-plane. The artist can regard the picture-plane in three ways. The first is to acknowledge it and thus make the viewer aware that he or she is in fact looking at a flat surface. This is the logic behind much abstract art and art concerned with creating patterns. The second way is to allow the image partially to penetrate the picture-plane and the marks made on it to seem to exist within a shallow space, as in ancient Egyptian painting. The third way is to penetrate this plane totally and to use perspective to conjure up the illusion of infinite depth. The surface becomes in effect a window through which we regard another world.

Three basic forms of perspective are used to create increasingly sophisticated representations of space, all dealing with the way parallel lines seem to converge towards an imaginary point called the 'vanishing point'. They are known as one-point, two-point and three-point perspective. A cube is an object composed of parallel lines and is a good example to demonstrate this principle. When viewed from the front it can be successfully depicted with simple one-point perspective. All lines that are vertical and horizontal to the edges of the picture-plane are drawn as such and the parallel lines that penetrate into the picture are seen to converge towards a single vanishing point. When such a cube is depicted as being seen from an oblique angle then we must employ two-point perspective which uses two vanishing points. Here only the verticals will appear upright and all the other parallel lines will seem to converge towards either one of the two vanishing points. If the cube is resting on a flat plane these points will be on the horizon. With three-point perspective no set of lines will appear as parallel to the edges of the picture plane as they will each converge towards one of the three vanishing points. This is used to render the illusion of objects in space viewed from both an oblique angle and a high or low viewpoint. On a flat plane two of the vanishing points will appear to be on the horizon and the third either above or below it, depending on the point of view of the observer. If you are unfamiliar with these three forms of perspective, experiment with them now as rough sketches. Those who already have a grasp of these principles might care to try them out right away with exercise six, an architectural drawing, introduced later in this book (see page 113).

You will find that as images appear further away from your vanishing point and approach the edges of the picture they will appear more distorted. This will be more apparent the more vanishing points that are employed. In the past artists have avoided this distortion by not making their compositions so wide for this to become evident or

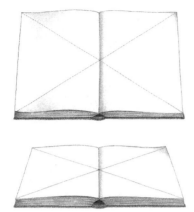

Foreshortening becomes apparent when objects are viewed from an oblique angle. If you tilt this book away from you (above) you will see the apparent depth of the pages progressively shrink until they vanish when seen end-on.

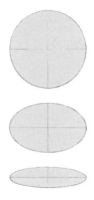

An ellipse is what we see when a circle is foreshortened. Its length remains the same but its apparent height diminishes as the tilt away from the observer increases. The knack of drawing accurate ellipses is to ensure that each quadrant is a mirror image of its neighbour.

else have artfully disguised this tendency by carefully placed irregular forms such as foliage or drapery.

With linear perspective there is an application that usually confounds those unfamiliar with it. It concerns the problem of rendering foreshortening, the way things appear squashed up when viewed from an oblique angle. If you take this book and gradually tilt it away from you you will see that the pages appear to become narrower and narrower until they finally vanish when you are looking at them end on. Notice too, that as the book is tilted the centre of the page will appear progressively nearer the far edge. Just as when drawing a square the centre of any rectangle in perspective can be determined by drawing diagonals from each of its corners. The centre is where these lines cross. This is the basic principle underlying the rendering of foreshortening and can be applied in most situations. When a circle is rendered with foreshortening it becomes an ellipse. A disc seen head on will look circular but will become flatter as its angle to the observer is inclined. You can see this by taking a coin and tilting it away from you. Ellipses must be drawn so that they do not look pointed at the ends like an airship or flattened in the middle like a cigar. The key to drawing an ellipse is that if it is divided into quarters each quadrant will be an identical mirror image of its neighbour. With any ellipse the centre will appear to remain fixed however foreshortened it is drawn.

There is a geometric method for depicting the way the intervals between regularly spaced objects such as telegraph poles will appear to decrease as they recede from the observer. To do this we draw the pole nearest to us and project lines from the top and bottom of it to the vanishing point on the horizon and use this to determine the position and height of the second pole in the series. We then project a similar line from its centre to the vanishing point. Next we project a diagonal construction line from the top of the first pole through the point where the centre line bisects the second to the base line. This indicates the position of the third pole in the series. The procedure is repeated to determine the positions of the subsequent poles as they march towards the horizon. This principle will work equally well for any regular progression such as an arcade or a tiled floor.

Ancient Chinese art observed another convention with formal rules in its portrayal of perspective in which objects do not seem to converge towards a vanishing point on the horizon. Instead it employs a system of parallel perspective in which parallel lines are always drawn as such and thus seems to disregard what we in the West think of as 'real' perspective. This is then combined with a view from above to render its own unique illusion of distance. This also created visual

problems of distortion which the artist needed to disguise with devices like foliage. In the early part of this century the Cubists arrived at yet another solution, and their use of perspective took into account the element of time in the way in which we view our surroundings. Our perception of a scene is composed of many separate views in time and space, and they attempted to convey this simultaneously in a single static image. Thus what might at first sight seem to be a portrait with four eyes, three ears and two noses is in fact a representation of a normal person with these items observed a number of times from different viewpoints over the period that it took to create the work. They also used reverse perspective, that is with parallel lines diverging, to convey the experience of moving around an object. First we see the object from one side, then from the front and then the other side. This is a fusion of the conceptual and perceptual methods of perspective which you may find useful.

All of these are valid ways of using perspective. None of them is absolutely true to the way we see and it must be remembered that in this respect all art is fiction. Whichever of these principles you wish to adopt you will find that they will serve you well as guidelines, but you must be prepared to bend them or depart from them completely when it seems necessary.

FORM

FORM, THE SUGGESTED SOLIDITY OF OBJECTS, CAN BE DEPICTED USING LINE ALONE. The brain, drawing on the wealth of information gleaned from years of experience, will then fill in, as it were, what is only implied from a few simple marks on a sheet of paper. Thus a circle can represent a sphere, a triangle a pyramid or cone, a straight line the horizon of the sea and a jagged set of lines distant mountains.

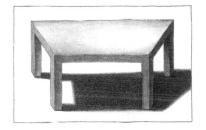

Reverse perspective was originated by the Cubists and used to imply movement around an object. This table appears 'wrong' if you look at it all at once, but if you first cover one half of the image with your hand you seem to view it from one direction, then when you move your hand to cover the other half you will seem to have moved around to view it from the other direction.

The geometric method for depicting perspective can be employed when we wish to represent regularly sized and spaced objects such as telegraph poles (below), columns or regularly divided planes like tiled floors receding from the observer.

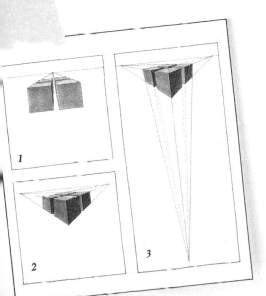

One-point perspective is the simplest form of linear perspective and represents parallel lines converging towards a single imaginary vanishing point in space (1). Two-point perspective is a more sophisticated treatment of space and uses two vanishing points (2). Three-point perspective uses three vanishing points and is capable of depicting objects viewed from either above or below (3).

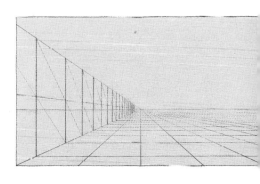

35

Outlines do not exist in reality: they are an artistic convention used to delineate the boundary of an object in space relative to other objects in space or to indicate where different areas of colour or tone meet. But lines can be more than simple boundary marks as they can be made to express something more about what they are depicting or about the way the artist making them feels about what he or she is drawing. Handwriting is often similarly expressive about the personality of the writer. This use of line and therefore the ability to abstract solid forms from it is universal and is to be found in even the most primitive works of art. Although it is possible to make a drawing without using line it is a rare drawing that does not make use of it somewhere.

The artist can use line alone to imply form. The mind of the observer is capable of interpreting these few simple lines as an entire landscape.

Each type of drawing instrument will make its own individually characteristic mark. The choice of media will depend on the subject you wish to depict but more importantly on your degree of skill and the way you feel towards any particular medium. It is possible to draw anything with a pencil, but I know from personal experience how difficult it is to try to render something like the subtle gradations of tone observed in a clear sky with pen and ink. Strong lines used boldly can arrest the eye and rhythms of lines can lead the viewer through a picture. The eye will skim rapidly over blank areas and areas of even tone or texture but will be drawn to examine more closely those parts of a drawing where lines have been rendered with more expressive use of the chosen medium. The way in which you draw a line can also convey a feeling of texture. Whereas a continuous, flowing line will express smoothness, the same line drawn as a succession of angled straight marks will express something harder and faceted, while if accentuated with a series of dots or points along its length it will convey a sense of grittiness or graininess.

Line can be used to create the illusion of recession by carefully varying the weight, interval and detail shown, all of which are made to decrease with distance portrayed.

The majority of drawing instruments enable you to vary the pressure that you apply and so make the line itself more interesting. With pencil, charcoal or crayon this will have the effect of making the line darker, but the same technique used with a brush or dip-pen will progressively thicken the line the more pressure that is applied. This factor becomes very useful in putting into practice some of the points made previously about perspective. To help to create the illusion of recession we can decrease the weight of the line or the pressure we use to make it as we depict things further and further away. If we are using a series of marks to denote texture, then by gradually decreasing the weight, intensity, intervals and detail shown this impression of increasing distance is achieved. When using line it is not necessary to delineate faithfully every single outline. Human perception has a remarkable ability to fill in details that are only suggested on the observed drawing. For example, something drawn

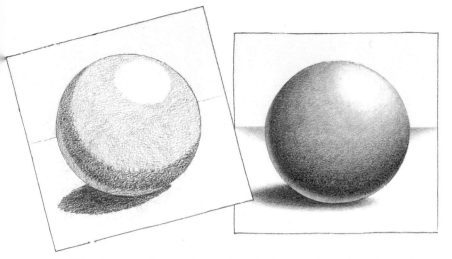

Leonardo suggested that five tones are observed when looking at an object such as a sphere. The brightest is the highlight nearest to the light source followed by the mid-tone and then the shadow edge. There will be reflected light at the far edge of the sphere and a dense cast shadow on the surface that it is resting upon. In practice, these all merge imperceptibly into one another.

as if in deep shadow against a dark background need not have these areas as clearly defined as they would need to be if portrayed in strong light.

Line, used alone, can only ever imply form. To render it in a more substantial or illusionistic manner we need to employ the use of tone. Tone is the modelling used to express the way light falls on a subject and provides us with its appearance of solidity. If an object is angular or faceted the light that falls upon it will be broken into distinct tones as the planes will each be at certain angles to the light source. Those that face it directly will appear the brightest, those furthest away from it darkest and those at oblique angles to it will be composed of intermediate tones. The light will also be affected by the material from which the object is made, be it matt, glossy, reflective, textured, transparent, multi-coloured or fabricated from a combination of materials. Light falling on a shiny surface will be reflected back coherently and will cause reflections to be noticeable, but light falling on a matt surface will be reflected in an incoherent manner and the gradation of tones will be unaffected.

Even if you are depicting the tone of a flat area, bear in mind that it is unlikely that the light is illuminating it evenly as that section of the plane nearest to the light will be brighter than the rest. Photographers who specialise in taking photographs of flat works of art must take great pains to ensure that the subject is evenly illuminated and, of course, natural light cannot be manipulated in the same way that photographic lighting can. When light falls on a curved surface, for instance a sphere, the gradation from light to dark is gradual and progressive and reflections will play a greater role than is the case with angular shapes. In his notebooks Leonardo noted that light falling on such an object created five areas of tone, although in reality these merge imperceptibly into each other. Nearest to the source of light will be the highlight and next to that the mid-tone of

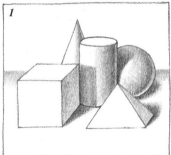

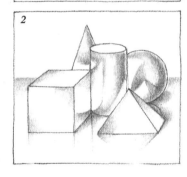

Light acts on all objects in essentially the same way. Surfaces nearest to the light source will be more strongly illuminated than those further away and the objects will cast a shadow that is proportionate to the intensity and position of the light and to the shape of the object (1). Shiny objects reflect light coherently and both reflections and shadows will be apparent (2).

*Shadow edges can be 'forced',
making them slightly darker and
the background around them
slightly lighter to make their
values seem truer (right). As the
eye scans a scene the pupil will
automatically expand and
contract, regulating the amount of
light that enters it, and the artist
uses this technique to compensate
for that fact.*

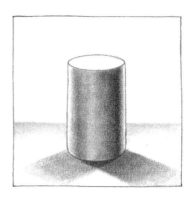

*An object illuminated from more
than one direction will have
highlights and shadows directly
proportionate to the intensity of
the light sources. The stronger the
source the brighter the highlight
and the deeper the shadow.*

the sphere. There will then be the shaded area, and at the far edge, furthest from the light source, will be a small crescent of reflected light. The darkest area of all will be the shadow cast by the sphere upon the surface on which it is resting. It is worth bearing in mind when drawing such an object that the brightest tone available is often the white of the paper that one is working on.

The plotting of shadows is the principal way that we can suggest form in a work of art. Everything that we can see casts a shadow. The intensity of this will change according to the type and brilliance of the light source, and a shadow cast by an object under an overcast sky will be vague, but when illuminated by strong sunlight it will be bold and well defined. This use of shadow will also give the viewer a great deal of information about such things as the time of day represented – an early-morning shadow will be long and stretched out and much more condensed at noon – and whether the scene is lit naturally or artificially. If there is more than one light source there will be an equal number of shadows cast and their intensity will be directly proportionate to the intensity of the light source they are derived from. A shadow falling on another object will follow the contours of that object, and obliquely lit textures will seem more pronounced than if they were illuminated from overhead. It is only in comic books that shadows are black: in reality they reduce the illumination of the area they occupy, filling the cast-shadow area with reflected light, which will contain a proportion of its complementary colour. Shadows are joined to objects and are inseparable from them, and when depicted in a picture give them their sense of presence by anchoring them in space. They are the major clue that the artist can give to convey a sense of form and depth and, used creatively, can be expressive of moods of mystery and intrigue.

For rendering such things as form and shadow it is possible to blend tones together into a continuous gradation when using such

media as pencil, crayon, charcoal or pastel, but when using pen and ink, ball-point and felt-tip pens, for example, this is impractical. In these cases form must be expressed by creating areas of tone by cross-hatching, stippling or with hachure lines. Because the eye is constantly regulating the amount of light that enters it we can employ the principle of 'forcing' to the rendering of shadows. This means emphasising the intensity of one tone where it meets another to compensate for this.

Combinations of all of the preceding principles can be used when making a drawing, and indeed most drawings are combinations of line and tone, angular and rounded shapes, a variety of different types of mark and, sometimes, a combination of two or more media.

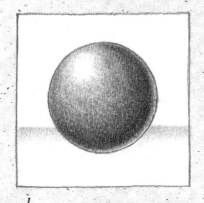

1

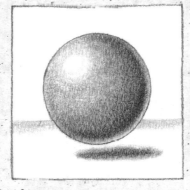

2

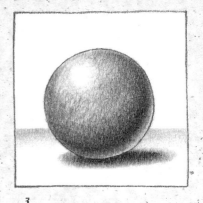

3

Colour

WE ALL KNOW WHAT COLOUR IS BUT IT CANNOT BE DESCRIBED IN ABSOLUTE TERMS. Any colour will be modified by the light that illuminates it – daylight has a bluish tinge, while most forms of artificial light are markedly yellow – and also by the nature of the material of the object, which is itself coloured. It is fascinating that any colour, for example yellow, when viewed under a coloured light will still be perceived as yellow even though it is actually quite distinctly coloured by the light. Even colours that we think of as absolutes, like black and white (technically neither is a colour), in practice contain traces of other colours. If you assemble a group of black or white objects from around your house you will be able to see for yourself the enormous variations within them. Also it can never be proved with any degree of certainty that what I perceive as a particular colour is the same as anyone else's experience of that same colour. The sensation of colour only exists when visual information received by the eyes is decoded by the brain.

Shadows should be regarded as an inseparable part of the object that casts them. The lack of a definite shadow will impart an indeterminate position in space (1) while the position of the shadow will clearly define the object's position relative to other elements in the composition (2 and 3).

Throughout history there have been numerous attempts to codify colour, one of the best known being the Munsell system which was first published in 1915. The inventor, the American painter Albert Henry Munsell, defined three parameters for assessing a given colour: 'hue' equivalent to wavelength, 'tone' (or 'value') equivalent to reflectance, and 'chroma' equivalent to purity of colour. In everyday terms this means that a particular colour can be identified by its Munsell number. For example, Munsell 5R4/8 will indicate a mid-red (5R) with a tone value of 4 and a chroma of 8. Nowadays colour parameters are generally defined as 'brightness', 'hue' and 'saturation', where brightness refers to the intensity of the colour, hue to the proportion of any other colour present (as the amount of blue in bluish-green, for instance) and saturation to the purity of the colour. Colours are therefore characterised by their chromaticity (hue + saturation) and brightness. Information stating the numbers of such systems as Munsell and Modular (another similar system) can often be found on tubes of good artists' colours together with an indication of their permanence.

The basic colours are called 'primary' colours. These are the colours that cannot be mixed from others. There are three primary colours, but interestingly, they are different when we are dealing with light than when dealing with pigments. With light the primaries are red, green and blue and by mixing them we can achieve the secondary colours of light. Red mixed with blue light gives magenta, blue mixed with green light gives cyan and green mixed with red light gives yellow. If the three primary colours of light are mixed together they result in white. This is known as the additive method of colour combination; this process is reversible, making it possible to break down white light into its constituent colours with the aid of a prism. On the other hand, colours made with pigments behave differently: this is known as the subtractive method. This difference is due to the complicated manner in which the pigments themselves are absorbing and reflecting light (otherwise they would not appear coloured). The primary colours for pigments are red, blue and yellow, and mixing them to create secondary colours results in red and blue making violet, blue and yellow making green and yellow and red making orange. Combinations of a primary and a secondary colour mixed together result in one of the tertiary colours of red-violet, violet-blue, blue-green, green-yellow, yellow-orange or orange-red. The tonal values of these colours are also progressive, from the darkest at violet to the palest at yellow and back again. All of the colour reproductions in this book are made up from countless tiny dots of the three primary colours of printing inks – magenta, cyan (greenish-blue) and yellow plus black to enhance the form – and

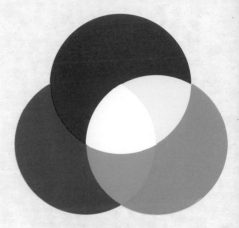

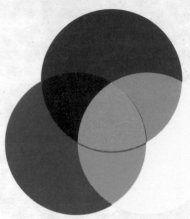

The primary colours of light (top) are red, blue and green. When they are mixed together in equal proportions we perceive white light. It is not possible to make non-spectral colours such as brown or grey by this method.

The primary colours of pigments (below) are red, blue and yellow. By mixing them in various proportions we can arrive at any other colour. Grey is an equal mixture of these three primaries.

they can be observed with the aid of a magnifying glass. Because pigments, unlike light, are never pure we cannot always achieve the colour we desire by mixing them. In practice, if we mix black and yellow we do not end up with dark yellow but with green because of the proportion of blue pigment that exists in black paint. Similarly, it is impossible to mix a good violet from red and blue as these pigments are themselves impure. Knowing just what you can mix from your colours is a case of trial and error as each manufacturer will have his own formula for a particular colour. Over a period of time you will come to prefer the colours of one maker over those of another and you will gradually acquire your own knowledge of how they behave.

The way in which colours relate to one another can be demonstrated with the aid of a colour wheel. This can be either simple or more complicated depending on the amount of information it conveys. At its simplest it is a disc divided up into six equal segments. In each of three alternating segments appear the three primary colours of red, blue and yellow and separating them the three secondary colours of violet, green and orange, made (in principle) by mixing two neighbouring primaries. In such an arrangement any one colour will be diametrically opposite its 'complementary' colour. Thus blue is opposite its complementary orange, yellow its complementary violet and red its complementary green. The colours that appear next to each other on the colour wheel are said to harmonise with their neighbours. Thus blue harmonises with violet and green, yellow with green and orange, and red with both violet and orange. If we mix the three primary colours together we arrive at a neutral grey, although in practice the proportions of each colour used will be different as each has a different staining power. Make your own colour wheel to demonstrate this and to keep as a reference for the future.

There is a symbolic language of colour which is obvious to most people even if they have never had to think about it. Red is perceived as signifying danger, probably because of its connotations with fire and blood. Green is the colour of plants and therefore has associations of growth and freshness, while the colour of sunshine – yellow – gives an impression of joy and warmth. Blue will be expressive of calmness as it is the colour of an untroubled sky, while white has connotations of purity probably because it is untainted by any other colour. We tend to think of black as the colour of death possibly

The colour wheel. The colours in the largest segments are the three primaries, those in the intermediate segments the secondaries made by mixing together two primaries and those in the smallest segments are the tertiary colours, which are made by mixing a primary and a secondary together. Each colour is diametrically opposite its complementary colour.

because it is impenetrable, although in the Orient this connotation is conveyed by white. In Western society there are also many other associations of colour with emotion. Red is thought of as a lustful colour – we speak of red-light districts and of scarlet women – blue is often a synonym for sadness, yellow has connotations of cowardice and to be green is to be seen as inexperienced. Such a list is virtually endless and it is a mistake to attach too much importance to such associations. We will each make our own personal links between colours and states of mind, which is of much more relevance to a medium of self-expression.

However, colours do have certain properties that are worth exploiting. Red, orange and yellow are all warm, vibrant colours and will have the effect of attracting attention and of coming forward when used in a picture. Blue, indigo and violet, being cool colours, will have the opposite effect and be seen to recede. Green is a neutral in this respect, but a yellow-green can be made to advance slightly and a blue-green to retreat. Interesting things are seen to happen when one colour is juxtaposed with others. A small amount of red surrounded by blues and greens will be intensified, as will a blue used amid reds and yellows. It is also possible to make a turquoise seem blue by placing it next to purples and blues and the same colour to appear green by putting it next to yellows and greens. The more that you use colour and become acquainted with it the more such contradictions you will find.

There are a number of ways that colours can be used against one another. You can contrast pure, undiluted colours against each other, and a vivid red put alongside a vivid blue or green of a similar tone will be seen to create a visual vibration or scintillation at the point where they meet. This effect was employed by certain Op-artists in the 1950s and 1960s to make their works seem to pulsate. Various contrasts can also be exploited, such as the light/dark contrast of placing, say, a yellow next to a violet, or contrasts between warm and cool colours: green and blue will seem cooler than violet and blue and it is also possible to modify a yellow to seem cool and a green to seem warm. The eye is known to have a tendency to overcompensate in attempting to create some kind of visual equilibrium. Thus a neutral grey adjacent to a green will appear reddish and the same grey placed next to a red will appear greenish. Try this simple experiment for yourself.

Some colours have been with us since the beginning of recorded time while others have only appeared very recently. During the history of colour some colours have become extinct. Who today has heard of bice (an early form of blue made from azurite) or mummy (a form of brown made from mummified bodies)? Other colours like

Ancient Oriental art rarely used colour as its creators believed that the observer would colour in the image from his or her own experience. Drawings are most often made in monochrome as is the case with these flags which, at a certain level in the mind, are coloured.

bitumen have ceased to be used because while it is an attractive transparent brown when freshly applied it has proved to be fugitive and ages over a period of years to form a texture like the hide of a crocodile. Many early colours were made from insect or plant material which have proved to be fugitive when exposed to light. Nowadays many synthetic versions of traditional colours exist, such as synthetic ultramarine, which up until Victorian times was made from ground lapis lazuli. In the past this pigment was so expensive that the amount to be used in a painting often governed the price of the finished work. Thankfully many modern colours are much less expensive and have a very high degree of permanence.

The names of artists' colours can be very confusing for beginners and unless they are used to them or have some knowledge of chemistry they will probably not realise that 'Oxide of Chromium' is a cool green or that 'Havana Lake' is a cool violet red. Any such colour will also vary from manufacturer to manufacturer. Because of the variations that even good colour printing has it is only possible to reproduce swatches that approximate to the colours mentioned here: see them for yourself before you decide to purchase any. The list on the right will act as a guide through the confusing minefield of colour names and also represents a good, versatile range of colours to acquire. Do bear in mind when using paint that colours used straight will be brighter and purer than any you can mix yourself and that the more colours are mixed the muddier they will become.

Most drawings do not use colour and when they do it is in terms of single coloured marks on white or coloured paper. Whether you choose to use colour and how you use it is a personal choice and contributes to your style. When colour is employed it can be used in a broad way or your palette can be deliberately limited and restrained – again the choice is yours. With a monochrome drawing we allow the mind of the spectator to fill in the colours, as it were, from his or her own experience: in this way a texture of small vertical lines representing grass will be taken as being green. This will even work when using a strong colour like sanguine on a coloured paper. When drawing on coloured paper it is possible to create highlights with a lighter colour, which is impossible when working on white. Use such highlights sparingly their impact will be lost and you will end up with a bland, mid-toned drawing lacking vitality. Restrict them to the very lightest highlights – less equals more.

Everything outlined in this book so far is the kind of background and principles that every art student has to learn and absorb in the early part of training and establishes a vital continuity with the timeless aspects of art. Now we must turn our attention to the more practical matters of the media we can use to make our drawings.

ALIZARIN CRIMSON
A purplish red
CADMIUM RED
A good strong red
CADMIUM ORANGE
A strong bright middle orange
CADMIUM YELLOW
A bright middle yellow
YELLOW OCHRE
A brownish earth yellow
VIRIDIAN
A middle green
HOOKERS GREEN
A dark green
MONASTRAL BLUE
A strong bright blue
ULTRAMARINE
A dark blue
COBALT VIOLET
A strong violet
BURNT UMBER
A versatile dark earth brown
RAW SIENNA
A warm middle earth brown
IVORY BLACK
An all-purpose black
PERMANENT WHITE
An opaque white

THE ABOVE LIST REPRESENTS A BASIC PALETTE AND YOU MAY WISH TO ADD THE FOLLOWING:

HAVANA LAKE
A cool violet red
INDIAN RED
A strong brownish red
VERMILION
A bright orange red
LEMON YELLOW
An acid pale yellow
NAPLES YELLOW
A cool yellow or buff
OXIDE OF CHROMIUM
A cool green
CERULEAN BLUE
A bright sky blue
RAW UMBER
A cool earth brown
BURNT SIENNA
A warm middle earth brown
PAYNES GREY
An all-purpose grey

MEDIA

THE STUDIO

THE IDEA OF AN ARTIST'S STUDIO OFTEN CONJURES UP AN IMAGE
OF A BARE ROOM IN AN ADVANCED STATE OF DISARRAY WITH DIS-
CARDED PAINT TUBES AND EMPTY ABSINTHE BOTTLES LITTERING
THE FLOOR AND UNFINISHED CANVASES STACKED AGAINST THE WALL.
We have Hollywood and bad novels to blame for this colourful but
inaccurate picture. A studio is merely the place where an artist works:
at various times my studios have been anything from a friend's kit-
chen table to the corner of my bedroom, and without exception they
have always been clean and tidy. Few people can afford the luxury
of a separate room to use exclusively as a studio and in practice this
will need to be improvised in some way. Even if you choose to create
your work exclusively out of doors you will still need some place in
which you can store your materials, conserve your works and gener-
ally make the kind of adjustments and finishing touches that cannot
be performed anywhere else.

Most artists will spend much or all of their working life in a studio
and there are certain requirements that every studio must fulfil.
The first is that it should be a place where you can be calm and
where you will not be disturbed. The act of drawing requires an
enormous amount of concentration and I find that this can only be
done when I am completely alone and surrounded by silence. We
are, of course, all different and I know of artists who like to work in
the company of other people and to the sound of music. In the end
this must be a personal choice with effectiveness being the sole cri-
terion. The amount of space that you feel you need is also something
to consider. Some people need a certain airiness to feel happy, but

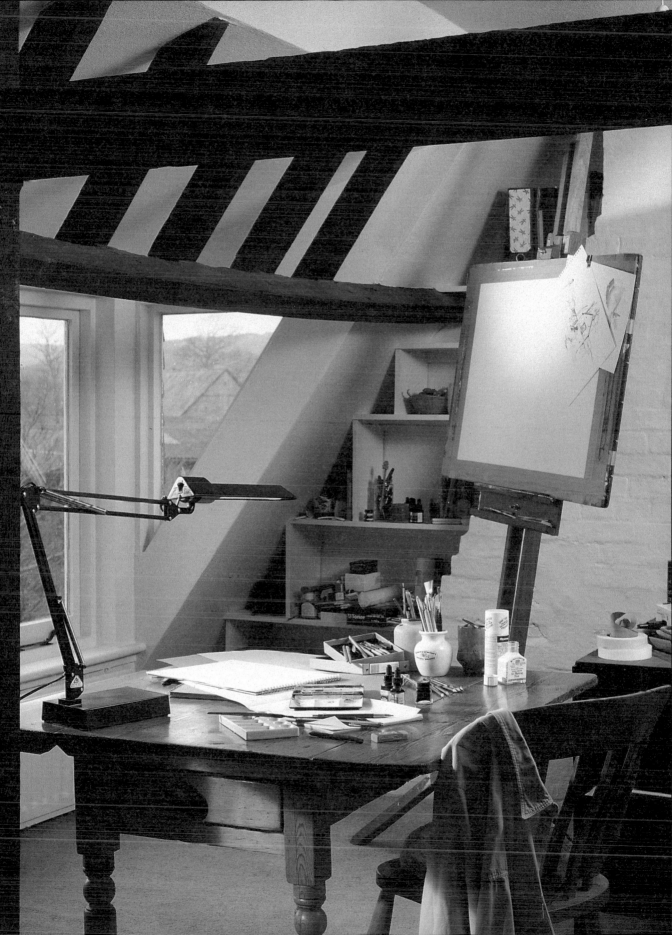

normally a table-top is large enough to accommodate most drawings. You will also need somewhere safe and clean where you can store all of your equipment. The priority of light is equally important. The ideal studio is large with ample natural illumination from windows or skylights facing north – the traditional artist's north-light (which must be a south-light in the southern hemisphere). A studio lit like this benefits from even, indirect daylight where any shadows will seem to remain constant and not follow the passage of the sun. Few people are lucky enough to have a suitable room correctly oriented, but this is probably only essential if you are constantly drawing from life in your studio. My studio has blinds on the windows to regulate the light, but as I work almost exclusively from my imagination I do not find this such a critical factor. Where the natural light is inadequate or when one wishes to work after dark then artificial lighting is essential. This is best achieved by a good level of all-over illumination – much stronger than you would expect to find in an average living-room – that avoids casting your own shadow across your work. This will need to be augmented with a direct light source such as an Anglepoise work lamp that can be manipulated to cast strong direct light just where it is needed. Always remember that all artificial light is tinted and therefore will make the task of judging any colour that you are using difficult. Normal everyday tungsten light is markedly yellow, halogen is less so but generates a lot of heat that may be found uncomfortable and fluorescent tubes are either bluish or pinkish but have a dead quality of light that I personally find intolerable. If you find artificial light indispensable and fluorescent light bearable then there are work lamps that match a warm and cool tube to approximate daylight.

As most drawings are made horizontally a table-top is usually adequate. If the surface is uneven then a sheet of thick card taped down on top will provide a good temporary solution. Better still is a good-quality drawing board, which has the advantage of being portable for working out of doors and can also be propped up with books if you prefer an angled work surface. Some even come equipped with a set of adjustable legs so that they can be angled towards the artist, and you can buy small table-top frames to achieve the same result. If you feel that you need to work upright then I suggest a combination easel, which is capable of being articulated from horizontal right through to vertical.

Other factors have to be taken into consideration when choosing a work space, such as the need to keep paper which must be stored flat and away from sunlight which will discolour it and dry it out. A plan chest is ideal if you can afford one and have the space, but a good alternative is to keep paper well protected from dust under a

bed. Colours and brushes should also be kept away from sunlight and dust. Creating works of art need not be messy, although some media frequently are, so protect floors and work surfaces against any mess that you might make, especially if you have requisitioned another part of your home as a temporary studio. This is also true for your clothing: sleeves and laps are especially prone to staining from drawing materials. It is a good idea to keep an old shirt to use as a smock. It often takes a long time to create a drawing, and as self-expression is the world's most addictive drug you will inevitably want to spend more and more time creating. Ensure that you are perfectly comfortable in your studio, however grand, basic or temporary this space might be. If you choose to work seated make sure that your chair is soft enough and provides sufficient support and that the studio is adequately heated or ventilated. In this way your concentration will be entirely on your work and your creative energy free to flow.

Drawing aids

DRAWING AIDS MUST BE ALMOST AS OLD AS DRAWING ITSELF AND RANGE FROM SIMPLE EVERYDAY OBJECTS THAT YOU ARE SURE TO HAVE AROUND THE HOUSE TO SOPHISTICATED GADGETS THAT YOU WILL ONLY WANT IF YOU ARE A PROFESSIONAL ARTIST OR AN INVETERATE COLLECTOR OF IMPLEMENTS. Tools specific to various media will be introduced later; this is an outline to the general equipment, most of which I find indispensable and use from day to day. The most basic drawing aids will help you to create lines and curves. For drawing straight lines rulers come in several standard lengths. A good-quality clear plastic ruler calibrated in both metric and imperial systems is a good choice (1), but, like wooden ones, is hopelessly inaccurate for taking serious measurements. Some come with a rubber strip on the reverse side to prevent it slipping when ruling lines. Make sure that you choose one long enough to cover all likely eventualities. Plastic or wooden rulers should never be used for cutting against. Parallel rulers are two straight-edges joined together with hinges that are useful for creating series of parallel lines and there is a similar device incorporating a roller which can be set to stop at pre-set intervals (2). Both of these mimic the sophisticated parallel-motion draughting machines of architects and engineers. The T-square is the traditional, and remains the best, basic tool for creating parallel horizontal lines and is used in conjunction with set-squares for creating verticals and various angles. A 45° and a 60° set-

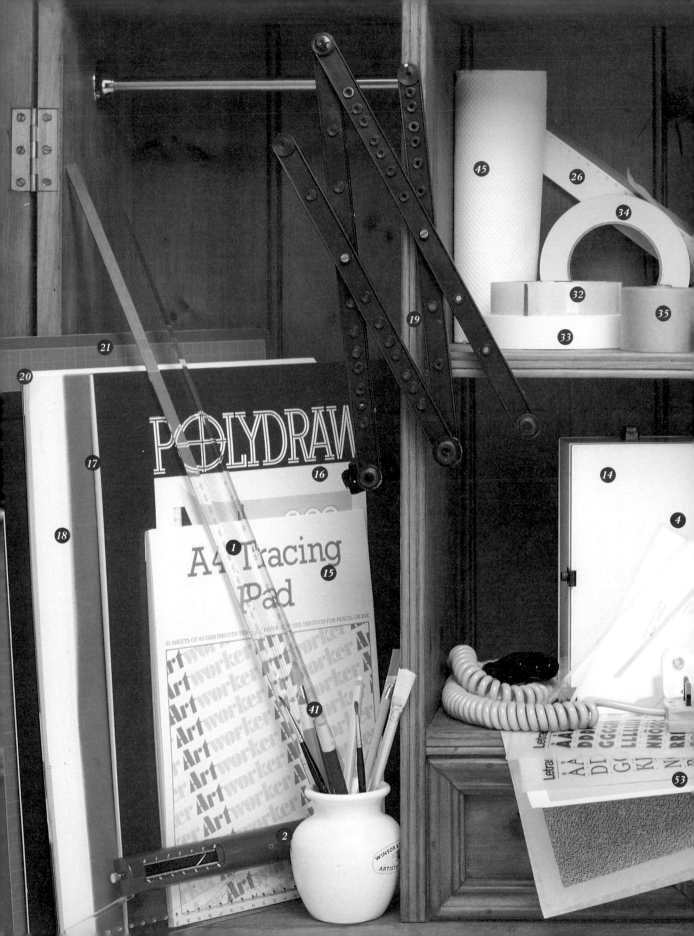

square each with a long edge of at least 30 cm (12 in) are good instruments to acquire (3 and 4). A single adjustable set-square (5) is a good alternative which can be set and locked at any desired angle and is probably more useful than a protractor, which can only be used to measure angles (6). To rule an ink line you will either need a stylograph pen or a ruling pen that can be adjusted to draw a line of any width (7).

The most versatile aid for drawing circles is a compass. For making large-diameter circles you must use a beam compass (8), some of which are available with extension arms. Smaller circles can be drawn with a normal spring-bow compass, while a pump-compass will cope with those circles with tiny radii. To avoid making a hole in the drawing paper lightly tack a small piece of thin card with masking tape where you position the point. Templates are an alternative way of drawing circles and have the advantage of not leaving a hole in the paper; these can be anything from everyday objects such as plates and cups (9) to purpose-made templates with a wide range of diameters (10). The drawing of ellipses is notoriously difficult for the novice and there are several aids to help with this. Draughtsman's templates are the simplest and least expensive (11), but there are gadgets such as the Ellipsograph and angles of ellipses can be calculated with an ellipse wheel. As soon as you can, acquire the habit of drawing these shapes by eye as this inevitably proves to be the best solution in the end. For creating more complicated compound curves there are two aids available in the form of French curves (12), which come in sets and are used sequentially in conjunction with one another to build up the desired curve, or the flexible curve (13), which can be bent to assume any shape but will not cope with tight curves. Lines drawn with these tend to have a rigid, unsympathetic quality, but they certainly have their uses.

There will often be the need to copy or transfer drawings from one surface to another, and this can be done in one of two simple ways. The best method when working on paper is to trace a drawing through on to the paper by illuminating it from behind with the aid of a light-box (14). However, these are expensive and a daylit window can be used to achieve the same result. The second way is to trace the drawing on to tracing paper (15) or an acetate made to take line – sometimes called draw-film (16) – and then to trace this down on to your final sheet with tracing-down paper (17), which is coated with graphite and acts as a transfer sheet. As the film is more stable it will serve you better if you intend to make several copies from the same tracing. Do not select a heavy-grade film for this. Always remember that the more stages a drawing goes through the greater the risk of its losing its accuracy or vitality. Graph paper is sometimes useful

if you need to create a drawing to a set size (18). Other aids for transferring drawings and proportions are a simple pantograph (19) or a set of proportional dividers, where the degree of reduction/enlargement can be set on a sliding scale.

A good range of cutting tools is also invaluable. Cutting should always be done on a suitable surface such as a sheet of thick card (20), which can be periodically renewed, or there are special self-sealing cutting mats available if you think you will be doing a lot of this kind of work (21). A good-quality craft knife is essential for cutting heavy papers and card and also for sharpening pencils (22). Keep one blade for cutting paper and a second for pencils as this inevitably blunts it, and graphite or crayon dust will be bound to discolour the surface of the paper. Alternatively, use a high-quality pencil sharpener – manual (23) or electric – and a block of sandpaper to keep the points perfect as you go along (24). A scalpel and a set of disposable blades is the best possible tool for cutting small fine areas (25). Cutting straight lines should always be done against a metal straight-edge – a 60-cm (24-in) one is probably the best compromise (26). You will also need at least one pair of high-quality scissors which should be reserved exclusively for cutting paper (27).

I like to keep a versatile range of paper adhesives in the studio. These include a non-staining rubber-based cement (28), which is applied with a plastic spreader (29), a similar product in an aerosol for extra large areas (30) and a can of petroleum lighter fuel (31), which is a colourless solvent for this gum. Rolls of clear adhesive tape (32), double-sided tape (33) and low-tack masking tape for sticking things together temporarily (34) are also very useful. Gummed *paper* strip (35) is used exclusively for stretching paper. Spring clips for attaching paper to a drawing board (36) are useful, especially when working out of doors, and drawing pins (37) perform the same function but make a mess of the surface of your board and are best kept for pinning things up around the studio.

You will also need a range of erasers. A brand-new scalpel blade can be used carefully to scrape off indelible marks such as ink and there are also erasers specially made for this. Some have microscopic globules of solvent suspended in them (38) and others are made from materials such as fibreglass that gently abrade the surface until the mark vanishes. A soft india rubber (39) and a harder synthetic one (40) are useful for removing pencil lines, and fine details can be tackled with a pencil-shaped eraser (41) which is sharpened by unpeeling the paper surrounding it. For removing or modifying softer media such as pastel or charcoal you will need to use a kneadable putty rubber (42) or even a ball of white bread will do the trick (43). I like to keep a large soft brush handy for gently brushing away

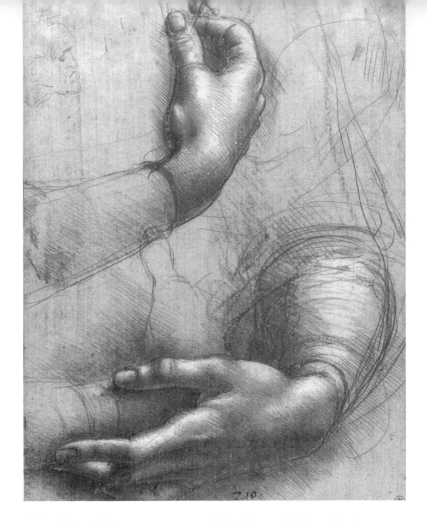

Study of Arms and Hands *by*
Leonardo da Vinci (1452–1519).
This drawing was made in
silverpoint, a forerunner of the
modern lead pencil, with
highlights added in white chalk.
The corrections have been left
visible.

the residue left by an eraser, and it is also useful for clearing away excess charcoal or pastel dust (44). A roll of kitchen paper is handy (45), as is a burnisher (46), and for the parsimonious a porte-crayon or pencil extender will enable you to use a pencil right down to a stub.

Palettes made from porcelain (47) or plastic (48) are used to mix colours or as vessels to dilute inks in, and you will need a water container, which is normally no more than an old jam jar. Other things that I like to have handy are masking fluid (49), which is painted on and when dry acts as a resist before being peeled off with the fingers to expose the untouched surface beneath, and a pot of bleed-proof white (50) for painting over colours with a high staining power that are impossible to obliterate in any other way. If you need to include some kind of formal lettering in your drawing this can be achieved with either draughtsman's stencils (51) or better still with one of the instant lettering systems such as Letraset (52), which is just rubbed down on to the surface of the paper and, when correctly used, gives a highly professional result. There are also sheets of tone (53) or texture (54) that work on the same principle.

When a drawing is finished it will need to be fixed if it has been executed in an impermanent medium such as pastel, charcoal or soft pencil. Fixative comes both in aerosol form (55) and bottles (56); with the latter the fixative has to be applied to the drawing by blowing it on through a mouth atomiser (57), which is also a useful way of applying a spatter technique when working with ink or water-colour. Varnish also comes in spray cans (58) or bottles (59); bottled varnish is applied with a varnish brush, which should be kept exclusively for this purpose. Ensure that the varnish is formulated for paper.

At one time or another I have found most of these items useful, and it is certainly not 'cheating' in any way to use a ruler or tracing paper in the course of making a drawing. All of these are aids to drawing and they are only useful if treated as such. They will not improve poor observation or shoddy drawing and if they are used too much or in an unsympathetic manner their hard, somewhat lifeless, quality will be to the detriment of the finished work. When I need to employ such aids I usually use them to make faint construction lines, which I then draw over freehand.

Pencil

THE WORD 'PENCIL' WAS ORIGINALLY USED TO DESCRIBE A SMALL PAINTBRUSH AND IT IS ONLY IN FAIRLY RECENT TIMES THAT IT HAS BEEN USED FOR THE DRAWING INSTRUMENT THAT WE ALL KNOW TODAY. This is the simplest and most versatile of any drawing medium and can be used for making marks from the most mundane doodle right up to a highly finished work on a very wide range of surfaces. What we call a lead pencil is in fact made from graphite fired with clay to produce a kind of ceramic rod, known as the lead, that is most commonly encased in cedar wood. All graphite will make marks of the same density and the relative blackness of the lead is only determined by the proportion of graphite particles suspended in the clay. Thus a hard pencil is predominantly clay and a soft one graphite. The forerunner of the modern pencil was the silverpoint. This was sometimes a pointed rod of silver, but was more often made from an alloy of lead and tin. This is possibly where we get the term 'lead' pencil from or else from the mistaken belief, common at one time, that graphite was a form of lead. The way in which silverpoint was used was quite complicated. First a drawing surface had to be prepared with a suitable ground made from pigment mixed with animal size (and sometimes finely powdered pumice) which was allowed to dry to a mildly abrasive finish. This was then drawn upon with the silverpoint, leaving hardly any mark

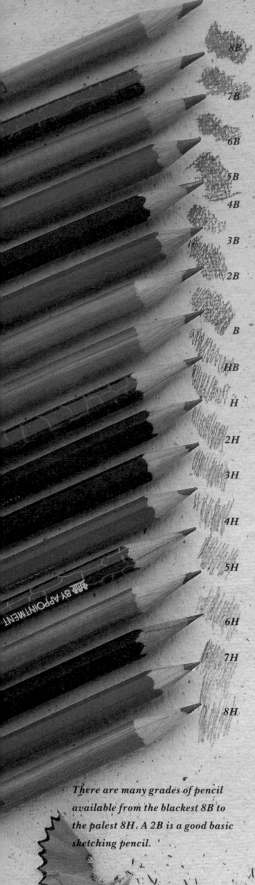

The labels beside the pencils, from top to bottom, read:

8B
7B
6B
5B
4B
3B
2B
B
HB
H
2H
3H
4H
5H
6H
7H
8H

BY APPOINTMENT

There are many grades of pencil available from the blackest 8B to the palest 8H. A 2B is a good basic sketching pencil.

from the abraded silver residue; it was only when this was left exposed for a period of time to tarnish that the marks acquired their true value.

Modern drawing pencils come in a range of grades termed 'H' for hard and 'B' for black or soft. An 8H is the hardest pencil commonly available, which will make fine, pale lines, and an 8B the softest, used for rich, black marks. As you might expect, an HB is between the two. There are also several grades of carbon pencils that all make deep black lines rather in the nature of charcoal. They are not really compatible with lead pencils and are best used on their own unless you are striving to create a special effect. In practice, a 4H, 2H, HB, 2B, 4B and 6B will be adequate for all but the most ambitious pencil drawings. With all art materials, including pencils, quality is directly related to price and it will be a false economy to purchase any but the very best you can afford.

There are a variety of different types of pencil besides the regular ones encased in wood, but they are essentially all the same instrument. Clutch pencils are usually made from metal or plastic and have a screw-operated or spring-loaded set of jaws to hold the leads, which are available separately and come in the full range of hardnesses. When the point becomes blunt the jaws can be relaxed, allowing more of the lead to be exposed; the lead is sharpened on a block of sandpaper. Some have a sharpening device in the button on the end that operates the clutch jaws. There is a technical version of this pencil with an extremely thin lead that obviates the need to keep sharpening it. As it wears down the lead is advanced a fraction at a time by depressing the end button. These pencils are intended for draughtsmen, who need to make fine lines of a uniform width, and are therefore only available with a range of suitably hard leads. Carpenter's pencils are very effective for making large, flowing drawings; these have a soft rectangular lead that can be sharpened like a chisel to make either thin lines or broad, dark ones. These are also excellent for calligraphic work but I personally find their oblong shape awkward to hold for long.

A porte-crayon is an extension device designed to grip a pencil stub and therefore enable one to use the short remnant that would otherwise be thrown away when it was too uncomfortable to hold. Alternatively, some artists find that a short length of pencil is useful for creating free, flowing marks on the paper.

The business end of the pencil is the point and this must always be kept sharp. You will find that the softer the pencil the sooner it will wear down, while very hard pencils seem to stay sharp indefinitely. Sharpen a pencil with a very sharp craft knife or even a scalpel to create a long tapering cone that exposes enough of the lead to be

A pencil should be sharpened to a long tapering cone with enough of the lead exposed to make broad marks when used on its side. The point can be kept sharp with the aid of a block of fine sandpaper.

```
A0 - 1188 × 840 mm

A1 - 840 × 574 mm          A2 - 574 × 420 mm

                     A3 - 420 × 297   A4 - 297 × 210

                                      A5 - 210
                                      × 148.5
```

International 'A' paper sizes (DIN). These are replacing the older sizes such as imperial, crown and elephant. A0 is twice the size of A1, which is twice the size of A2, and so on. All 'A' sizes have identical proportions.

useful when drawing broadly with the side. The point should be like a needle for a hard pencil but increasingly less so the greater the softness. Pencil sharpeners are usually a poor second option, but to my surprise I have recently found an excellent (but expensive) electric sharpener. Obviously such a gadget will be useless when working outdoors.

A pencil will make marks on a wide variety of surfaces but for the majority of drawings this will most often be paper. The choice of paper that can be used to make a pencil drawing is wide when working with soft pencils but less so when using hard ones as their needle-like points tend to shred thin or poor-quality papers. Cartridge paper is a good all-round choice; it is available in various weights and as sheets as well as bound together into pads. The weights of papers are expressed either in the metric system as grams per square metre (gsm) or in imperial pounds. A 120 lb paper means that a ream (480 sheets) will weigh this amount. Experiment with various weights to discover which suits you the best. Unless you are a committed miniaturist use a fair-sized sheet to begin with – it can always be trimmed down to size later. The most frequently encountered sizes of sheet paper are the traditional (standard) 'imperial' (572 × 775 mm or 22½ × 30½ in) or the more modern 'A' sizes such as A1 (594 × 840 mm, approximately 23¼ × 33 in). Nowadays drawing blocks are most often found in A sizes from A5 up to A1 – the higher the A number the smaller the sheet by a factor of a half. Thus A3 (420 × 297 mm, approximately 16½ × 11¾ in) is half the size of A2 (594 × 420 mm, approximately 23¼ × 16½ in) and so on. The largest A size is A0 (840 × 1188 mm, approximately 33 × 46½ in). All A-sized sheets have the identical proportion of length to width. The texture of the paper will also play an important role in the final look of the drawing. Some highly textured watercolour papers will give interesting effects and if you ever feel confident (and rich) enough seek out some of the beautiful hand-made Japanese papers.

Various grades of pencil are used when making an elaborate pencil drawing. Dense dark areas can be achieved with a soft pencil and fine details delineated with harder ones. As the sharpened end of the pencil lead assumes the form of a cone this enables one to use the instrument in different ways to create different qualities of mark. For details the point of the pencil must be used and this is best controlled by holding the instrument in the same way as you would when writing. For making broader marks the pencil is often held 'underhand', as it were, so that the edge of the lead can be stroked across the paper. This has the added advantage of helping to maintain the point. The weight, quality and nuance of the line can be

altered by the grade of pencil chosen, whether the mark is made with the point or edge, and also by the amount of pressure applied.

Areas of tone can be created in several ways. When using harder pencils you will need to use hatching – roughly parallel lines drawn close together. The closer these lines are together, the blacker the pencil used, and the more pressure that is applied the more intense this tone will be. By repeating this procedure over the top in a different direction – called cross-hatching – this tone can be darkened further. Such lines can also be used to help to describe the form of the subject by following the contours depicted; these are called hachure lines. 'Stippling' is the use of repeated dots to build up a tone, and is also useful in representing a texture. Continuous gradations of tone such as seen in a photograph are created with soft pencils. These areas are first drawn in broadly using the edge of the lead, starting with the darkest tones using the softest pencil and working towards the lighter areas, which are made with less soft ones. These areas are then carefully blended together with the aid of a compressed paper stub called a 'torchon'. Working again from the dark areas towards the lighter ones you will find that as well as blending the tones the torchon will soon have picked up enough graphite to have become a drawing instrument in its own right; this can then be used to create the palest areas. A similar effect can be achieved using a piece of rag or ordinary kitchen paper, but this offers a lesser degree of control and is best reserved for describing broad areas of tone. A finger will perform the same trick but runs the risk of leaving accidental traces where you do not want them. It is wise to work on such a drawing with a piece of clean scrap paper under your drawing hand to avoid smudges and the occasional perspiration stain. When working on a large drawing with soft pencils it is a good idea to stop periodically and fix the drawing as it might otherwise be partially erased accidentally as it progresses.

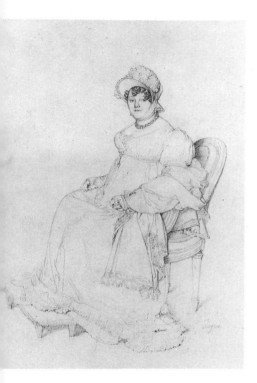

Portrait of Mme. Guillaume Guillon Lethière *by Jean-Auguste-Dominique Ingres (1780–1867). Pencil on paper.*

Simple pencil marks include hatching (1), cross-hatching (2), three-way cross-hatching (3), tone from smaller areas of cross-hatching (4), stippling (5), unmodified tone (6), tone blended with a torchon (7), torchon alone (8), stone frottage (9), wood frottage (10), erased image (11), hatching lines over an area of blended tone (12).

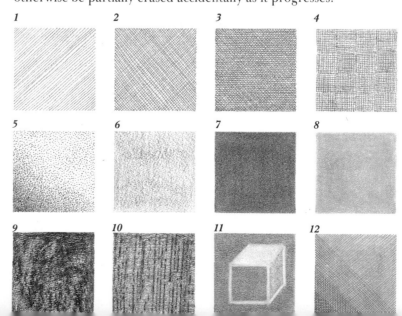

Interesting textures can be created by employing 'frottage'. This word comes from the French verb *frotter*, meaning to rub, and is accomplished by placing the sheet of paper on a suitably textured surface such as a plank of wood or sheet of textured glass or plastic and rubbing over the surface of the paper with a soft pencil, which results in the texture being transferred on to the drawing. The range of textures available in this way is enormous and only limited by your imagination and by what you can find. Do be careful of over-employing this technique, though, as its simplicity and effectiveness can prove seductive to the beginner.

Erasers can be used for removing pencil marks prior to correcting them but it is often a good idea to leave such errors visible and to make your corrections over the top. A common fault with beginners is to erase the mark only to redraw it in precisely the same position. On many old Master drawings such corrections will have been deliberately left evident and it is always much easier to adjust your lines when the previous ones are still to be seen. Any errors can always be erased when the drawing is complete. Once the pencil marks have begun to appear on the paper they can be modified in several ways. The original area can be worked over with a pencil of a different grade and areas of tone made with a soft pencil can be drawn into with an eraser. The general rule when erasing pencil marks is the harder the pencil used the more abrasive the eraser needed to rub it out. You should also consider your choice of paper as the surface of poor-quality paper will deteriorate rapidly when subjected to the abrasive action of an eraser. Soft pencil marks used to create an area of tone can have highlights added by drawing into them with an eraser. I find that a morsel of putty rubber pulled off and kneaded into a point works well when modifying soft pencil marks; for drawings made with harder pencils I might slice a fat sliver off the corner of a harder eraser or else use one shaped like a pencil. Drawings made using hard pencils will of necessity have been made on a more durable surfaced or coated paper and it is also possible to work into them with a highly abrasive ink eraser, or even the point of a scalpel to scratch highlights and fine lines.

When a drawing made with soft pencil is finished it will need to be fixed to render it permanent. This is best done with a proprietary fixative in a spray can, and it is wise to do it out of doors as the fixative is noxious if inhaled. Hold the drawing vertically by the very edge with one hand and apply the spray evenly over the entire surface for a few seconds as directed on the aerosol and then put it aside to dry. If you are applying the spray from a bottle with a mouth atomiser tack the drawing lightly to a wall with masking tape and blow the spray on evenly with the spray device.

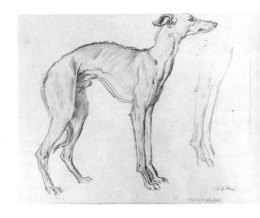

Study of a Whippet *by Augustus John (1878–1961). This beautiful pencil study on paper uses simple strokes of the instrument to describe its form. The artist tried out the animal's forelegs as a rough sketch to the right of the main image before incorporating them into the final drawing.*

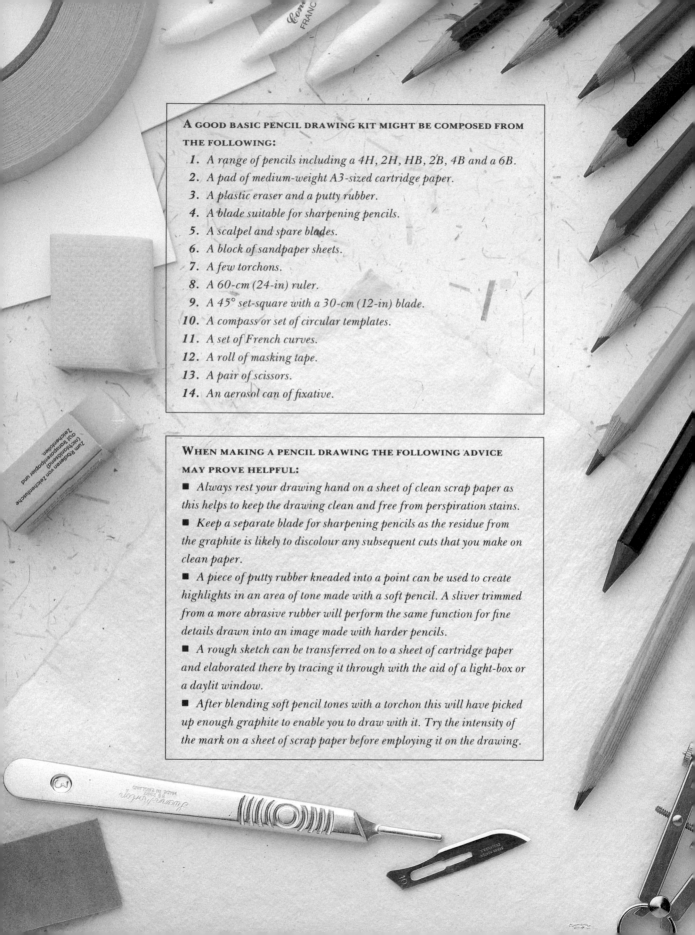

A GOOD BASIC PENCIL DRAWING KIT MIGHT BE COMPOSED FROM THE FOLLOWING:

1. *A range of pencils including a 4H, 2H, HB, 2B, 4B and a 6B.*
2. *A pad of medium-weight A3-sized cartridge paper.*
3. *A plastic eraser and a putty rubber.*
4. *A blade suitable for sharpening pencils.*
5. *A scalpel and spare blades.*
6. *A block of sandpaper sheets.*
7. *A few torchons.*
8. *A 60-cm (24-in) ruler.*
9. *A 45° set-square with a 30-cm (12-in) blade.*
10. *A compass or set of circular templates.*
11. *A set of French curves.*
12. *A roll of masking tape.*
13. *A pair of scissors.*
14. *An aerosol can of fixative.*

WHEN MAKING A PENCIL DRAWING THE FOLLOWING ADVICE MAY PROVE HELPFUL:

■ *Always rest your drawing hand on a sheet of clean scrap paper as this helps to keep the drawing clean and free from perspiration stains.*

■ *Keep a separate blade for sharpening pencils as the residue from the graphite is likely to discolour any subsequent cuts that you make on clean paper.*

■ *A piece of putty rubber kneaded into a point can be used to create highlights in an area of tone made with a soft pencil. A sliver trimmed from a more abrasive rubber will perform the same function for fine details drawn into an image made with harder pencils.*

■ *A rough sketch can be transferred on to a sheet of cartridge paper and elaborated there by tracing it through with the aid of a light-box or a daylit window.*

■ *After blending soft pencil tones with a torchon this will have picked up enough graphite to enable you to draw with it. Try the intensity of the mark on a sheet of scrap paper before employing it on the drawing.*

A USEFUL BASIC KIT FOR DRAWING WITH COLOURED PENCILS MIGHT BE MADE UP FROM:

1. A set of 60 coloured pencils.
2. A pad of medium-weight A3-sized cartridge paper.
3. A few sheets of line board.
4. A synthetic eraser.
5. A blade for sharpening pencils.
6. A scalpel and spare blades.
7. A 60-cm (24-in) ruler.
8. A 45° set-square with a 30-cm (12-in) blade.
9. A compass or circular templates.
10. A set of French curves.
11. A roll of masking tape.
12. A pair of scissors.

WHEN MAKING A COLOURED PENCIL DRAWING THE FOLLOWING HINTS MIGHT PROVE USEFUL:

■ Before using a fresh colour make a mark with it on a piece of scrap paper to ensure that it has not picked up any trace from another colour that might have been drawn over.

■ When using a pointillist or stippling technique do not sharpen the point as much as you would when using the pencil to draw lines as it will be more inclined to break.

■ Large areas of a pale colour can be achieved by shaving a quantity of coloured dust from the lead of a pencil with a scalpel and then applying this to the paper by wiping it on and then gently working it in with a wad of kitchen paper. This is a good way of using up stubs of pencil that have become too small and unwieldy to use in the conventional way.

Coloured pencil

Coloured pencils are a relatively modern medium unknown to the old masters. They are manufactured in a similar way to lead pencils, but with pigment substituted for the graphite. When selecting coloured pencils it is important to distinguish between the kind of inexpensive product intended for children or for non-specific uses such as marking price tags and sales charts and those intended for use by serious artists. This is not to suggest that such tools cannot be used to make interesting art works, but they will lack the quality, versatility and permanence of professional drawing instruments and will not be as pleasurable to use.

Artist's-quality coloured pencils are available in a limited range of hardnesses but in a very wide range of colours. Some brands have a choice of as many as 72 shades, but about 60 is probably the norm. They can all be purchased separately and it is possible to select the colours you might require from this range, but individual pencils are primarily intended as replacements for those that have been used up from a set. Different-sized sets are available that will contain from as few as a dozen colours right up to the full range. If this medium attracts you then it is worth buying as large a set as you can afford.

Coloured leads are available for clutch pencils, but only in a very limited range of colours. There are also ranges of coloured pencils that are water soluble; marks made with these can be modified to run or 'feather' when brushed over with clean water, adding a water-colour effect to the drawing. These have an interesting quality when used on dampened paper, but in the end they are not as controllable as conventional coloured pencils. Coloured pencils are used in much

Chairs, Mamounia Hotel, Marrakesh, 1971 by David Hockney (1937–). The pencils have been used in a fairly free manner on cartridge paper, but the observation and underlying draughtsmanship are highly accurate. Much of the current popularity of this medium is due to the work of this artist.

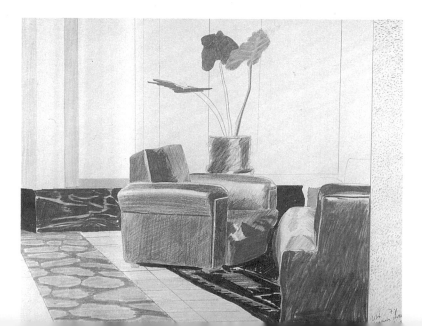

the same way as lead pencils, but it is not really possible to blend them together with a torchon. Instead, one must use a technique similar to that previously described for drawing with hard lead pencils. Once laid down, an area of colour can be modified by drawing over the top without fear of the two running into each other, and the quality of the resulting colour will appear different if the pencils have been used boldly or with the subtle use of hatching.

The marks made with some makes of coloured pencil can be removed with a synthetic eraser. Others prove to be more permanent and any erasure must be carried out by carefully scraping back the colour with a scalpel blade used flat; this will only be possible if you have used a good-quality coated paper or line board. This is also a good way to add highlights.

Another way of employing coloured pencils is to create your drawing with a 'pointillist' technique. Pointillism or Neo-Impressionism was a late-nineteenth-century French art movement and its most notable exponents were Georges Seurat and Paul Signac, both of whose best works display a vivid freshness and clarity. Pointillism involves the placing of tiny dots of pure colour in close juxtaposition which the eye then blends together to create a new colour that is only really there in the mind of the beholder. Thus to create a representation of, for instance, a lawn thousands of tiny blue dots are intermingled with thousands of equally small yellow ones which, when seen from a distance, is interpreted by the eye as green. The individual coloured points can be varied infinitely with a resulting high degree of subtlety. Such a stippled technique seems ideally suited to this medium. Apart from this technique it is not possible to mix two colours together to create a new one in the same way as one would with paints, which is why a large set of many colours is desirable. Normally the subject is described by the weight of pressure employed and by different colours being selected. It is usually unnecessary to fix this medium as one would a soft lead pencil drawing.

Some basic ways of employing this medium include diagonal hatching (1), two-way cross-hatching in different colours (2), three-way cross-hatching in different colours (3), stippling (4), two-coloured stippling (5), gradated colours (6) and colours laid on different coloured papers (7, 8, 9).

PEN AND INK

PEN AND INK HAS AN EXTREMELY LONG HISTORY AS A WRITING AND DRAWING MEDIUM, AND THE OLDEST SURVIVING EXAMPLES DATE FROM MORE THAN 4500 YEARS AGO IN THE FORM OF ANCIENT EGYPTIAN PAPYRI. This is a great recommendation for its qualities of permanence and its continuing attraction for artists. It was used during the Middle Ages and great works exist by the old masters of the Renaissance and later, including Leonardo, Dürer, Holbein,

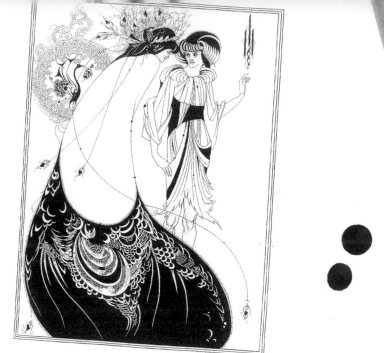

The Peacock Skirt, *1893, by*
Aubrey Beardsley (1872–1898).
One of Beardsley's most celebrated
images, originally an illustration
for Oscar Wilde's **Salome,** *displays*
his classic technique of fine lines
juxtaposed with bold areas of solid
black.

Rembrandt, Canaletto, Hogarth, Beardsley, van Gogh and Picasso.

Early pens were made from reeds (in the East this was bamboo) and later from quills. The pinion feathers of a goose were thought to be the best and these had to be cut by hand with a small sharp knife: today any small folding knife is still referred to as a penknife. Pens made from reeds, bamboo and quills are still in use today and each will make a mark with its own distinctive character. Separate nibs, sometimes called pens, which could be inserted into penholders, began to appear in the eighteenth century and these would have originally been made from small sections of quill or else from horn or tortoiseshell. Towards the middle of the nineteenth century steel nibs specifically for drawing were perfected by Joseph Gillot and began to be manufactured and marketed. In the twentieth century rechargeable fountain pens were perfected which did away with the need to dip the pen constantly in ink, and today there are a variety of drawing pens with reservoirs to choose from.

The inks with which the pens were charged also have their own history. One early form of ink was the deep brown sepia extracted from cuttlefish and another was made from the tannin found in certain tree barks and galls. Ink made from boiling lampblack and gum, which resulted in a blue-black colour, was the forerunner of our modern Indian ink, which is made from carbon black stabilised with shellac and numerous other substances. Wood soot was widely used in the past to create an ink with a warm transparent brown colour called 'bistre', which is commonly seen in old master drawings.

Modern drawing pens fall into two categories – dip pens and reservoir pens. In the former category reed, bamboo and quill pens are all still manufactured, but it is a simple matter to make your own

once you have found the basic piece of material. Using a scalpel simply cut off the end at an oblique angle, trim it into a suitable point and make a 1-cm (½-in) slit lengthways from the point to act as a channel to hold the ink.

Steel-nibbed dip pens will require a penholder. The nibs can be fitted with small brass reservoirs which lodge underneath to increase slightly the amount of ink that they can hold. When selecting nibs make sure you differentiate between those intended for writing and those for drawing, although there is no strict rule for this and you may be very happy and achieve splendid results drawing with a writing nib. It is prudent to buy several of any particular nib at a time as they do wear out and sometimes snap. Mapping nibs and crow quills (despite the name it is in fact made from steel) will both make very fine lines and as they are tubular in shape they will require separate holders. Other nibs are semicircular in section and can all be fitted into the standard penholders.

Writing nibs include the italic, which is available in a range of different widths and has a square end that will make either thick, bold down-strokes or thin horizontal and diagonal ones. Left-handed people must be sure to select italic nibs made specially for them where the end is slightly angled. Script nibs likewise come in a range to create different thicknesses of line and have a disc at the point that spreads the ink out as it flows on to the paper and will make a mark that is the same width in whichever direction it is drawn. A copperplate nib is offset and will make an increasingly bolder mark when moving vertically than when moving horizontally; it is intended for writing in the flowing style from which it derives its name. Some manufacturers market sampler sets that contain several penholders and a wide variety of different nibs. These are an excellent idea to enable the beginner to get acquainted with this medium.

Reservoir pens are also divided into those intended as writing instruments and those specifically made for drawing. Designed as a writing instrument, the fountain pen can be used successfully to make drawings, but the nib will not be as responsive and it is not interchangeable. You must *never* load a conventional fountain pen with drawing ink as this will soon clog it up completely. However, there is a fountain pen on the market that is especially made for drawing and this will take waterproof Indian ink quite happily. There are also sketching pens that are loaded with ink cartridges that can be bought in different colours. A Graphos pen is an instrument made for technical drawing and was originally devised for ruling straight lines. It comprises a barrel with a reservoir and a range of interchangeable nibs, each of which will make a line of a precise width.

Here is the simple sequence demonstrating the way in which a quill or reed is trimmed to form a point suitable for drawing or writing.

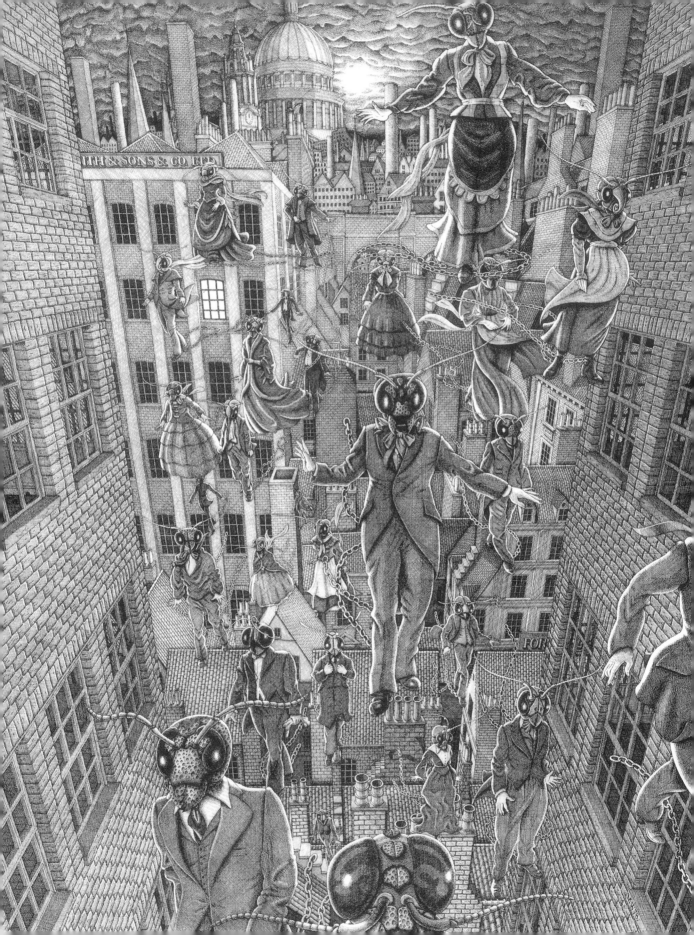

There are many versions of the stylograph pen on the market which attests to its success and popularity despite a fairly high price. It usually consists of a barrel which is nothing more than a hollow tube into which are screwed the working parts of the pen. These include a refillable reservoir and the filter which has a small ball to agitate the ink and prevent it from clogging. From there a channel carries the ink to the drawing point which is in the form of a tube with a tiny diameter. A stylograph pen will make a line of a precise and constant thickness which is indicated on a colour-coded ring on the exterior. These instruments are excellent for drawing free flowing lines that will never need to be interrupted by having to lift the pen from the paper to refill it. With a pen of this type one can produce beautiful, regular cross-hatching, and the finished drawings often have the flavour of an engraving or etching. In theory you will need a whole range of these pens to make marks of all thicknesses – I possess a dozen that will make lines with a thickness from 0.1 mm to 1.2 mm. In practice, however, I use the finest of these for more than 99 per cent of the time, a slightly thicker one very occasionally and the rest only for very rare special tasks. Remember that in a drawing made with a fine line all the faults will be evident, whereas those made with thick lines are flattering to poor draughtsmanship.

With a dip pen it is possible to use any type of ink or even diluted paint to make a drawing, but with a reservoir pen it is vital that the ink is of the type recommended. What are generally termed 'drawing inks' are most often waterproof made with a base of shellac or gum, and these will dry to a dense, shiny finish and can be thinned with distilled water. Indian ink is the commonest form of black drawing ink and can be found anywhere. Inks for stylograph pens will normally only be available from art shops and come in plastic bottles with a spout for ease of filling. They are available in a range of fairly boring standard colours which can be mixed together with limited success. For drawing with a conventional fountain pen it is best to stick to normal writing ink even though this will lack body.

There are various ranges of coloured drawing inks, some with a choice of over 20 colours. They are all waterproof – and therefore only suitable for a dip pen or brush – and once thay have dried they can be overlaid with inks of another colour *ad infinitum* without fear of one bleeding into another. Personally, I rarely use coloured inks, but other artists do and you may care to experiment with them. There are also opaque white drawing inks that are good for adding highlights or for working on coloured papers, and even metallic inks which can produce amusing effects. Brushes used to apply drawing inks should be washed out immediately after use. It is also possible to prepare your own ink from a traditional Chinese stick. These are

(Above) An actual-size detail of Ghosts *showing how the cross-hatching was used to achieve gradations of tone.*

(Left) Ghosts, 1978, *by Mike Wilks. All of the tones in this large picture were built up from cross-hatching. The sky area of the drawing has been cut away and replaced undetectably.*

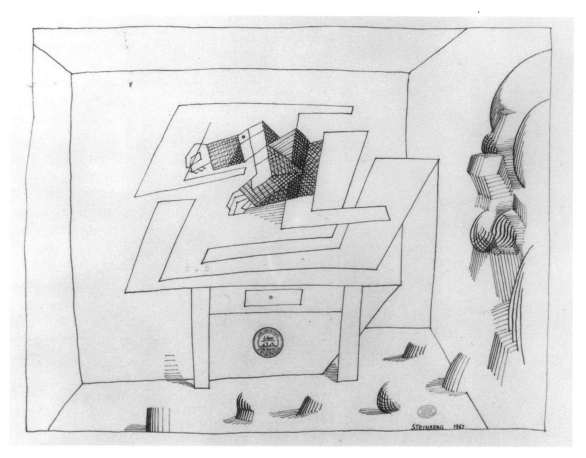

Autobiography, 1967, by Saul Steinberg (1914–). Ink on paper, (19 × 25), Collection of the Housatonic Museum of Art, Bridgeport, Connecticut. This sensitive drawing demonstrates how the pressure that is applied to a dip pen nib will alter the weight and nuance of the line. Note the witty inclusion of the rubber stamps.

often packaged together with an ink stone, but a saucer will work almost as well. The sticks of solid ink are rubbed down on the stone with a little water being gradually added until it is at the desired consistency, which can be anything from a stiff paste to very runny, depending on the use you wish to put it to. This ink is not waterproof.

When making a pen-and-ink drawing the choice of paper is very important. Cartridge paper will be suitable for very simple compositions, but it will not take a great deal of working as its soft surface will start to break up under attack from a sharp steel nib. It will be adequate for drawings made with reed, bamboo or quill pens, and as its surface is slightly porous the ink will sink in, giving a softish quality of line. Dip and reservoir pens will usually dictate the use of a coated paper or line board. Opaline paper is an inexpensive hard-surfaced paper suitable for this medium, but the more expensive line papers and boards will allow more latitude for the beginner to make and correct mistakes. Such material has a very thin, hard coating of china clay on the surface and lines made on this will be very crisp and clean. If you intend to apply large areas of wash or ink with a brush it will be necessary to stretch the paper as described in the

section on wash drawing (see page 87), but this will not be necessary if you are using board.

A pen is an instrument designed to make a line and the best pen-and-ink drawings will celebrate this. The simplest drawings executed in this medium will only use outlines to convey their subject, but paradoxically this is perhaps the hardest thing to do successfully. Lines can be made either with a reservoir pen, in which case their weight will be uniform and will need to be laid down with accuracy and sensitivity, or else with a dip pen, where the pressure on the nib will change the weight of the line. A form of aerial perspective can be achieved by employing lines that have been made by increasingly diluting the ink as they depict things further and further away. This effect can be enhanced by delineating those things in the foreground with a broader nib and those in the background with progressively finer ones. This medium is superb for making spontaneous drawings, but when working on a more ambitious composition it is a good idea to sketch in the position of the major elements lightly with faint pencil lines; these are later worked over and elaborated in ink.

Tones can be created in an ink drawing by the use of hatching and cross-hatching and are made in a similar way to working with hard pencils by laying down areas of roughly parallel lines side by side and over the top of each other in various directions. With this medium, however, the use of a paper with a more durable surface will mean that this process can be carried to greater extremes and cross-hatching can be laid over cross-hatching until the original paper surface is all but obliterated; this results in a rich, dense area of tone with a distinctive character which is unobtainable by any other method. Another

Some simple ways of creating marks with this medium include diagonal hatching (1), two-way cross-hatching (2), three-way cross-hatching (3), four-way cross-hatching (4), lines scratched into an area of dense cross-hatching (5), area made from smaller areas of cross-hatching (6), cross-hatching made with a ruler (7), stippling (8), area of texture made by scribbling (9), ink applied with a sponge (10), ink spattered with a toothbrush (11) and an area of tone built up from monoprints made with the thumb (12).

effective but more laborious way of creating tone is to use stippling with thousands of tiny dots, and this is easiest to do with a stylograph pen. This tool is also useful for making scribbled marks to suggest a random texture representative of such things as foliage.

Another random texture can be created by spattering. First you will need to mask out all those areas where you do not wish the spatter to appear, with masking fluid, self-adhesive masking film or newspaper taped down with low-tack masking tape, which will not damage the paper surface. Then charge an old toothbrush with the ink you wish to use and spatter this on to the surface by pulling something such as a knife blade towards you across the bristles. Alternatively, you can insert a mouth atomiser into a bottle of ink and blow this on to the masked-out areas, which will give a much coarser spatter. This is best done with the drawing taped to a wall in an upright position – make sure that the masked part includes the wall as you will be surprised just how large an area this covers.

Other interesting techniques can be achieved by drawing on to dampened paper (this will need to have been stretched first), which will have the effect of softening or feathering the marks, depending on just how wet the paper is. Monoprints (one-off prints) can be incorporated in the drawing by painting something suitable such as a leaf or piece of wood with ink – you may need to mix a drop of washing-up liquid with the ink to help it to adhere – and then pressing this down with another sheet of paper over the top on to the drawing in the desired position. Coloured inks can be used to make pointillist drawings or employed to create multi-coloured cross-hatching. The hard surface of line papers and boards is also ideal for scratching into with the point of a scalpel blade.

It is quite natural to think of pen and ink as an indelible medium, but it is in fact possible to make extensive corrections and modifications provided you have used a suitable coated paper in the first place. An ink eraser, either with particles of solvent suspended in it or the abrasive fibreglass kind, will cope well with most minor marks. For larger areas or more elaborate changes the inked area can be carefully scraped away with the flat edge of a new scalpel blade. The area which is left will then need to be burnished over – a modelling tool or even the back of a clean tea spoon will serve (ensure that this is made from steel and not from silver which will mark) – before it will be in a state to take ink again. The technical term for a drawing made over the top of an erased one in this way is a 'palimpsest'. Stains made on uncoated cartridge paper are more difficult to tackle, but if blotted quickly, lightly soaked with a brushful of clean water, blotted again and then rubbed with a soft eraser when dry they will usually be eradicated.

Several years ago as the result of a bad error of judgement I found myself having to renew almost half of an elaborate pen-and-ink drawing which had been so heavily worked that scraping it back was impractical. Rather than abandon it and start again I lightly tacked it with masking tape over the top of a clean but otherwise identical sheet of paper. Then after summoning up all of my courage I cut the offending section away freehand along a well-defined ink line, pressing hard enough to cut through both sheets of paper. I then took this identically shaped clean piece of paper to substitute for the ruined section, which I fitted together like a jigsaw puzzle with tape on the reverse. When this drawing was finally finished it was impossible to tell that it was made on two separate pieces of paper. I have since used this technique to build up finished drawings from a patchwork of smaller ones, and I recommend this ruse to those of you with strong nerves and steady hands.

The Sea at Saintes-Maries *by Vincent van Gogh (1853–1890). This drawing was made on paper with a reed pen and uses different weights of line and types of mark, including hatching, stippling and free-flowing lines. Pencil lines used to sketch in the composition are evident.*

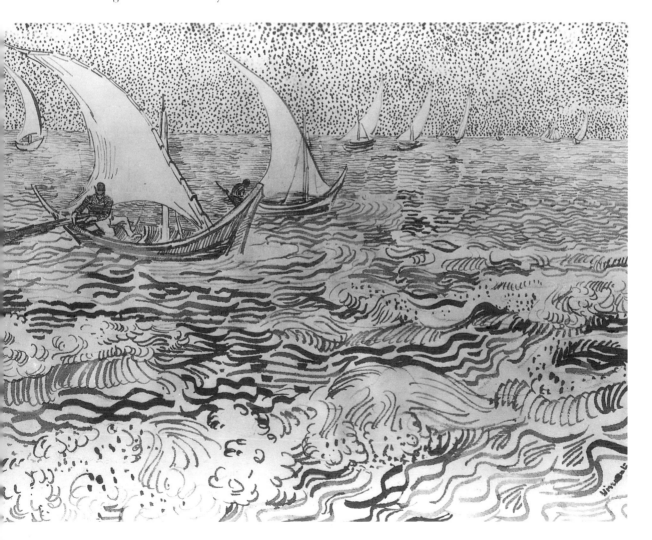

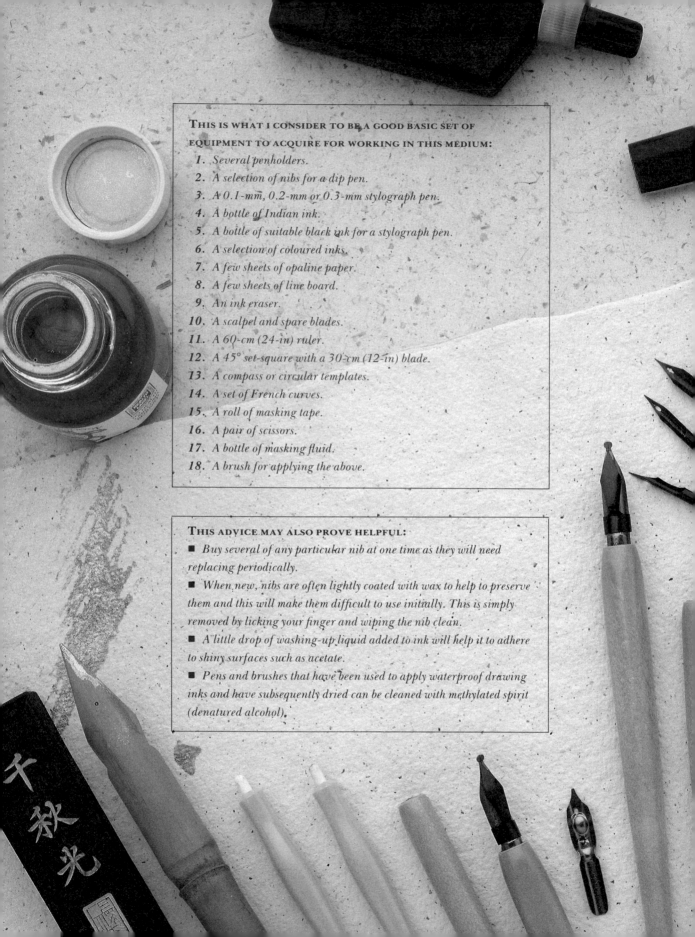

THIS IS WHAT I CONSIDER TO BE A GOOD BASIC SET OF
EQUIPMENT TO ACQUIRE FOR WORKING IN THIS MEDIUM:

1. *Several penholders.*
2. *A selection of nibs for a dip pen.*
3. *A 0.1-mm, 0.2-mm or 0.3-mm stylograph pen.*
4. *A bottle of Indian ink.*
5. *A bottle of suitable black ink for a stylograph pen.*
6. *A selection of coloured inks.*
7. *A few sheets of opaline paper.*
8. *A few sheets of line board.*
9. *An ink eraser.*
10. *A scalpel and spare blades.*
11. *A 60-cm (24-in) ruler.*
12. *A 45° set-square with a 30-cm (12-in) blade.*
13. *A compass or circular templates.*
14. *A set of French curves.*
15. *A roll of masking tape.*
16. *A pair of scissors.*
17. *A bottle of masking fluid.*
18. *A brush for applying the above.*

THIS ADVICE MAY ALSO PROVE HELPFUL:

■ *Buy several of any particular nib at one time as they will need
replacing periodically.*

■ *When new, nibs are often lightly coated with wax to help to preserve
them and this will make them difficult to use initially. This is simply
removed by licking your finger and wiping the nib clean.*

■ *A little drop of washing-up liquid added to ink will help it to adhere
to shiny surfaces such as acetate.*

■ *Pens and brushes that have been used to apply waterproof drawing
inks and have subsequently dried can be cleaned with methylated spirit
(denatured alcohol).*

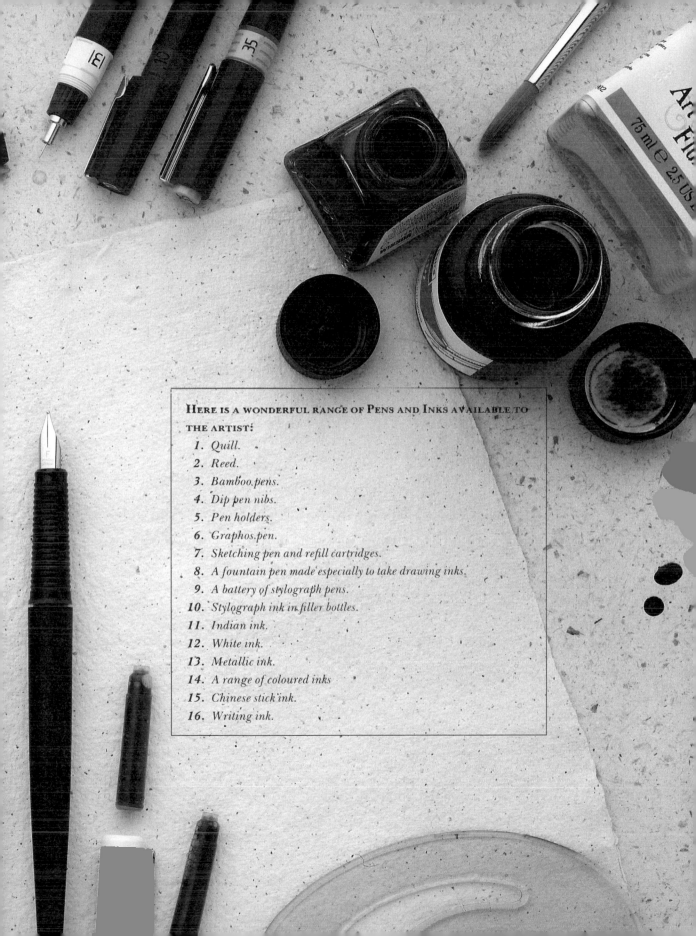

Here is a wonderful range of Pens and Inks available to the artist:

1. Quill.
2. Reed.
3. Bamboo pens.
4. Dip pen nibs.
5. Pen holders.
6. Graphos pen.
7. Sketching pen and refill cartridges.
8. A fountain pen made especially to take drawing inks.
9. A battery of stylograph pens.
10. Stylograph ink in filler bottles.
11. Indian ink.
12. White ink.
13. Metallic ink.
14. A range of coloured inks
15. Chinese stick ink.
16. Writing ink.

CHARCOAL, CHALK
AND CRAYON

IF PEN AND INK HAS A LONG HISTORY THEN THAT OF CHARCOAL AND CHALK MUST BE EVEN LONGER. It is known that these substances were used to make prehistoric cave drawings, but their impermanent nature means that very few examples, even from the more recent past, have survived. This is often a good medium for the beginner to tackle as after an initial acquaintance it is easy to use and creates bold marks, has a natural softness and kindness, is very easily erased and corrected and is forgiving to inexpert drawing.

Charcoal comes in various forms. Stick charcoal is available in several thicknesses and degrees of hardness and there is a choice of willow charcoal or the better and more expensive vine charcoal. These sticks are about 15 cm (6 in) long, but they can easily be broken into smaller lengths if this suits you. Very thick sticks are known as scene painter's charcoal, and this name betrays its origins. There are also sticks of compressed charcoal, which is made from charcoal dust fixed together with a binding medium. These will produce marks with a different quality from those made with natural sticks. Charcoal pencils bound in either wood or paper are also made from compressed charcoal and come in four degrees of hardness – 6B, 4B, 2B and HB. All of these will make much blacker lines than lead pencils of a similar grade. Even hard charcoal is very soft and it is only really possible to sharpen the thicker sticks with a blade. Smaller sticks can be sharpened on a sandpaper block or the edge of a freshly snapped stick will produce a thin line. This medium is not suited to detailed work, but a charcoal pencil that can be sharpened in the normal way can be used.

Drawing chalks are softer and easier to use than the type of schoolroom chalk that is made for writing and they traditionally come in the standard colours of black, white and red, also known as sanguine. Schoolroom-type chalks often come in a limited range of pastel colours. Chalks and charcoal are compatible and can be used together. White chalk is especially effective for adding highlights to a charcoal drawing made on coloured paper.

The crayons that most people are familiar with are the small coloured wax sticks that we might have used as children, but these are not of great use when making drawings. When this term is used by artists they are usually referring to Conté crayons. These were invented by the Frenchman Nicolas-Jacques Conté who was also responsible for inventing the modern lead pencil during the Napo-

The techniques for using these media are broadly the same and shown here are Conté crayon marks made on rough paper (1), not paper (2), hot-pressed paper (3) and coloured Ingres paper (4). Charcoal marks on rough paper (5), not paper (6), hot-pressed paper (7), cartridge paper (8) and an image made by erasure with a putty rubber (9).

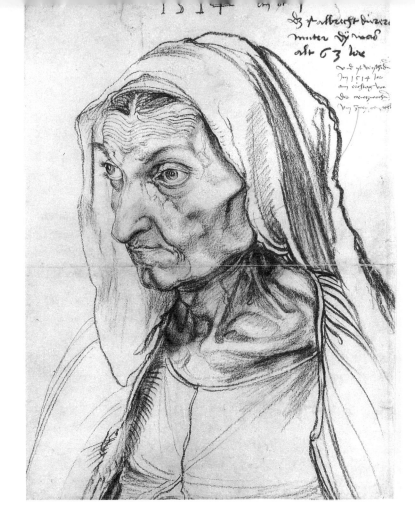

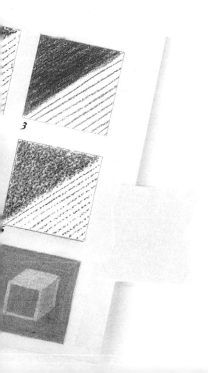

Albrecht Dürer's Mother, *1514,*
by Albrecht Dürer (1471–1528).
This is an exceptionally fine
example of a charcoal drawing on
paper by the German Renaissance
master. Note the sensitive
contrasting use of blended and
unblended marks.

leonic wars, when raw materials such as plumbago graphite were prevented from reaching France by the British. Conté crayons are made from pigment and graphite bound together with gum and a little grease. They are square-section sticks about 8 cm (3 in) long and are also available in the form of pencils. They are more permanent than charcoal or chalk and are not so prone to accidental erasure, but it is a good idea to fix the drawing once it is complete. There are several earth colours as well as black and white which come in three degrees of hardness and have proved themselves to be a popular and enduring medium for the artist. The papers to select when working with charcoal, chalk and Conté crayon will all be similar, and those with a pronounced textured surface will bring out the distinctive qualities of the marks. Coloured or tinted papers come into their own here and the wide range of Ingres papers, some with tiny fibres suspended in them, are especially suited and widely used.

The techniques for using these three media are broadly the same and they are ideally suited for creating tone drawings and for working on a large scale. The flat side of a stick of charcoal will make

broad marks and the point of a pencil or the edge of the broken end of a stick will make finer lines. When drawing with charcoal and chalk, areas of tone can be blended together with a torchon or the finger and mistakes can be easily eradicated either by merely blowing the marks away or else by rubbing them off with a rag or a wad of kitchen paper. These media are naturally messy and the ease with which these marks are removed means that the artist must take great care not to touch the drawing too much with hands or sleeves. For this reason it is often a good idea to work with the drawing upright. When tackling an extensive charcoal or chalk drawing it is wise to stop and fix it at intervals to prevent accidental erasure. Highlights are simply added by drawing them in with a piece of putty rubber or by the traditional method of using a pellet of kneaded white bread. This can only be done before the drawing has been fixed. When the drawing is complete it will have to be fixed to make it permanent. This is best done with an aerosol spray fixative and will need at least three coats to ensure that the image is locked on to the paper. Make sure that each coat is thoroughly dry before applying the next. An alternative way of fixing a charcoal drawing is periodically to dip the sticks of charcoal in linseed oil during the course of making the drawing; this will slightly alter the quality of the marks but will dispense with the need to spray it when finished.

To make charcoal, chalk or crayon drawings I would suggest the following items:

1. Various sticks of charcoal of different sizes.
2. Sticks of black, white and red chalk.
3. A range of Conté crayons.
4. Several different-coloured sheets or a pad of Ingres paper.
5. A putty rubber.
6. A few torchons.
7. A blade for sharpening the charcoal.
8. A block of sandpaper sheets.
9. A 60-cm (24-in) ruler.
10. A 45° set-square with a 30-cm (12-in) blade.
11. A roll of masking tape.
12. A pair of scissors.
13. A roll of kitchen paper.
14. An aerosol can of fixative.

Here are some hints to help you make drawings in these media:

■ Select textured papers for drawings made with stick charcoal and smoother ones for working with compressed charcoal or charcoal pencils.

■ Try always to use the finer vine charcoal as this will make a richer mark and mistakes can be simply blown off the paper. Cheaper sticks and compressed charcoal are less easily erased and blended.

■ Powdered charcoal can be used with a torchon to create tones or applied to the paper with a rag or a wad of kitchen paper to create large areas of grey.

Fibre-tip, felt-tip and ball-point pen

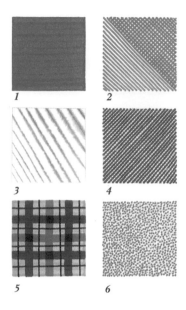

Felt-tip and fibre-tip pens will make a similar quality of mark in a wide range of highly saturated colours. These marks were made by a broad-tipped marker (1), hatching and cross-hatching in a single colour (2), lines drawn on dampened paper (3), cross-hatching in two colours (4), a plaid pattern made by strokes overlaid on one another (5) and stippling in two colours (6).

FIBRE-TIP, FELT-TIP AND BALL-POINT PENS ARE ALL VERY MODERN MEDIA AND IN FACT HAVE ONLY BECOME AVAILABLE DURING MY OWN LIFETIME. The ranges are enormous and they are on sale everywhere, from local shops to supermarkets and even art supply stores, who invariably stock better-quality products.

Fibre-tip pens are disposable plastic instruments with sealed reservoirs containing ink which feeds a point made (usually) from fibreglass. The better-quality pens have a tip that will not deform, but the less expensive ones will quickly go soft and the quality of the lines that they are capable of making will deteriorate. These are best purchased in sets that contain as many as 100 different colours, although normally 30 or 40 should prove sufficient. Pens of professional quality will have a range comprising fine tips and a parallel range containing identically coloured inks but with fat, chisel-shaped tips for making medium and bold marks. As a rule, fine-tip instruments are generally termed 'pens' and those with broader tips 'markers'. They are all disposable and must be replaced when expended, although there is a version with a reservoir that has interchangeable nibs and several different-coloured spirit-based inks.

Felt-tip pens come in similar ranges, but as their tips are made from a softer material they will have a different feel when used, although they will make a similar quality of mark. There is no strict division, but as a general rule, fibre-tip pens use a water-based ink and felt-tip pens are spirit-based. The two different inks are not really compatible, but it is sometimes possible to draw over water-based marks with spirit-based inks and vice versa. Neither will need fixing, but the water-based inks are easily affected by dampness and even perspiration, and care should be taken when storing them. Unfortunately, the formulation of the ink is not always specified so it is wise to seek advice from the supplier – or else a quick sniff will give you the answer.

These types of instrument were originally designed for use by commercial layout artists and designers who need to make quick, reliable marks in a wide range of bright colours that dry almost instantaneously. And they are indeed the simplest and most rapid way of creating rich, saturated coloured marks. The fine pens are meant for defining an outline which is then filled in with the identically coloured broader-tip markers. Broad strokes are best laid rapidly side by side, working from top to bottom, which will lessen the

tendency of these marks to appear as individual stripes. You will find that the more permanent spirit-based markers will make a mark that fattens very slightly as it dries on the paper; in order to compensate for this they should not be used right up to the edge that you wish to delineate. This becomes easy to judge with a little practice. Up to a point, spirit-based colours can be laid one on top of another without them bleeding, but this is impractical with the water-based inks.

These pens are best used with smooth-surfaced paper and they are inclined to bleed through lightweight or flimsy paper. There are pads of special marker or layout paper on the market which come in a wide range of 'A' sizes. They are excellent for initial compositions and the paper has the advantage of being semi-transparent which enables one to trace through elements of a drawing from another sheet. The spirit-based inks will render thin paper translucent, and it is interesting to see such drawings displayed against a daylit window. Interesting effects can be achieved with water-based inks by drawing on dampened paper which will serve to feather and soften the lines. The spirit-based inks are waterproof and will mark almost any non-greasy surface, but the water-based ones are only suitable for paper. All of these instruments require care in that they will dry out rapidly if the caps are left off for any length of time. It is all but impossible to erase marks made with these pens and only bleed-proof white paint will obliterate them completely as the inks have a high staining power that will bleed through anything else. It is always possible to adopt a 'patch-work' technique as outlined in the section on pen-and-ink drawing (see page 69).

Page from Sheep Sketchbook, *1972, by Henry Moore (1898– 1986). This drawing was made in black ball-point pen and exploits perfectly the sliding quality of the medium to create tones from a scribbled texture.*

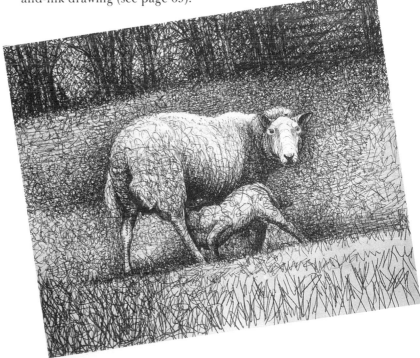

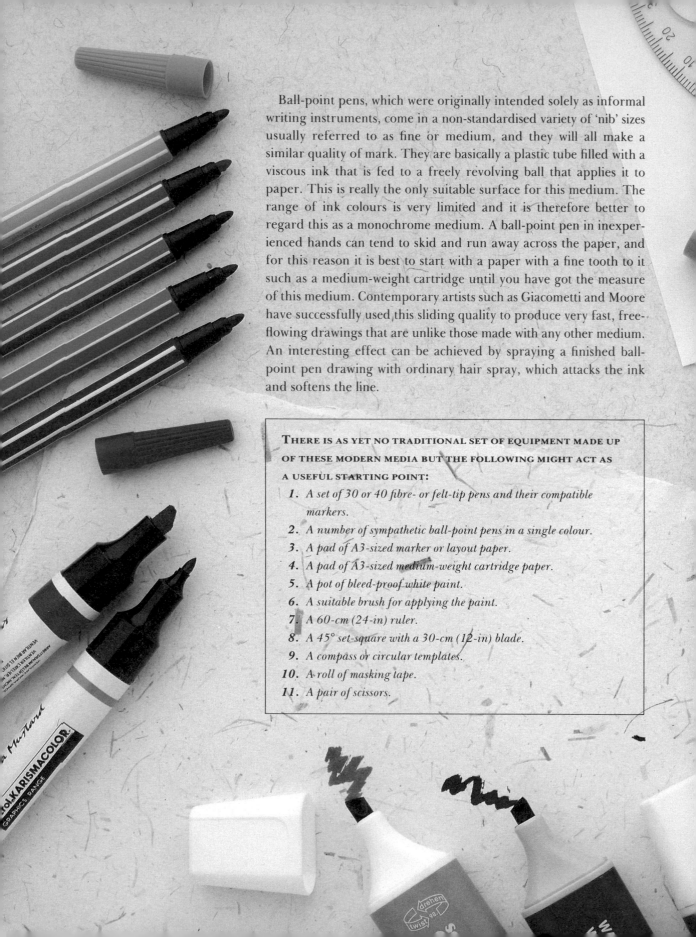

Ball-point pens, which were originally intended solely as informal writing instruments, come in a non-standardised variety of 'nib' sizes usually referred to as fine or medium, and they will all make a similar quality of mark. They are basically a plastic tube filled with a viscous ink that is fed to a freely revolving ball that applies it to paper. This is really the only suitable surface for this medium. The range of ink colours is very limited and it is therefore better to regard this as a monochrome medium. A ball-point pen in inexperienced hands can tend to skid and run away across the paper, and for this reason it is best to start with a paper with a fine tooth to it such as a medium-weight cartridge until you have got the measure of this medium. Contemporary artists such as Giacometti and Moore have successfully used this sliding quality to produce very fast, free-flowing drawings that are unlike those made with any other medium. An interesting effect can be achieved by spraying a finished ball-point pen drawing with ordinary hair spray, which attacks the ink and softens the line.

THERE IS AS YET NO TRADITIONAL SET OF EQUIPMENT MADE UP OF THESE MODERN MEDIA BUT THE FOLLOWING MIGHT ACT AS A USEFUL STARTING POINT:

1. A set of 30 or 40 fibre- or felt-tip pens and their compatible markers.
2. A number of sympathetic ball-point pens in a single colour.
3. A pad of A3-sized marker or layout paper.
4. A pad of A3-sized medium-weight cartridge paper.
5. A pot of bleed-proof white paint.
6. A suitable brush for applying the paint.
7. A 60-cm (24-in) ruler.
8. A 45° set-square with a 30-cm (12-in) blade.
9. A compass or circular templates.
10. A roll of masking tape.
11. A pair of scissors.

THE FOLLOWING ADVICE MIGHT HELP YOU IN MAKING DRAWINGS WITH THESE MEDIA:

■ *A drop of petroleum spirit on the tip of a seemingly dried-up spirit-based pen or marker can often revive it for a limited spell. Applying water to a water-based pen often performs the same trick.*

■ *Before using a fresh coloured pen or marker test it out on a scrap of paper to ensure that it has not picked up a trace from another colour.*

■ *When working on thin paper with markers place an extra sheet beneath the sheet you are drawing on as these colours have a tendency to bleed through.*

■ *When working with ball-point pens stop periodically and remove the residue of ink that accumulates around the tip on a piece of kitchen paper.*

PASTEL

Shown here are pastel marks on white (1), grey (2), tan (3), brown (4), claret (5) and black paper (6). The side of the pastel used on rough paper (7), the edge on hot-pressed paper (8), three tones on cartridge paper unblended (9) and blended (10), an image erased with a putty rubber (11) and an area of flat colour made by rubbing the pastel into the paper with a wad of kitchen paper (12).

DRAWING IS A FIELD OF ART PRIMARILY CONCERNED WITH LINE AND TONE, AND PAINTING WITH COLOUR AND FORM, AND THERE HAS ALWAYS BEEN DEBATE AS TO WHETHER PASTEL IS A MEDIUM FOR PAINTING OR DRAWING AS IT ENCOMPASSES ALL OF THESE. It is either the most graphic form of painting or, as described here, the most painterly form of drawing.

Chalk, the ancestor of pastels, has always been an artistic medium, but it was only ever available in a limited range of colours and it was not until the introduction of pastels in the eighteenth century that drawing with a full chromatic range was possible. The earliest successful exponents of this medium used them very much in the manner of oil paints, delicately fusing colours and tones together with great subtlety. Great old masters (and mistresses) who utilised pastels to the full include Chardin, (Quentin) de la Tour and Carriera, who perfected this technique for the medium. In the nineteenth century Cassat and especially Degas went on to broaden the possibilities of the medium by adopting a more graphic use of the instruments. All of these artists should be studied by aspiring pastelists.

Pastels are regarded as a very pure medium as they are made with raw pigment with just enough gum added to bind them together, and as a result they have a very high degree of permanence once properly fixed. It is possible to make your own pastels by mixing the chosen coloured pigment with various proportions of zinc white, which acts as a filler, and then making this into a paste – from which the name pastel is derived – by adding distilled water and a little gum tragacanth or leaf gelatine as a binding agent. Various tones

are created by the proportion of zinc white added to the original pigment. The resulting paste is then rolled into shape on a sheet of absorbent paper and put aside to dry for a day, after which it is ready to be used. Of all artistic media, pastels come in the greatest range of colours. There are about 600 different shades available from various manufacturers and a professional set will contain over 300 separate sticks. It is not necessary for the beginner to buy such a large set, and sets are available with as few as a dozen colours, although a slightly larger range is of more use. Often these sets will contain colours that are especially suited to landscapes or portraits; this will be indicated on the box and is an excellent introduction if you know just what your subject-matter will be. When you have discovered if this medium attracts you it is wise to invest in one of the larger boxed sets, but all of the sticks can be purchased separately should you have need of a special range of colours.

Pastel sticks are normally all the same size – about 8 cm (3 in) long – and they are available in three degrees of hardness. All pastels,

Vincent van Gogh, *1887, by Henri-Marie-Raymond de Toulouse-Lautrec-Monfa (1864–1901). Not as well known as a pastelist as his contemporary Degas, Toulouse-Lautrec's portrait of his friend van Gogh demonstrates a profound sympathy for the medium and exploits fully its graphic qualities.*

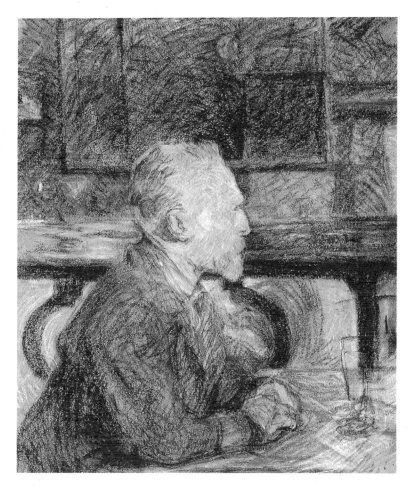

even the so-called hard ones, are soft and easily broken and should be stored carefully in a rigid container where the individual sticks are isolated from one another and prevented from moving about. This is particularly important if you intend to work out of doors and travel with your materials. Pastel pencils are also available, but they do not have the versatility of the sticks.

With this medium the choice of paper is vitally important as its surface will have to retain what is essentially powder. For this reason the best papers to choose have a textured surface and a good white water-colour paper like Saunders or Arches paper will prove sympathetic. Good-quality textured coloured papers will be similar to those selected for charcoal, such as Ingres paper. It is even possible to draw on ordinary decorator's glass paper, but for very fine drawings, where the subtle blending of tones is required, the traditional surface has always been a very fine quality of parchment made from calf skin called vellum.

So many individual colours are available because pastels cannot be mixed together like paint, and therefore to create the gradation of a colour several subtly different shades must be applied to the paper side by side. It is important to keep your pastels in strict order in their container to help you in selecting them, especially if you have a large range of colours. Once drawn such an area can either be left in this state, emphasising its graphic qualities, or else carefully blended together with a torchon or a hog's-hair brush. Charcoal is often employed to key in or indicate the main elements of the composition, as these lines are soon lost when the pastels begin to be worked. The pastel sticks are applied to the paper in the manner described for the use of charcoal, with the side being used to make broad marks and the end or an edge for finer lines. If the pastel is applied with pressure it will fill the grain of the paper, while less force will let the texture show through. It is almost impossible to erase pastel marks successfully, as this will destroy the texture of the paper, which allows the pastel to adhere in the first place. This makes it a demanding medium to use. However, highlights and areas of pale tone can be drawn into the picture as it progresses with a piece of putty rubber.

It is essential to fix a pastel drawing once it is finished or even several times during the course of making it if it is an ambitious composition, when it runs the risk of being rubbed off by hands or sleeves. In the past this had to be done by carefully brushing on a gum solution, by steam or with the vapour from a pan of boiling milk. Thankfully, this can now be achieved with a modern fixative applied with an aerosol spray which, when carefully used, will neither dislodge the pastel powder from the paper nor discolour the pigments.

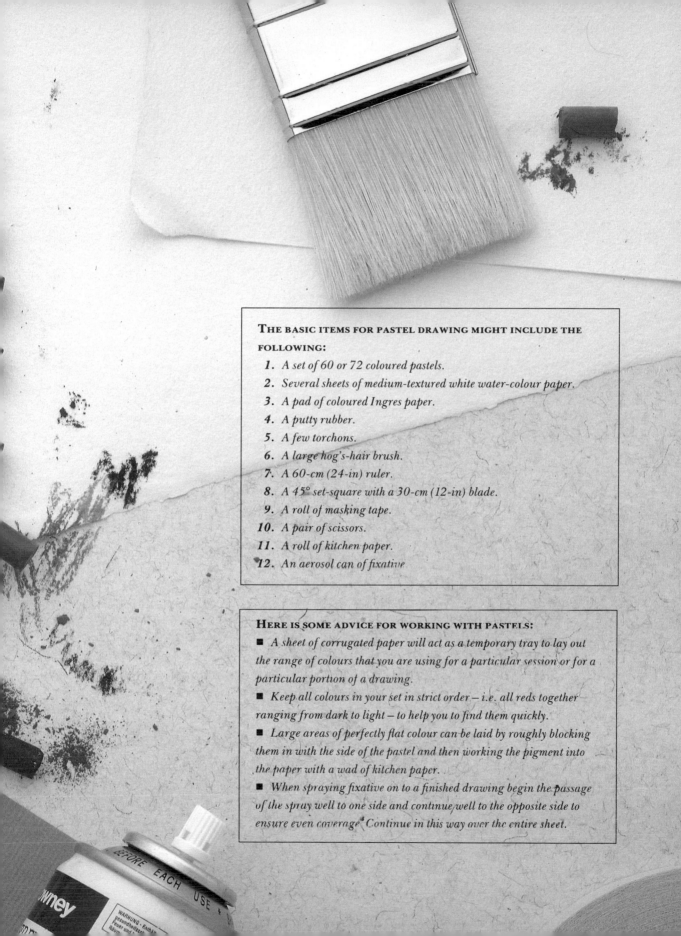

THE BASIC ITEMS FOR PASTEL DRAWING MIGHT INCLUDE THE FOLLOWING:

1. A set of 60 or 72 coloured pastels.
2. Several sheets of medium-textured white water-colour paper.
3. A pad of coloured Ingres paper.
4. A putty rubber.
5. A few torchons.
6. A large hog's-hair brush.
7. A 60-cm (24-in) ruler.
8. A 45° set-square with a 30-cm (12-in) blade.
9. A roll of masking tape.
10. A pair of scissors.
11. A roll of kitchen paper.
12. An aerosol can of fixative

HERE IS SOME ADVICE FOR WORKING WITH PASTELS:

■ *A sheet of corrugated paper will act as a temporary tray to lay out the range of colours that you are using for a particular session or for a particular portion of a drawing.*

■ *Keep all colours in your set in strict order — i.e. all reds together ranging from dark to light — to help you to find them quickly.*

■ *Large areas of perfectly flat colour can be laid by roughly blocking them in with the side of the pastel and then working the pigment into the paper with a wad of kitchen paper.*

■ *When spraying fixative on to a finished drawing begin the passage of the spray well to one side and continue well to the opposite side to ensure even coverage. Continue in this way over the entire sheet.*

Woodcutter Gazing at a Waterfall, *1798, by Hokusai (1760–1849). This drawing was made with ink on an absorbent rice-paper scroll and demonstrates both the spontaneity and subtlety achieved by a master who completely understood his medium.*

WASH DRAWING

THE IDEA OF A WASH THAT WILL STAIN SOMETHING RATHER THAN CLEAN IT HAS ALWAYS APPEALED TO THE PERVERSE SIDE OF MY NATURE. When this term is used in art it refers to diluted paint or ink that is applied with a brush either to create a work of art in its own right or to enhance a drawing made with another graphic medium. Wash was first used in the East and predates its appearance in the West possibly by several thousand years. Oriental styles were derived from the way the brushes were used to create calligraphy, and pictorial and calligraphic elements are often combined in the same composition. The inks were prepared by hand from sticks and laid out in various dilutions from very pale to full strength. These were then applied with a brush with a bamboo handle and a point of badger, rabbit, goat or fox hair. These brushes are widely available and you may care to experiment with them. Personally I find their nature incompatible with that of the more springy Western brushes and I have never been totally happy with them. The brush was charged with ink and used in a vertical manner without the hand touching the surface to make a flowing series of marks that relied on a form of concentrated spontaneity for their effect. These drawings were made purely from recollection on either very fine papers with beautiful surfaces made from rice fibres or on silk. They were laid flat on a table or the floor to be worked on. The finished work would most usually have been a monochrome image – colour was rarely used – which was subsequently displayed on a wall or in the form of a scroll, some of which were over 30 metres (98 feet) long and were viewed sequentially as the image was unrolled from one scroll and rewound on to the other by hand. Study the works of Kuo Hsi and Tai Chin from China and of Hokusai and Utamaro from Japan as an introduction to this fascinating area. In the Western tradition wash

has been used either to make sketches intended as preparatory studies for paintings or to create individual finished drawings intended to exist in their own right. It is most often combined with another linear medium such as pen, pencil or charcoal.

Washes are usually applied with different sorts of brushes from those used in the East: they have a springier quality and are made with a higher-quality hair that retains paint better. They are also easier to control. There are many different shapes and sizes of brush available with a wide variety of hairs or bristles. Very large, bold areas of wash can be laid in with a decorator's paintbrush, sometimes as large as a distemper brush with bristles maybe 20 cm (8 in) wide, and occasionally hog's-hair brushes intended for oil painting might be used to make really bold marks, although their use is uncommon. These brushes come in five basic shapes. A 'flat', as its name suggests, has the bristles arranged to form a flat profile and has a square end and is useful for putting in broad areas. A similar brush but with shorter bristles is called a 'bright'. An 'oval' also has a flattened profile but the bristles at the end assume a rounded or oval form. A 'round' has the bristles arranged cylindrically and tapering towards a point, the fineness of which depends on what they are made from. A 'filbert' is a compromise between a round and a flat with a flattened end at the ferrule that tapers slightly to a rough point and will make either broad marks when used flat or finer ones when the edge is employed. Such broad brushes are unsuitable for fine work and are traditionally made from hogs' hair. Modern synthetic versions are available with bristles of nylon or polyester which is slightly softer and more suited to applying washes. Other materials commonly used in paintbrushes are ox hair, camel hair, squirrel hair and blends and mixtures of various other hairs. Large areas of wash can also be laid with an artist's sponge or cotton wool.

A 'wash brush' is a broad, flat brush with soft hairs. Inexpensive Oriental versions can be found, but undoubtedly the best instruments are the Western kind with the business end made from red sable. The finest sable is called 'Kolinski' and is nothing less than the tips of the tails of Siberian mink. Weight for weight sable is more expensive than gold, but this substance is very light and most brushes will not use much. Even so, sable brushes are expensive, but anything less will usually prove to be unsatisfactory. With wash brushes it is possible to get by with the less-expensive varieties of sable, but for the round brushes, which will form the largest part of your battery when working in this medium, insist on only the finest. The shop where you buy them should provide a pot of water into which you may dip the brushes to ensure that they have a fat body – which indicates that they will retain the medium that they are to be charged

Hog's-hair brushes come in several different shapes – (left to right) flat, bright, oval, filbert and round. Sable brushes are either round or flat, better known as a wash brush.

Gradations of wash from undiluted to almost clear water (1). Wash can be used on rough paper (2), not paper (3) hot-pressed paper (4), the same tone overlaid several times (5), wet on wet gradation (6), masked area (7), image scratched into a wash tone (8), a spatter laid with a toothbrush (9), texture laid with a sponge (10), decalcomania (acrylic paint was added to the wash to stiffen it) (11), wash laid over a wax resist (12) and spots washed out from a flat wash (13).

with – that tapers to a superfine point. This will be true of all round sable brushes irrespective of their size.

The brush size is indicated on the shaft and ranges from the smallest normally available – 000 – to the largest – 12. In practice, it is not necessary to have a complete set, and an 00, 1, 2, 4, 6 and 8 together with a couple of broader, flat sable brushes will normally be adequate. Very fine details are sometimes added with a mapping pen. I find that the larger brushes last much longer than the smaller ones if properly cared for. This should be done by rinsing them thoroughly in clean water as soon as you have finished working with them and then, at the end of each day, washing them on a bar of soap under running water until all traces of colour are gone and rinsing them thoroughly in the palm of your hand until all trace of the soap has also disappeared. They should then be re-formed into a point by drawing them across your hand and stored vertically, points uppermost, in a pot or jar. *Never* leave a paintbrush standing on its hairs even momentarily.

The best papers to select for making wash drawings will be those made specially for water-colour work, and these are available as three distinct types. 'Rough' paper has a pronounced texture and is selected when a broad approach is to be employed. A liquid wash will accumulate in the pits of the texture, imparting a mottled effect to the finished drawing. 'Hot-pressed' paper has a hard, smooth surface and is often chosen when there is a lot of line work to be drawn before the washes are applied. Hot-pressed is often simply abbreviated to 'HP' paper. 'Cold-pressed' paper has a rougher surface than hot-pressed paper and is commonly referred to as 'not' (meaning not hot-pressed) and is between rough and hot-pressed in terms of its surface, which will take a certain amount of line work as well as extensive washes. This is the most commonly used type of paper for this medium and a good one for the beginner to select. There are also many coloured papers suitable for wash drawings, the most common being Ingres paper. These are especially good for taking monochrome washes, which can then have highlights added with opaque white gouache.

This medium demands good-quality papers and these will all be available in several weights, which are usually still expressed in pounds per ream. Thus a lightweight paper of 70 lb means that this is the weight of a ream of 480 sheets. A medium weight is about 120 lb and a heavyweight one about 200 lb. Beyond this weight there are water-colour boards which are identical papers laminated on to stout cardboard. The weights of cardboard are often expressed as two-sheet, four-sheet, six-sheet or eight-sheet, this being the number of sheets of paper laminated together to make the card. The very best

papers are still hand made with a high linen-rag content and one side will be specially sized to take the wash or water-colour. You can tell which side is which by looking at the maker's name in the water-mark, which will be the right way round when the correct side is towards you. If you wish to experiment with Oriental rice papers then seek out one called Kozo, which is less fragile than most of the others and a good choice for the inexperienced. All rice papers will be much more absorbent than Western water-colour papers.

When working with wash, unless you have selected a heavyweight paper or a board the paper will need to be stretched to prevent it buckling and wrinkling when liquid is applied to it. To stretch paper you must first soak it in cold water either in a bath tub or with the water liberally applied to both sides with a large sponge. Lay the paper on a stout drawing board, which should be at least 5 cm (2 in) larger than the paper all round, and smooth it flat with the sponge or the flat of your hand. It is then a good idea to leave it for a couple of minutes as it will expand slightly. Stick the paper to the board with gummed *paper* strip that has been already moistened on the adhesive side. Do this by sticking opposite edges alternately, over-lapping it on to the paper by about 1 cm (about half an inch). As the paper dries it will shrink and become taut so that when washes are later applied they will not cause it to warp. This procedure does not affect the quality of the paper at all.

I have already outlined the types of inks available, but 'artist's' water-colours – which are the ones to select as distinct from those of lesser quality – come in three different forms. They are all basically the same substance and which type you choose is a matter of personal preference. All water-colours are transparent and rely on the paper they are used on to give them their luminosity. The most familiar sort are those available in pans or half pans which are small blocks of solid colour in individual plastic dishes that are wetted with a damp brush. These are the easiest to transport in metal water-colour boxes for when working out of doors. Colour that comes in tubes must be squeezed out on to a palette and mixed with water until it has reached the desired consistency, whereas liquid water-colour is supplied in glass bottles usually equipped with an 'eye-dropper' device in the cap that can be used directly at full strength or diluted with water in a palette. Liquid water-colours are more brilliant than the other kinds, but their containers are obviously more fragile and are there-fore best kept for working in the studio. Water-colours, especially in liquid form, have a tendency to be fugitive – they will fade when exposed to strong light. For this reason it is advisable to purchase only the best-quality colours, in which this tendency will be less pronounced.

Before applying a wash to thin paper it will need to be stretched. First it is dampened and placed on a stout drawing board, where the edges are stuck down with gummed paper strip. As this dries the paper will shrink and become taut. It is then ready to be worked on and will not wrinkle.

Once dry, the stretched paper is used to make your drawing in
pen and ink, pencil or whatever in the normal way. To add washes to
this or to make a wash drawing in its own right it is first necessary
to prepare them with either ink or water-colour. To make a mono-
chrome wash with waterproof drawing ink it will need to be diluted
with distilled water; ordinary clean tap water is sufficient for water-
colour. Select a palette with a number of small depressions or a
series of individual palettes made from china or plastic. One section
of the palette contains the pure, undiluted colour and the others are
filled with clean water to which the colour is added to create a gra-
dated range from very dark to very light. These can be tried out on a
piece of scrap paper and adjusted until you have a range suitable for
your drawing.

Cemetery by Moonlight, *1834, by
Caspar David Friedrich (1774–
1840). Here a sepia wash has been
combined with pencil to create this
eerie image. Note that the lightest
tone in the drawing is the moon
and the darkest the open grave.*

A wash is distinct from a painted line in that an area of wash will
be broader than a single brushstroke and of a uniform tone where
individual brushstrokes will not be apparent. To do this the area to
which the wash is to be applied is dampened with a brush charged
with clean water and then the wash is brushed on in several strokes
which will merge together imperceptibly. This should be done
quickly and simply and then left alone to dry; any modelling intended
to suggest form is then applied over the top with a brush charged
with the appropriate tone. Large areas of gradated tone are created
in a similar way, but several dilutions of wash are employed, laying
the darkest tone first and progressing through the lighter ones.
Lines can also be added when the wash is dry. Remember when
working on white paper that this will be the lightest tone that you
have at your disposal, although highlights can be added by scratching
them in with a scalpel blade or with Chinese white or gouache – an
opaque form of water-colour. Highlights are perhaps most easily
managed for the beginner by painting them on to the line drawing
beforehand with masking fluid.

Other ways of applying wash effects are the use of spattering,
either with a toothbrush or a mouth atomiser, the incorporation of
monoprints from leaves, wood, feathers, etc., and stippling with a
fine brush. In addition, water-colour or ink washes can be applied as
a random texture suggestive of natural phenomena such as leaves or
rocks by dabbing them on with an artist's sponge or a small wad of
cotton wool or kitchen paper. It is a good idea to test such marks
first on a spare piece of paper and then to mask out the areas to be
textured in this way with scrap paper and 'low-tack' masking tape,
which will not damage the surface of the paper when it is later
removed. The Surrealist decalcomania technique can be applied to
the paper by first painting the liquid wash on to glass or a sheet of
non-absorbent paper such as tracing paper and, while it is still wet,

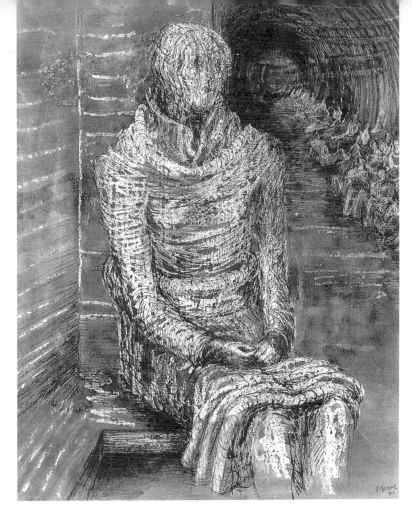

Woman Seated in the Underground, *1941, by Henry Moore. This is one of Moore's famous* **Shelter Drawings** *made in London during the Blitz. He used wax crayon as a resist to which he then applied wash.*

carefully pressing your final sheet on to this before peeling it off to reveal a unique and complex area of texture. Another interesting technique is to block in the required textured area roughly with an ordinary (colourless) household wax candle before applying the wash, which will stain to the paper where the wax is not present and be repelled where it is. This can either be left as it is as part of the picture or the wax can be lifted by placing a sheet of brown wrapping paper (kraft paper) over the top and ironing it with a hot iron; this will draw the wax residue from the water-colour paper up into the wrapping paper.

This is a difficult medium to erase or modify once the marks are made, but with care some things can be achieved. Once the wash is completely dry it is possible to use a slightly abrasive eraser on it, but as the colour will have soaked into the paper this is bound to destroy the surface, making it difficult to rework. Highlights can be scratched in with a scalpel blade and the intensity of a wash can be reduced by gently rubbing the area with a damp sponge or cotton wool and carefully drying it with blotting paper or a hair drier. This is repeated until the required degree of paleness has been achieved.

HERE IS A RANGE OF MATERIALS FOR MAKING WASH DRAWINGS:

1. *A couple of sable wash brushes.*
2. *A range of round sable brushes in sizes 00, 1, 2, 4, 6 and 8.*
3. *A range of water-colours.*
4. *A tube of Chinese white or white gouache.*
5. *A range of waterproof inks.*
6. *Some distilled water.*
7. *A water pot.*
8. *Several sheets of water-colour paper.*
9. *A scalpel and spare blades.*
10. *A 60-cm (24-in) ruler.*
11. *A 45° set-square with a 30-cm (12-in) blade.*
12. *A compass or set of circular templates.*
13. *A roll of 'low-tack' masking tape.*
14. *A roll of gummed paper tape.*
15. *A pair of scissors.*
16. *A bottle of latex masking fluid.*
17. *An inexpensive brush for applying the masking fluid.*
18. *A small artist's sponge.*
19. *A roll of kitchen paper.*

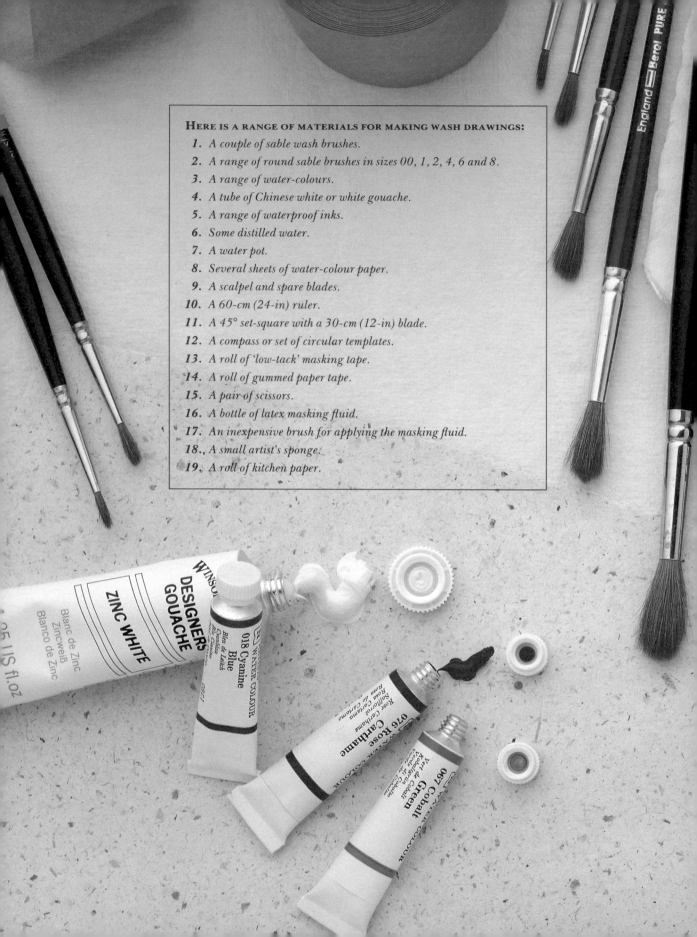

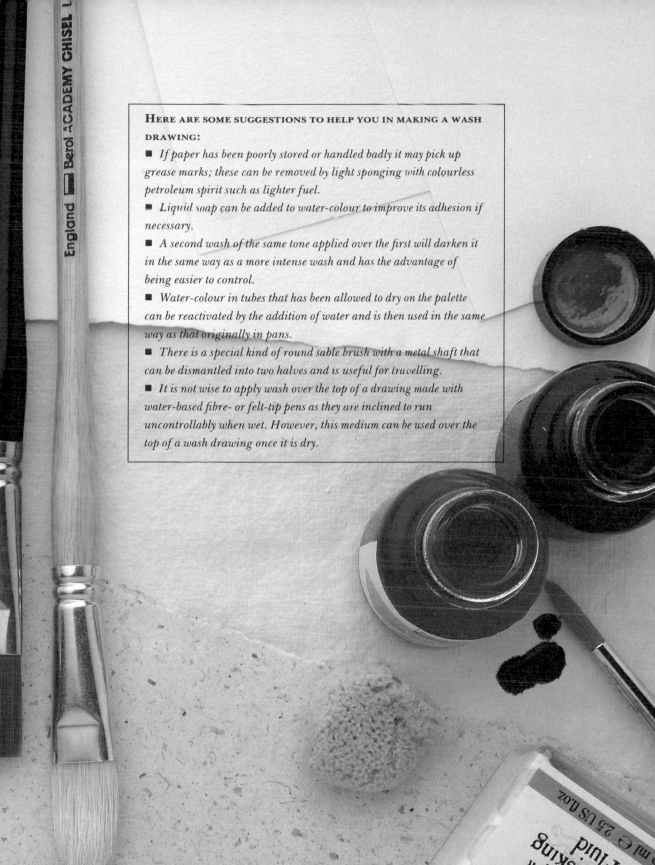

HERE ARE SOME SUGGESTIONS TO HELP YOU IN MAKING A WASH DRAWING:

■ *If paper has been poorly stored or handled badly it may pick up grease marks; these can be removed by light sponging with colourless petroleum spirit such as lighter fuel.*

■ *Liquid soap can be added to water-colour to improve its adhesion if necessary.*

■ *A second wash of the same tone applied over the first will darken it in the same way as a more intense wash and has the advantage of being easier to control.*

■ *Water-colour in tubes that has been allowed to dry on the palette can be reactivated by the addition of water and is then used in the same way as that originally in pans.*

■ *There is a special kind of round sable brush with a metal shaft that can be dismantled into two halves and is useful for travelling.*

■ *It is not wise to apply wash over the top of a drawing made with water-based fibre- or felt-tip pens as they are inclined to run uncontrollably when wet. However, this medium can be used over the top of a wash drawing once it is dry.*

MIXED MEDIA AND OTHER DRAWINGS

A Week of Happiness or The Seven Capital Elements – Blood, 1934, by Max Ernst. In this collage Ernst has not actually drawn anything with his own hand but has selected and pasted together images from different sources to create this dream-like picture.

ONE OF THE MANY DIFFERENCES THAT CAN BE FOUND BETWEEN TRADITIONAL AND MODERN ART IS THE RANGE OF MATERIALS THAT HAS BEEN USED TO CREATE THE LATTER. It is not uncommon for a contemporary work of art to be made from several media: this is called 'mixed media'. There is no set of rules as to what can or cannot be done, and many successful works have been brought about by artistic experiment or even accident. Strictly speaking, an ink drawing with a water-colour wash is an example of a mixed media composition, but it is seldom referred to as such. One of the most common ways of mixing media is to incorporate actual objects into the drawing. Three-dimensional objects are sometimes used with varying degrees of success, but the flimsiness of drawing paper or board usually means that this is impractical. Objects made from paper or fabric are more commonly stuck on to or otherwise incorporated into drawings, and their use is termed 'collage' from the French verb *coller* meaning to stick. Provided that it is light and has a flat surface enabling it to be glued to the paper, almost anything can be used in this way, and leaflets, tickets, pieces of tablecloth, food packets, lengths of string, matchsticks, advertisements, diagrams, nails, leaves, feathers and plastic toys have all been used to make collages.

Such *objets trouvés* or found objects are normally attached with an adhesive. With paper items the best sorts of adhesive are rubber-based cements specially made to stick paper and which will not stain. These are available either in cans, when the glue must be applied with a plastic spreader, or in aerosol sprays, which are more suitable for large areas. Whichever variety you use both surfaces must be clean and free from grease and evenly coated with the adhesive, which is allowed to dry slightly before they are brought into contact with each other, whereupon the bond is instantaneous. Any excess adhesive can be removed simply by lightly rubbing the deposits with a clean finger. Objects can be lifted with the aid of petroleum spirit (cigarette-lighter fuel), which dissolves the adhesive and which will not stain. Objects other than paper will require the use of a stronger adhesive. Always ensure that the adhesive will not wrinkle or stain the paper before applying it by testing it on a scrap of similar material.

Another drawing medium rarely used today is scraper board (sometimes also known as scratch board). This is a sheet of card that has been coated first with a chalky preparation and then with a layer

of black Indian ink. The drawing is made by scratching away the black surface to reveal the white ground underneath with a range of sharp, pointed scraper board tools, each of which is capable of making a distinctive type of mark. The tools fit into a standard penholder. Minor corrections can be made by repainting an area with Indian ink and then re-scratching it. Scraper boards are also available in white and several other colours, where you can draw a black image that is then scratched away; it is possible to add simple colour to drawings made in this way by applying water-colour. Scraper boards come in various standard sizes and, with care, it is possible to trim them to a smaller size with a sharp craft knife and metal straight edge.

The most controlled way to apply liquid colour to paper is with the aid of an aerosol spray can of paint. Do ensure that this is specially made for paper and board and not for general household use or for repairing the paintwork of cars. To use an aerosol spray to apply colour to a drawing it is first necessary to mask out the area where you do not want the colour to appear. This can be accomplished with latex masking fluid applied with an inexpensive brush. When the fluid is dry the area can be sprayed, and when this too is dry the mask can be removed by rubbing with a soft eraser or with a clean finger. An alternative form of mask can be made with transparent self-adhesive masking film, which is removed from its backing and stuck down over the drawing. The area to be sprayed is cut around with a scalpel, taking great care to cut only through the film and not through the paper as well, and then peeled away leaving the mask intact where the colour is not to be applied. The adhesive for this type of film is 'low-tack' and will not damage the paper or board. As this procedure must be repeated for each area to be sprayed it is a very time-consuming process. The most basic form of mask is made by attaching scrap paper or newspaper with masking tape to obscure the areas that will not be sprayed. This will only work for bold, simple areas. When repeated shapes are to be sprayed a reusable mask is cut from a piece of thin card or, better still, acetate. The sheet from which this is cut must be much larger than the area to be sprayed and placed in firm contact with the paper, as the atomised globules of colour have a tendency to cover a much larger area of colour than you would expect and to creep under the edges of the mask.

The finest, most controllable sprays are applied with an airbrush. This is charged with paint or ink, which is blown on to the paper by compressed air. All of this equipment is very expensive and is only worth buying if this is to be your chosen medium and you wish to create the fine gradations of tone achieved in this way.

The Canadian Club, 1974, New York Townscape, *by Richard Estes (1936–). This type of image is known as 'Photorealism' and was created by meticulously copying a photograph on to canvas with an airbrush. The result is quite unlike any other medium, but requires the use of expensive equipment.*

PRESENTATION AND CONSERVATION

TIME SPENT ON ENSURING THAT THE PRESENTATION OF YOUR DRAW-INGS IS PERFECT WILL NEVER BE WASTED, AND WHILE THIS WILL NOT TURN THE BANAL INTO ART IT IS VERY SATISFYING TO SEE YOUR WORK, HOWEVER SUCCESSFUL, PRESENTED IN THE BEST POS-SIBLE LIGHT. The most important factor is to make sure that your work is absolutely clean. An artgum eraser is useful for removing grubby marks, and if the drawing has been executed in a soft medium such as charcoal, pastel or soft pencil, then once it is clean it is a good idea to give it a final coat of fixative.

The most common way of presenting a drawing is to frame it for hanging on a wall. The nature of a drawing means it must first be masked, which will hide any extraneous marks around the edges made during the course of working, create an area of contrast around it to enhance its appearance and help to protect it. The mask should ideally be made from acid-free card, which will not react with the paper or drawing medium over a period of time and should be chosen to complement the image. A fine, pale pencil drawing will be visually swamped by a large black mask and a bold charcoal drawing will overpower anything too subtle. The size that you use, the pro-portion of mask to drawing, is also important and the most common fault is to make any mask too small. A real sense of presence can be imparted to a small drawing by a large mask and even a larger drawing will benefit. Boards suitable for masking come in a wide range of shades and weights and the colour that you choose is very important. Although very much a matter of personal preference it is usually a good idea to use the basic colour of the drawing as your

starting-point. In this way, a sepia drawing will look splendid with almost any tone of brown mask and one executed in pencil with one in a tone of grey. White masks are seldom effective for any drawing and certain colours in a work may be enhanced by an unexpected choice of coloured mask.

A mask is cut with the edges that are adjacent to the image bevelled to about 45°. There are special mask-cutting gadgets, but with a little practice it is possible to cut a perfect mask with a craft knife and a *metal* straight edge. I always use a new blade for this and cut on a sheet of scrap card to ensure an absolutely clean cut. The mask should overlap the area of the image that you wish to display by 2–3 mm (about ⅛ in). There is an optical illusion to be considered here in that if the aperture or window of the mask is cut dead centre in the card it will have the appearance of being too low. The aperture should therefore be centred to the left and right but to allow slightly more of the surrounding mask at the bottom than at the top to compensate for this. Sometimes a mask can be covered in hessian, velvet or thin cork to help it to blend into a particular interior.

The drawing is fixed to the mask from the back with paper strips to which water-based mounting paste has been applied or with masking tape, which is also better for temporary mounting. Harsh adhesives are unsuitable for drawings made on paper as are dry-mounting techniques. A sheet of hardboard or stout card the same size as the mount is then placed over the back which is later attached to the frame with strong adhesive tape. If the drawing has been made on thin or otherwise slightly transparent material place a sheet of white paper over the backing board to prevent the discoloration that might be caused by show-through.

The drawing will then need to be framed. Unless you are a competent carpenter or have a purpose-made frame-cutting apparatus it is advisable either to leave this skilled job to a professional picture framer or else buy a do-it-yourself framing kit, of which there are many on the market. If you choose the latter then ensure that the outside dimensions of the mask coincide with the internal dimensions of the frame. Wooden frames will look best with drawings of a traditional nature while metal and coloured plastic ones will complement works with a contemporary flavour. You are bound to find one to suit your needs. Small drawings will seldom need a wide frame, but avoid finishing a work with a generous mask with a frame that is too meagre. All drawings should be framed behind glass – either normal picture glass, which is half the thickness of the glass used for windows, or the more expensive non-reflective kind intended for picture framing. The mask also serves to keep the drawing from touching the glass and thus avoiding damage to it.

When a mask is cut the aperture must not be centred otherwise it will appear too low (above). To compensate for this it needs to be positioned slightly above centre (below).

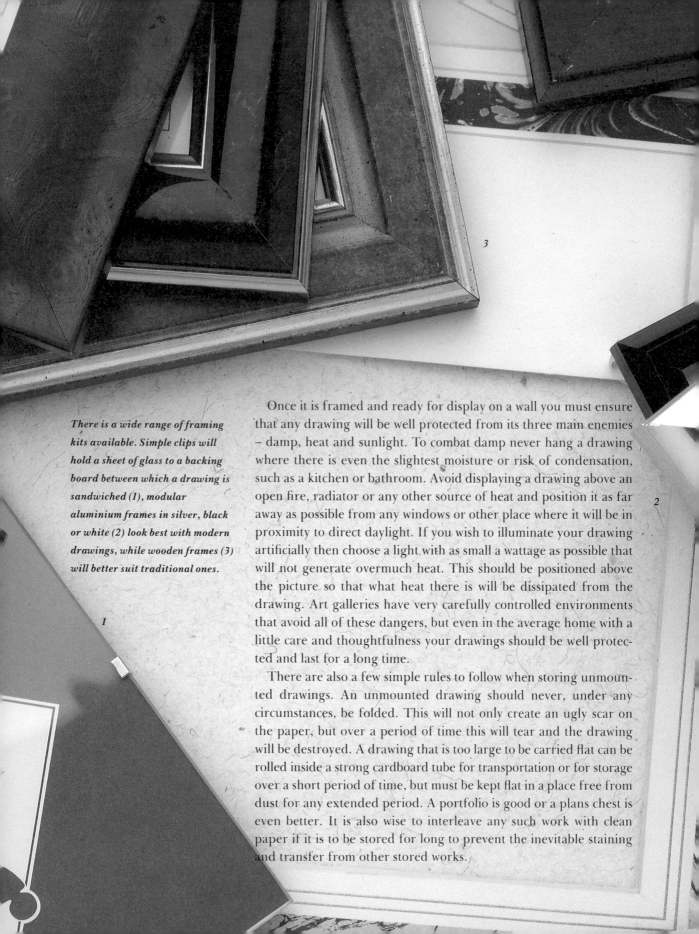

There is a wide range of framing kits available. Simple clips will hold a sheet of glass to a backing board between which a drawing is sandwiched (1), modular aluminium frames in silver, black or white (2) look best with modern drawings, while wooden frames (3) will better suit traditional ones.

Once it is framed and ready for display on a wall you must ensure that any drawing will be well protected from its three main enemies – damp, heat and sunlight. To combat damp never hang a drawing where there is even the slightest moisture or risk of condensation, such as a kitchen or bathroom. Avoid displaying a drawing above an open fire, radiator or any other source of heat and position it as far away as possible from any windows or other place where it will be in proximity to direct daylight. If you wish to illuminate your drawing artificially then choose a light with as small a wattage as possible that will not generate overmuch heat. This should be positioned above the picture so that what heat there is will be dissipated from the drawing. Art galleries have very carefully controlled environments that avoid all of these dangers, but even in the average home with a little care and thoughtfulness your drawings should be well protected and last for a long time.

There are also a few simple rules to follow when storing unmounted drawings. An unmounted drawing should never, under any circumstances, be folded. This will not only create an ugly scar on the paper, but over a period of time this will tear and the drawing will be destroyed. A drawing that is too large to be carried flat can be rolled inside a strong cardboard tube for transportation or for storage over a short period of time, but must be kept flat in a place free from dust for any extended period. A portfolio is good or a plans chest is even better. It is also wise to interleave any such work with clean paper if it is to be stored for long to prevent the inevitable staining and transfer from other stored works.

EXERCISES

THE EXERCISES

THE EXERCISES ARE ARRANGED AS AN IRREGULAR CYCLE. If you wish, you may start at any of the suggested projects or indeed select them in any order that you think will suit your particular interests. If, for instance, you have a strong feeling for drawing animals it is unlikely that an architectural composition will interest you overmuch and you should therefore feel free to ignore it and to pursue this course via those exercises and in those media that are particularly relevant to your tastes and abilities. You may then want to repeat your chosen cycle by tackling the exercises again in different media, utilising as much, or as little, of them and the preceding outlines of principles and media as you find useful.

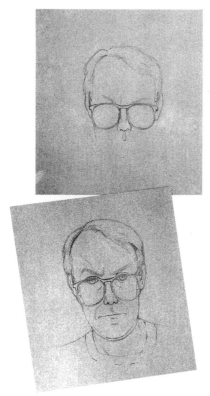

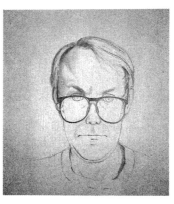

Before starting I ensured that I had all materials within reach and that I was perfectly comfortable. On a sheet of mid-grey Canson paper with a 2B pencil I drew in my spectacles, as a pivot around which I would compose the other elements of my face. After roughly drawing in the upper part of my face, I then drew in the half

A SELF-PORTRAIT

AT ITS SIMPLEST A SELF-PORTRAIT IS AN EXERCISE TO ENABLE YOU TO PUT INTO PRACTICE THE USE OF YOUR PREFERRED MEDIUM ON A SUBJECT THAT YOU KNOW VERY WELL — AFTER ALL, YOU WILL SHAVE, MAKE-UP OR OTHERWISE STUDY THIS SUBJECT EVERY DAY OF YOUR LIFE AND WILL HAVE COME TO KNOW EVERY DETAIL AND NUANCE OF ITS APPEARANCE. At its most difficult it is the most exacting of subjects to tackle for exactly this reason and one that has fascinated artists throughout history. Rembrandt produced many self-portraits in his lifetime and to view even a part of this output in sequence is to experience a profoundly moving commentary on the subject of ageing. I have chosen this both easy and demanding subject to introduce the practical side of this book in the hope that it will provide the impetus to carry you on to attempt the subject once more at a later date in another medium, bringing to it all that you will have learnt during this course of study.

The most important advice that I can offer the newcomer is not to attempt to create a likeness. If portraiture attracts you then that is something to pursue later on, but initially and for the purposes of this exercise it will be sufficient if you acquire a sympathy for whichever medium you choose to employ and apply the basic principles of composition and proportion to this drawing. Simple media for this subject are pencil and charcoal and the most demanding will be pen and ink and pastel.

Normally the most suitable format for a portrait is to use the paper with the long edge vertical (called 'portrait'). Any drawing is likely to take a long time to make so ensure that you will be comfortable and that all of the materials that you are likely to need are to hand so that you will not have to break off in order to go and find them. You will need the aid of a mirror. Make sure that it is large enough – a make-up or shaving mirror will not be adequate – and placed in such a position that your reflection is well illuminated. You should be positioned in such a way that you can see both your reflection and your drawing without moving your head. You will have the option of either posing yourself looking directly into the mirror (full-face) or looking off slightly either to the left or right (quarter-face). If you are looking to one side ensure that you do not centre your image on the paper but allow more space on the side towards which you are looking, to achieve a more pleasing composition. At

beneath my glasses all of the time measuring with my eyes the relationship of one part to another.

The darkest element that I could observe were my glasses and I elaborated these original marks with a 4B pencil towards what I felt was their true tonal value.

I carried on in the same way onto the lighted side of my upper face where I could use the graphite that the torchon had picked up to make some of the paler shading. I then switched to a 2B and an HB pencil to make the finer, harder lines suggestive of my hair, then back to the softer pencils to continue down the shadowed left side of my face. The drawing progressed until all of the face had received its tonal modelling with various combinations of hard and soft and blended and unblended pencil marks.

After having completed the drawing of the T-shirt, an

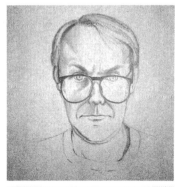

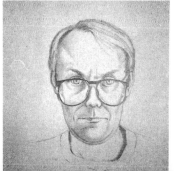

this point you will also need to decide whether you are simply going to draw your head or to include your shoulders and/or torso. At a later stage you may care to make a self-portrait that has been reflected by two mirrors. This will mean not only that you can draw yourself in profile but it is also the way other people see you and is not at all like the reflection that you are used to seeing.

Lighting plays an important rôle and will affect the mood that your drawing conveys. Daylight will always be best, and for the beginner a face lit slightly from the side will serve to define the form better by casting slightly oblique shadows. If you use artificial lighting it should never be harsh except to achieve a dramatic effect, such as illuminating the face from below which will impart an eerie, supernatural feeling. Fluorescent lighting is the worst possible choice as it has a flattening and deadening effect that is never flattering or informative, and it should be avoided at all costs. It is also not advisable to select a background that is too busy so that all of your attention is focused on the principal subject.

Make sure that your pose is comfortable because not only will you need to maintain it for a prolonged period but you will also be working while you hold it. Inevitably you will slump somewhat after ten minutes or so and it is often profitable to spend this initial period defining the general composition, plotting the over-all form of the drawing or making thumbnail sketches to feel your way into the subject. People often remark at the serious expression on the face of the subject of a self-portrait, but this is merely the result of the intense concentration of the artist and the impossibility of maintaining any kind of animated expression for the amount of time that it takes to make a drawing.

Start by making a painstakingly objective evaluation of just what you see before you. I described earlier the classical ideals relating to the proportion of the human head; this is the opportunity to test them against your own face. You will almost certainly find that they do not apply, but they will provide you with a useful starting-point. Draw an egg shape to represent your head and divide this horizontally into eight equal sections to aid you in positioning the principal facial features. When these elements are lightly sketched in study your own reflection and, item by item, alter them to match your own features. First, redefine the over-all shape of the head from the egg you initially drew and proceed on through the eyes, nose, mouth, ears, etc., constantly altering the relationship between them until the whole starts to assume its correct form. This is unlikely to happen immediately, but at some point, usually after much reworking, there will be a magic moment when the final form of the drawing begins to emerge out of the tentative marks on the paper. This is the point to

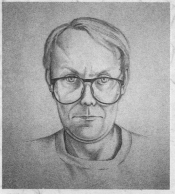

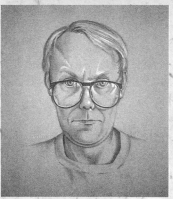

begin to make them bolder and more concrete as you feel your way towards the final form, bringing into play the techniques specific to your medium, as discussed earlier.

The history of art is littered with portraitists of genius, many of whom have produced brilliantly insightful self-portraits. I have mentioned Rembrandt, but you should also study the works of such artists as Chardin, Dürer, Van Dyck, Goya, Van Gogh, Hals, Hockney, John, Matisse, Modigliani, Picasso, Schiele, Spencer, Velázquez, Warhol and Wyeth.

If you really want to come to terms with the art of portraiture a knowledge of anatomy is indispensable. One must always be aware that just beneath the skin is a complex arrangement of muscles, and beneath those the bones of the skull, which are similar in everyone. But more than that, we must endeavour to perceive the elusive quality of individuality that is written on every face in the infinitely complex labyrinth of the features as clearly as in any biography.

assessment of the drawing told me that the tonal values needed to be enhanced. I therefore reworked the darker areas with a 6B pencil so as to improve the contrast.

With a white coloured pencil I started to indicate the brightest highlights and reflections to make the foremost elements such as my nose and spectacles appear to advance.

I continued this over the lower half of my face using the white to help to define the lower lip and chin. I then used more white marks to separate the T-shirt from my neck visually. The work was then sprayed with fixative. The drawing was made in a single session and took roughly six hours to complete.

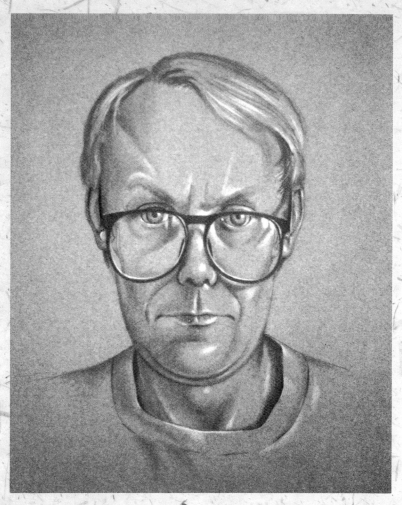

EXERCISE TWO

A STILL LIFE

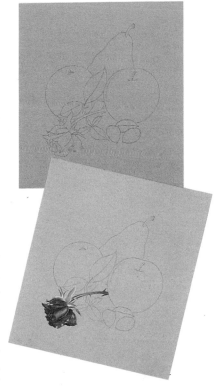

LIKE A SELF-PORTRAIT, A STILL LIFE IS A TRADITIONAL SUBJECT FOR ARTISTS. It probably reached the height of its popularity in the Netherlands during the seventeenth and eighteenth centuries and many fine examples have survived that will reward constructive study. Try to seek out examples of the works of Bosschaert, Heda, van Beyeren, Weenix and van Huysum. More recent examples by van Gogh, Cézanne and the deceptively simple works of Morandi will also prove instructive.

A still life can be composed of any group of inanimate objects; the only practical limits are the tendency of some organic matter such as fruit, flowers or dead animals to putrefy or otherwise change their appearance during the course of a drawing that might take many days to complete. The particular choice of objects is a personal matter and the best still-life drawings will often depict things that reflect the personality of the artist. Whatever you choose, you must ensure that the group will remain undisturbed for the duration of the work. It must be arranged and lit with great care and attention to detail. If it is to be lit by natural light, as is usually the case, then this must be considered from the start and the still life arranged in relation to it. With artificial lighting it is possible to light the subject after it has been arranged, but to do this well will involve the use of several movable lamps; the light will probably have to be diffused in some way, such as with sheets of tracing paper taped in front of the lamps. The backgrounds to still-life compositions are usually very simple in order not to detract from the principal subject; there is no set rule for this and there was a vogue in eighteenth-century France to create a still life from the product of a day's shooting, which (for obvious reasons) was painted out of doors and included the distant landscape where the animals were shot. If you should decide to include an elaborate background then it is best to associate it in just such a strong, direct way with the subject.

Do not arrange the composition as a block of objects but rather as a series of contrasts. For example, position the tallest object towards the rear of the group, and it is a good idea if this coincides with a vertical golden section line so as to provide a harmoniously positioned upright. Then, if the other objects are arranged to form an approximate triangle, you will have accomplished one of the traditional forms of composition. With any still life the choice and position of all

I decided that this drawing would best be made using coloured pencils, and I selected a sheet of pale brown Canson paper and first drew in the major elements of the composition with a 2B lead pencil. I started with the rose as this was the most perishable element in the drawing. Working from the deep purple, blue and red shadows towards the pale pink highlights I put in the principal areas of colour.

Initially using the pencils boldly and with the side of the lead the marks were gradually refined, and the semi-opaque quality of the medium was exploited by laying pale colours over darker ones to achieve subtle intermediate tones. The orange was first blocked in and then gradually refined with

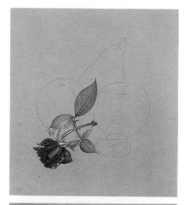

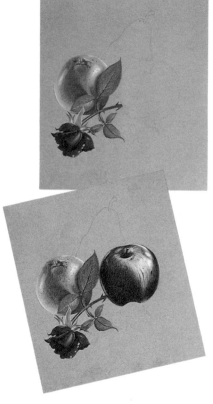

of the objects are infinitely variable and as such this provides the ideal opportunity to investigate the different approaches to composition outlined earlier (see page 19). Try out many arrangements and groupings as thumbnail sketches before finalising your composition. To carry the concept of contrast further juxtapose different surfaces and textures which will impart greater visual interest to the drawing as well as making it more demanding to create. A simple bowl of fruit can provide such contrasts with the spikiness of a pineapple against the fuzziness of a peach against the pitted texture of an orange against the glazed quality of cherries, etc.

Firstly, regard your subject as a series of abstract shapes. Spherical fruit as circles, bowls as hemicircles, circular plates as ellipses, cylindrical glasses as rectangles, bottles as cones, and so on, taking special care to plot accurately the proportions of one to another and of smaller groupings to the whole. Use your drawing instrument as a measuring tool and also use the objects in the group as guides to estimate the proportion of other things against them. It is valuable at this stage to ensure that you draw the spaces *between* things to coincide with what you see in front of you – what is not there assumes the same importance as what is. When you feel that each part of the drawing has the correct relationship to the others and the others to the entire composition, then that is the time to begin to alter the abstract forms on your sheet of paper to the concrete forms of the actual objects – the fruit is unlikely to be entirely circular or glasses strictly rectangular, bottles must have a neck and body formed from the cone, and so on.

It is only if you are attempting to depict angular objects that perspective will play an important rôle, but for most still lifes the depiction of one object in front of another together with the careful plotting of shadows will be enough to impart their solidity and spatial relationship to one another. It is rare to find great depth depicted in a still life (unless it has an outdoor background, in which case this part of the drawing is best treated as a landscape), so aerial perspective will not play a part and the earlier guidelines for drawing objects that are touching or close together in space will be applicable. For the shallow depth in a still life subtle emphasis of colour, tone or weight of line placed on those objects in the foreground will normally be sufficient.

careful regard to blending the five major areas of tone together. There was reflected light evident in the studio and the shadows cast by the rose leaves modified these colours further.
The apple, used to counterbalance the position of the orange in the composition, had a similar form but with a more reflective surface.

With this subject one is most commonly drawing objects that are familiar to everyone and therefore there is greater freedom to exploit their pattern value or otherwise to utilise a less strictly representational style of drawing. This would seem an ideal exercise in which to experiment with the ideas behind conceptual perspective or the reverse perspective of Cubism if you feel so inclined. Look at

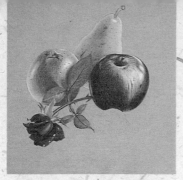

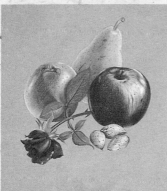

the still-life works of Picasso, Braque and Gris to see how they approached this. Di Chirico used still-life elements in many of his metaphysical paintings to create an altogether strange and wonderful world that mixed the exotic and the commonplace and which was not confined to the traditional table-top. Several decades later everyday commercial brand-name products often formed the subject-matter of Pop Art and it is interesting to see yet another way of approaching this subject in the works of such artists as Hamilton, Wesselmann, Phillips, Johns, Oldenburg, Rosenquist and Warhol.

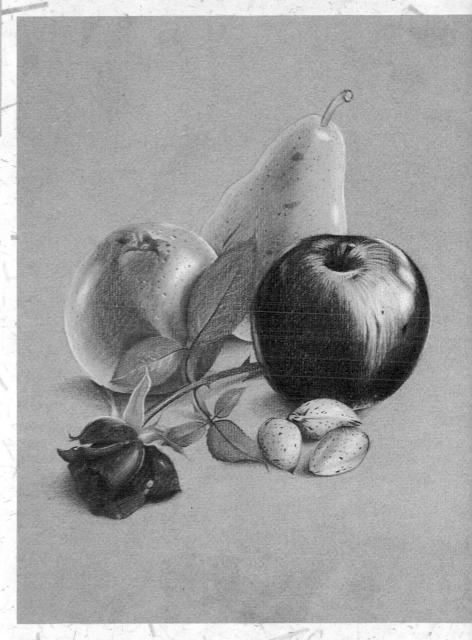

This dictated its treatment with bolder and more sharply defined shadows and highlights.

The yellowish colour of the pear was chosen as a visual link between the red and the orange, and its green tinted shadow side was used as another chromatic link with the rose leaf.

The almonds were drawn in and their brittle, pitted surface was suggested by using sharper lines drawn with the pencil points. The softer tonal qualities of the fruit had been achieved in the most part by utilising the pencil edge.

Lastly, the cast shadows were drawn in to anchor the objects to the implied surface that they were resting upon using several different tones of brown pencil. A drawing made in this medium is permanent and need not be fixed. This still life was drawn in two sessions and took thirteen hours to complete.

A PLANT DRAWING

AT THE TIME OF WRITING, THE MOST EXPENSIVE WORK OF ART IN THE WORLD IS A STUDY OF IRISES BY THE DUTCH POST-IMPRESSIONIST ARTIST VINCENT VAN GOGH. Plants and other organic forms have exercised a fascination for artists over the centuries and have always found a receptive audience who feel an affinity with nature and natural forms. To make a successful drawing of this subject requires a sympathy with the idea of free, flowing marks and skill with the media necessary to make them.

Throughout history a language of symbolism has been attached to plants, much of which has survived to this day and can be read in works of art. A red rose is an unambiguous symbol for love, a white lily for purity, an apple implies temptation, an oak tree steadfastness and holly and mistletoe are the very essence of Christmas. People who are attracted to this subject will doubtless have their own associations with natural forms and should use them to create a personalised iconography. The plant kingdom offers an incredible variety of subjects to choose from. Beginners will probably be happiest to select a small plant with a relatively simple shape that can be set up in front of them on a table-top. The plant need not be perfect or whole and such things as a partially decomposed leaf or a cabbage cut in half can offer incredibly beautiful patterns. The medium that you choose to make the drawing should in some way reflect the quality of the plant itself, and a crisp medium like pen and ink will prove a good choice when depicting the brittle, desiccated quality of dead or dried plants, while more flowing media such as wash, pastel or Conté crayon will be sympathetic to soft, growing forms with blossom or foliage. Diluted wash or fine pencil will convey the fragility of certain plants, while bolder media will be more apt to impart a sense of vigour to coarser forms, although this is by no means a firm rule. It is best initially to select a plain, uncluttered background that will focus attention on the subject and to make sure that it is lit in such a way – either by natural or artificial light – that the form is enhanced.

The appropriate paper should be selected and prepared for the chosen medium and various compositions investigated with the aid of thumbnail sketches on scrap paper before beginning the drawing proper. The secret to drawing plants, indeed to drawing anything from life, is careful observation of the subject. Observation is of

The palm was drawn from life and posed in a place where it was well lit by natural light and would not be disturbed. The position of the major trunks and leaves was first lightly sketched in with lead pencil on cartridge paper.

The drawing was to be made with coloured pencils and these were first employed broadly to block in some of the fronds of the top part of the plant. This was drawn against a white background so as to emphasise the elegant silhouette.

This continued with paler tones being added and the dark trunk blocked in to assess the contrast between it and the leaves. The finish of the leaves was constantly finessed as the drawing proceeded. The middle head of the palm began to be put in and the form of the topmost one altered slightly in relation to it, all the while assessing the drawn image in relationship to the subject in terms of shape, tone and colour. The drawing continued in a similar manner with bold marks gradually being refined into a more finished state as the drawing progressed, constantly adjusting the various nuances of colour.

equal importance to making actual marks on the paper and a *minimum* of 50 per cent of your time should be spent in looking intently and studying the subject. Before attempting to make any mark begin by looking long and hard at the plant in front of you, observing how it is formed, the shape and arrangement of the leaves, the disposition of the veins, the grouping of the blossoms and stalks, the nuances of texture and colour, the shape of the spaces between the various elements and the over-all thrust of the growth of the entire plant. At this point it is also worth deciding whether you wish to draw every part of the plant in the same detail or whether to concentrate on only one part and to indicate or otherwise suggest the remainder.

Trees and other large plants will obviously need to be rendered smaller than life-size, while many botanical studies are made actual size. Apart from this it is often a stunning idea to draw a small plant to a very large scale; just how spectacular this can be is apparent in the large flower paintings by O'Keeffe. The goal of this exercise is to convey the feeling of growth and vitality present in plants rather than strict representation, and it is perfectly acceptable to displace or transpose elements of the plant in the drawing to achieve this end, although be aware that each plant has its own distinctive form and growth pattern that will need to be plotted with careful regard to proportion.

Unless you are depicting the plant in its natural environment, perspective will not play as large a part in this exercise as in others and the simple expedient of emphasising the foremost elements to create the illusion of their advancing in space, together with subtle 'haloes' and the rendering of shadows, will impart a sense of presence and solidity. Oriental plant drawing normally employs none of these techniques yet still manages to convey perfectly a true sense of the subject through more spontaneous means. Another factor that should not be overlooked is the obvious pattern value of plants; you may choose to emphasise this in your drawing as did the nineteenth-century English Pre-Raphaelite artist William Morris, who applied his plant studies to beautiful fabrics and wallpapers. Other artists who have chosen this subject as a source for their works include Sutherland, Nash, Mackintosh, Redon and Rousseau, as well as many Oriental artists such as Kuo Hsi, Hokusai and Hiroshige.

During the course of making the drawing you will probably need to stop at intervals and make individual studies of certain elements to help you to understand them better. Unless you are planning to make a very formal finished drawing these details need not be made on a separate sheet. They can very well be drawn in odd corners of your main sheet which, apart from giving the study an attractive

and professional quality, also facilitates the copying of the detail into its appropriate position in the finished work.

The success or failure of your drawing can only be measured by your own criteria and this will depend on the goals that you set yourself when embarking on this exercise. If you feel that you have captured even some small fraction of the essence of the plant, either objectively or subjectively, then this can be deemed a success.

The lower part of the palm began to be drawn in in the same way and the trunks extended to unite the image as it progressed. Particular attention was paid throughout the creation of this drawing to the reflections on the glossy leaves. The final part of the actual plant was drawn and carefully compared with the subject. The position of some of the individual fronds was adjusted and the finish refined. Finally, the white pot resting on the white floor was drawn in in less detail in order to emphasise the palm itself. Shadows were added and reflections on the shiny floor were suggested. The drawing was made in two sessions and took roughly fifteen hours to complete.

DRAWING AN ANIMAL

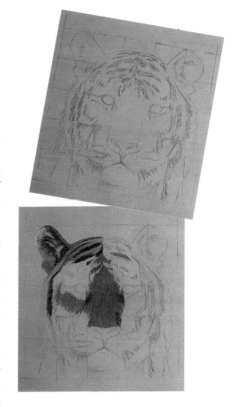

THROUGHOUT HISTORY MAN HAS HAD A COMPLEX RELATIONSHIP
WITH THE ANIMAL KINGDOM. Animals have been seen variously as a
source of food, as companions, as beasts of burden, as a means
of transportation, as creatures to help us fight our wars, as the object
of sports and as helpers in the pursuit of those sports, as providers of
amusement, as sources of clothing and a myriad other things. At one
time or another, all of these have been the subject of works of art.
Animals have also been seen as embodying attributes that our race
has coveted. Mankind has always sought to be as sharp-eyed
as a hawk, as courageous as a lion, as cunning as a fox, as swift as a
stallion, as graceful as a swan, as ferocious as a shark, as gentle as
a lamb or as wise as an owl. Accordingly, we name our cars, war
machines and sporting teams after them in the hope that these vir-
tues will attach themselves. As if these qualities were not enough,
man has gone on to imagine an entire bestiary of mythical beasts –
dragons, unicorns, centaurs, harpies, phoenixes, gryphons,
sphinxes, manticores, mermaids, wyverns and cockatrices, to name
but the most obvious. These can be drawn by looking at the original
animals that inspired them and combining them in one image, such
as a man, lion, porcupine and scorpion to form a manticore or an
eagle and a lion to form a gryphon.

It is unlikely that an animal will be drawn life sized and great fun
can be had, for instance, by drawing insects very large. The scale of
very big animals can be enhanced by making them fill the sheet of
drawing paper. It is normally only possible to draw animals in action
with the aid of photographs, but it is rarely a good idea simply to
copy this image as it will be unlikely to contain enough information
to make a credible drawing. One should therefore compose the
drawing using as many photographs of that animal as are necessary
– one might provide sufficient information to depict the head, another
the body, a third the colouring and so on. When using photographs
it is likely that the proportions will be distorted by foreshortening –
the tendency of an object to appear squashed up because it is being
viewed from an oblique angle. For example, if you were to look up
at a camel from a viewpoint beneath it the neck and head would
appear disproportionately smaller than the rest of its body and the
legs and feet abnormally large owing to the variations of apparent
size caused by its relative distance from the viewer. A camera lens

*Not having a tiger handy this
drawing was made from
photographs. One photograph
supplied the basic form and was
squared up and the principal
elements of the image copied on to
a sheet of brown Ingres paper with
charcoal.*

*Another photograph was used as a
guide to the colouring of the tiger
and the predominant colours were
then boldly blocked in using soft
pastels in one section to ascertain
their value against the tinted
paper.*

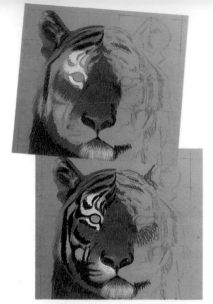

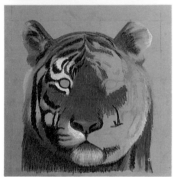

always aggravates this tendency. This would need to be taken into account and compensated for if you were to add other animals or backgrounds taken from other photographs with different points of view. Nowadays the enclosures at zoos often confine creatures to a state of relative inactivity, and it becomes fairly easy to make quite involved drawings from life there.

Bear in mind that a leaping animal or one in other obvious motion will look best if it has a visual space into which it is moving rather than being strictly centred on the sheet. Any such dramatic feature in a drawing will naturally serve as a focal point and the rest of the composition can be created around it. If the drawing is to feature a group of animals then one should be treated in such a way as to arrest the eye and draw the viewer into the picture. This can be achieved by making it bigger or bolder, by emphasising its colour, by positioning it on a golden section line, by directing the attention of the other creatures in the picture towards it or by isolating it from the group in some way.

When drawing an animal in its natural surroundings remember that its patterning and coloration have often evolved as camouflage and this fact can be exploited by the artist. Whereas a photograph will record the apparent effect of this camouflage, rendering the creature indistinct, the eye and the hand of the artist can discriminate and depict the subject more clearly. Done well this will reveal both the form of the animal and also convey the idea of concealment in its natural habitat. As with plants the pattern value inherent in certain animals is also worth exploiting. The stripes and spots of the large cats, the markings of zebras and giraffes, the variety of the patterns of fish, the distinctive plumage of birds and the multiplicity of form and colour in the insect world all provide an abundance of shapes and patterns that cannot but prove inspirational to the artist.

Once again, select your medium to sympathise with the creature that you have chosen to depict. Wash and pastels will prove a good choice to express the silky quality of soft fur, the dustiness of charcoal or chalk might be a good choice to render desert creatures, while I find that the precise quality of line that can be achieved with pen and ink or hard pencil is ideal for drawing feathers and scales. It is sometimes a good idea to make such a drawing on paper of a similar colour as the animal, such as a tiger drawn in sepia on a ginger brown sheet and enhanced with the careful application of orange, yellow ochre and black, or a salmon in various shades of blue, purple, black and white on grey paper.

If you seek out the work of the many artists who have used animals as their subject you will see just how diverse their treatments have been. Among those that I would recommend studying are Delacroix,

This process was continued and the white around the eye and the pink of the nose aided this assessment further. Shadows and modelling of the form began to be added, still using the pastels in a broad manner.

More of the same as one half of this symmetrical composition was blocked in and evaluated. At this stage this half of the drawing received a light coat of fixative to reduce the risk of smudging. The pastels began to be blended together with a large torchon and enhanced or subdued in value. The second half of the composition began to be blocked in using the pastels in the same direction as the growth of the animal's fur.

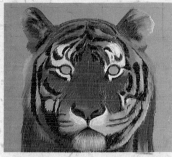

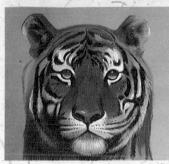

Dürer, Gainsborough, John, Landseer, Lear, Moore and, possibly the greatest animal painter of all, Stubbs. If you are attracted to drawing animals as a group then try to emulate the exuberance of the jungle scenes of Rousseau in his so-called *Mexican Pictures* (actually he never travelled outside of his native France and these works are a triumph of the imagination) or Uccello's *Hunt in the Dark Forest,* which I consider the greatest hunting image of all time. Fantastic or mythological subjects are often ideal 'hooks' on which to hang an animal picture, and such stories as Noah's Ark, The Garden of Eden, The Legend of Orpheus and the fables of Aesop all offer rich possibilities for pictorial compositions. The pets of such artists as Hogarth, Hockney, Manet and Steinlen have also provided inspiration, and the best of these rise above the sentimentality that is the most dangerous trap with this subject.

This process continued until all of the basic image was down on the paper. The lights and darks were further adjusted towards their final values. At this stage it was again lightly sprayed with fixative. Blending with the torchon continued, always following the direction of the fur, and other unblended lines were added to emphasise this quality. The eyes were put in, highlights added and the symmetry of the composition adjusted.

The modelling and shadows were then reassessed and the latter deepened to make the front of the face advance. The fine lines of the whiskers were flicked in with the edge of the pastel, and finally the finished drawing was cleaned and received three coats of fixative. The drawing was made in one session and took about nine hours to complete.

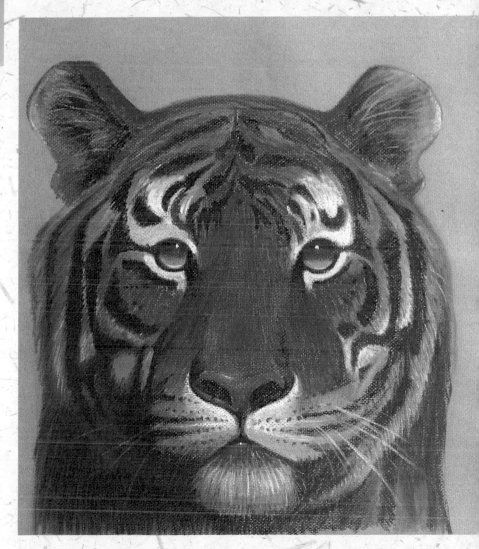

EXERCISE FIVE

A LANDSCAPE

IT IS SELF-EVIDENT TO ANYONE WHO HAS EVER SPENT A LITTLE TIME THINKING ABOUT ART THAT PICTURES AS WELL AS BEING REPRESENTATIONAL IMAGES ARE ALSO EXPRESSIONS OF, AND INVESTIGATIONS INTO, THE MYSTERIES OF THE WORLD AROUND US. This is possibly more true of landscape than of any other subject and it is often used as a metaphor by artists to evaluate man's relationship to the rest of creation. Such images are rarely solely topographical. In the works of Palmer and Turner this sentiment is writ large, and this should be the ultimate goal of every landscape artist.

Landscapes are also responsible for colouring our perceptions of a place, and the best of these succeed in capturing the 'genius loci' or guardian spirit of specific locations. We cannot look at Venice without seeing it through the eyes of Canaletto, Suffolk through the eyes of Constable, the French Riviera through the eyes of Dufy, urban America through the eyes of Hopper, the Low Countries through the eyes of Ruysdael or Los Angeles through the eyes of Hockney.

The name 'landscape' probably conjures up an Arcadian image in the mind, but this need not be the case as this subject can include any large-scale outdoors scene. Nor is it the obviously beautiful that is the subject of a landscape in every instance, as it is part of the artist's job to redirect our attention towards beauty that has been veiled by negative associations or obscured by convention. Artists such as Lowry have opened our eyes to the beauty inherent in decrepit industrial scenes, and others such as Cadmus and Hogarth have chosen to depict the seamier side of life in the city.

Landscapes are sometimes created in the studio from sketches made previously, termed 'pochades', but it is much more common for them to be drawn from life out of doors (called 'plein-air' drawing or painting), which creates problems of both a practical and technical nature. Unlike a still life the elements of a landscape composition are not amenable to being arranged by the hand of the artist and therefore you will need to choose your scene and the way you wish to draw it with care. When you have decided upon your viewpoint there are certain things that must be taken into consideration, such as the weather and the problems of making a drawing in rain, heat or a strong wind, the need to have *all* of the tools and materials that you are likely to need with you, some form of refreshment to take you through a long day's work and whether you need permission to

This drawing of a rock column in Bryce Canyon, Utah, was made from specially taken photographs, to capture the effect of the early-morning desert light. The first marks define the over-all shape of the central rock and the surrounding landscape.
The inspiration for this work was the stark contrast between the deep shadows and the sunlit rock in the clear air. These shadows were made with a soft 4B pencil and some intermediate tones were drawn in using a torchon that had

acquired enough graphite during the course of blending these black areas to have become a drawing instrument in its own right.
The dark shadow down the entire side of the column was blocked in and then blended to achieve a deep mid-tone, which then had even deeper areas of shadow added with unblended pencil.
More shadow tones were added using various combinations of 4B and 2B pencils and a torchon. The shadows were depicted with a hard edge where the rock planes appeared to change abruptly and shaded with a soft edge where this change of surface orientation was more gradual.
Cracks and crevices were put in with the sharp points of 2B and HB pencils. Shallower folds and depressions were suggested with the softer marks left by a graphite-loaded torchon.

be there sketching in the first place. If you intend to make a drawing with a fluid medium such as wash, then your paper will need to be stretched before leaving the studio. It is a good idea to stretch paper on both sides of your drawing board so as to allow for accidents or to make a second drawing. It is wise to make a list of all foreseeable eventualities and their solutions before venturing out into nature.

Any medium can be used to make a landscape drawing. If you have developed a particular feeling for one medium then you will probably feel most confident to continue using it, otherwise a medium can be selected to complement the landscape that you wish to depict, whether it be lush and verdant, dry and craggy, soft and misty, wild and windswept, mottled with shade and so on. Although there is no strict rule (like everything else in art) it is likely that a landscape will be made on a sheet of paper with the long edge horizontal. This format is known as 'landscape'. Take some time before putting any mark on the paper and look very hard at what you are about to depict. Regard it carefully as a series of shapes. Note the large shapes formed by objects grouped together rather than the minutiae of things – woods and forests rather than individual trees, towns and villages rather than single houses, crags and hills rather than their constituent rocks, the entire tracks of rivers and roads across the section of the scene that you have selected to draw and so on. Later on in the course of the drawing these shapes are broken down and their individual parts delineated.

The first, and simplest, decision to make is the position of the horizon, and if this is drawn to coincide with a golden section line then the paper is divided into land and sky according to a harmonious proportion and the composition is begun. The sky is likely to contain the strongest expression of mood in the picture and a dark, stormy sky will impart a sense of drama, while a placid sky with a few fleecy clouds a sense of calm. Unless you are drawing your landscape in some hot, exotic latitude try to avoid a clear sky which might lack the visual interest that clouds convey so well. Next plot in the large elements that you mentally noted when looking at the scene, all the while measuring their proportions and positions with regard to the other elements in your composition. At this stage no mark is final and you are free to add, subtract and alter each element as you proceed, weighing them all against each other as the drawing progresses. Look at the pen-and-ink drawings of the South of France by van Gogh as an object lesson to see just how a master tackled this subject.

If your composition includes angular objects such as buildings, industrial machinery or other man-made structures then you will need to use perspective, and at this point it will be instructive to

reacquaint yourself with its principles as outlined in the relevant section of this book (see page 29). Aerial perspective will almost certainly be applicable to a landscape drawing, and the extent to which the scene becomes progressively paler and less distinct with the distance depicted will depend on the atmospheric conditions prevailing at the time and at the specific location that you are drawing. A drawing will be likely to take many hours or even days to complete and you will find that during this time the light will change in quality, intensity and position, a problem to be faced by all landscape artists. Each will adopt his or her own tactic for dealing with this, either by drawing each day only during certain hours and returning each day until the drawing is finished, by 'averaging out' the passage of the sun or by using specially taken photographs as an aide-mémoire to capture a particular atmospheric effect.

A landscape will always need some device to impart a sense of scale. A human figure is the best, if most obvious, such device, but this need not be expressed in a direct way. For instance, we all know that a doorway is a little taller and a little wider than human stature. All of these considerations, together with insight gleaned from careful observation and sensitive handling of the chosen medium, will contribute towards creating a successful landscape drawing.

The sky was freely blocked in using the side of the lead of a 2B pencil and then carefully blended together with a large torchon until it was deep enough in relationship to the darks and lights of the column.

The shadows of the rock wall in the background were even deeper even though this contradicted the principles of aerial perspective and was due to the clarity of the dry air and reflected light from a neighbouring rockface.

All of the tones were constantly adjusted during the course of making the drawing as each new area of shading added modified the areas already down on paper. The texture of the small rocks on the trail that helps to lead the eye into the composition was added, before the image was finally fixed. The drawing was made in two sessions and took twelve hours.

EXERCISE SIX

AN ARCHITECTURAL STUDY

ARCHITECTURE IS ONE OF THE ORIGINAL FINE ARTS ALONG WITH MUSIC, POETRY, PAINTING AND SCULPTURE, EVEN IF TODAY ITS PRACTICE HAS BECOME SADLY DIMINISHED BY EMPHASIS PLACED SOLELY ON ITS UTILITARIAN, FUNCTIONAL OR COST-EFFECTIVE ASPECTS. Modern buildings need not be banal but often are; there are of course noble exceptions. This has probably been a *cri-de-coeur* throughout civilisation, but thankfully bad design does not have the longevity of good and is unlikely to be preserved beyond its commercial usefulness. The durability of architectural materials means that there are enough beautiful structures about, in both a pristine and a ruined state, to provide ample subject-matter to inspire the artist.

Buildings are vast like Chartres Cathedral and buildings are small like a crofter's cottage. They are intact like the Eiffel Tower and they are in ruins like the Parthenon. They are simple in form like the great pyramids and they are complex like an oil refinery. Whatever your abilities as an artist there is bound to be some sort of architecture that matches them. If you need inspiration beyond such works of art themselves then find examples of how artists throughout history have depicted architecture. Canaletto painted almost every imaginable aspect of the grander vistas of Venice; ironically, these were the picture postcards of their day and were bought by the wealthy making the 'grand tour'. Piranesi did the same for Rome with his stunning engravings of the city's ruins. Study the works of Pissarro to see how the streets of Paris looked at the end of the last century and those of Hopper for a unique taste of early-twentieth-century urban America.

Vernacular architecture uses materials like thatch, adobe, logs and peat, but most building materials are hard and fashioned into straight lines which are best rendered with media sympathetic to such fabric like pen and ink and the harder grades of pencil. Please note that this, like all of the advice in this book, is expected to be disproved by the dexterous or imaginative! New or otherwise pristine buildings may look best executed on smooth paper, but the use of tinted or textured papers might better express the weathered quality of time-worn materials.

Select the view that you wish to depict in your drawing and begin by intense observation for as long as you feel is necessary in order to

There were in fact two false starts to this drawing as unsuccessful experiments were made with other media to attempt to capture the elusive quality of this old stone building. It was finally decided to create it using wash applied in a number of different ways. A sheet of heavyweight not paper was selected and the main planes of the building drawn in in pencil using three-point perspective.

The edges of the drawing had been defined with masking tape before the principal foreground areas were masked off and a texture suggestive of weathered stone applied as a spatter with a toothbrush. This spatter was repeated several times from different directions until the desired depth of tone had been achieved.

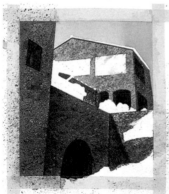

Large, simple areas were masked off using low-tack masking tape, but finer, more complicated shapes were masked with masking film. The tone of the sky was laid quite simply with wash of the correct dilution. The dark areas were similarly put in using the undiluted liquid water-colour from which the paler tones of wash had been derived.
The reflection of the sky in the windows was also applied as a conventional flat wash with a sable brush. The window-sills, window-

comprehend visually the nature of what you are observing. Strive to see it as opposed to merely looking at it. Only when you are satisfied that you have absorbed enough visual information should you commence drawing. The format, whether landscape, portrait or any other shape of paper, will have suggested itself by the nature of the over-all shape that you are drawing and your first marks should indicate the relative positions of the major horizontal and perpendicular lines.

Nearly all buildings are angular and unless you have made a conscious decision to depict the subject in a wholly decorative manner or by the use of conceptual, parallel or reverse perspective you will need to use linear perspective to render it successfully. Remember that all parallel lines – and architecture employs endless combinations of them – will seem to converge towards a point or points on the horizon termed the 'vanishing point'. A simple rendering of a building will utilise a single vanishing point (one-point perspective), while the same structure seen from an oblique angle will need the use of a second vanishing point (two-point) to describe it. If your chosen viewpoint is either very high or very low then a third must be added (three-point) to render it successfully. If you have not already done so, try out each of these approaches to the problem of rendering three-dimensional space on a flat surface on a spare piece of paper to investigate how they will apply to the subject that you have chosen. Use your pen, pencil or whatever as a measuring device to ascertain the proportions of the various elements in the subject and then gauge the proportions of one part of the building against another as a further indicator of their relationship to one another. You may judge that line alone is sufficient to create a true picture of the building or you might feel that the inclusion of tone (in the form of shading or cross-hatching in the case of pencil or pen and ink) is necessary to give a sense of the massiveness of the structure. To assess this first observe the over-all way that the subject is lit, with light falling on it from one direction lighting one face strongly, others in semi-shade and the face furthest from the source of light in shadow, which will also extend to any adjacent building or across the ground that the subject itself occupies. Unless the structure is very simple in form there will probably be light reflected back on to it from architectural details and the more complex angles of the design. The quality, and colour, of the light itself will be affected by the time of day depicted, which will in turn alter the apparent texture and colour of the material of which the building is constructed.

It is not strictly necessary to define every nodule and curlicue of architectural details or each single brick in an extensive structure, and a form of 'shorthand' can usually be arrived at to convey this

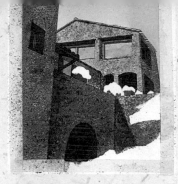

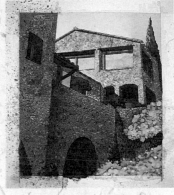

aspect of a building. Again, turn to the work of past masters to see how they solved this problem. The use of glass in a structure makes for interesting drawing as this obviously has a much more reflective quality than masonry. Everyone at some time must have seen a high-rise building with a multitude of windows seemingly full of sky and clouds or ablaze with the rising or setting sun. All buildings are made with humans in mind and there will be numerous indicators of scale, but if you wish you may also include figures in the composition to emphasise this or to act as a counterpoint to the angularity of the structure. The same applies to the inclusion of natural forms such as bushes and trees. Interiors of buildings are approached in essentially the same way and it is perhaps more advisable to include figures here in the habitable parts of a building.

By following these guidelines and by painstakingly observing the building you will be able to achieve a convincing drawing of a piece of architecture that fully conveys its solidity and relationship to the space that it occupies. Maybe even a work of art.

frames and lintels were painted on with a small sable brush drawn along the edge of a ruler, which was held clear of the paper surface.

The vegetation and foliage were then added with the cypress trees blocked in freely with modelling added with darker tones of wash once the first application was dry. The softer forms of foliage towards the foreground were made using a wet-on-wet technique where the dark tones were floated on to a wet middle tone and the paler areas lifted by blotting with the corner of a piece of absorbent kitchen paper. The small white areas used to suggest flowers on the softly treated bushes in the foreground were made by scratching them into the paper with the point of a scalpel blade. Excluding the false starts the drawing took eighteen hours to make over two and a half days.

EXERCISE SEVEN

AN IMAGINATIVE DRAWING

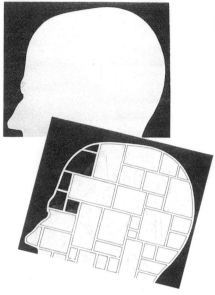

AN IMAGINATIVE COMPOSITION CAN BE ABOUT ANYTHING IMAGIN-ABLE AND THEREFORE THIS SUBJECT WILL REQUIRE THE APPLICA-TION OF MUCH MORE DISCIPLINE THAN ANY OF THE OTHER EXERCISES IN THIS BOOK. The individual elements of an imaginative composition will already exist in the world about us and it is the unexpected way in which they are combined that truly utilises the imagination. Reread Leonardo da Vinci's admonition to the artist printed in the front of this book and in particular the sentiment expressed in the final sentence, which provides the key to this mode of expression. Leonardo in his century did not have the advantage of photography or access to reproductions of the work of other artists from many cultures that we enjoy nowadays, and it is in no sense 'cheating' to seek inspiration or to incorporate elements into your work from these sources. When the artist sets out to depict something that already exists and is therefore familiar to everyone, he or she can concentrate his or her artistic energies on exploring different ways of representing it. When dealing with a product of the imagination that has never before existed outside the head of the artist much more attention must be paid to expressing it clearly so that the idea behind it is communicable to others. Here, *what* is being portrayed is more important than *how* it is being portrayed, although in practice neither can be entirely separated from the other.

Because of the infinite possibilities inherent in this subject it is not profitable, or even possible, to offer advice as to how to set about drawing something that only exists in your mind, although all of the advice given so far for the other subjects in this book will, I hope, prove valuable. I will attempt, however, to try to give some advice that I, and others, have found useful in creating pictures from the imagination.

Louis Armstrong, when asked the question 'What is jazz?', answered that if you needed to ask the question you would not understand the answer. The same is true when applied to the source of inspiration. Nobody can explain exactly where it comes from. It is a slithery and elusive beast and will often pounce on you at unexpected times in the unlikeliest of places. It is known to feed on nonsense, be attracted to the absurd, reside in proximity to a sense of wonder and be mortally afraid of logic. Even so, some artists have found a successful bait with which to trap this creature in the form of chance. The

The inspiration for this drawing was the search for inspiration itself. If one goes in search of it it invariably proves elusive. The work began life as a 'thumbnail' pencil sketch which helped to define the basic form and content of the drawing.

This thumbnail sketch was then transferred onto a sheet of Opaline paper at a larger size and the background drawn in with very fine four-way cross-hatching using a 0.1mm stylograph pen.

The drawing of the various rooms, or compartments, involved the use of one-point perspective, and guide lines for this were faintly drawn in with a hard 4H pencil. These marks would be lost as the drawing advanced.

The drawing progressed with the deepest tones made with closely spaced four-way cross-hatching,

and the progressively paler tones with three-way and two-way cross-hatching. The spacing of the hatching lines also contributed to the depth of the final tone.

The paler tones were achieved with straight forward hatching, that is closely spaced parallel lines in a single direction. As this medium is not especially amenable to eradication the basic forms of the stairways and apertures were faintly drawn in with fine pencil lines.

The three-dimensional effect was enhanced by additional cross-hatching where the extreme foreground of the white grid pattern met the background of the far walls of the compartments. The very darkest tones were made by multiple cross-hatching in many directions.

This process continued until the drawing neared completion. Right up to this point it still wasn't clear to me just what image I might use

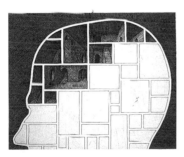

Surrealists played a collective game called 'Cadavre exquis' (exquisite corpse), where artists took turns to draw on a sheet of paper which was then folded so that the next in line could not see the previous part of the image. When they had all participated the paper was unfolded to reveal the entire picture for the first time, rather like a visual version of the party game of 'consequences'. These drawings were always remarkable, often startling and sometimes art.

I stumbled across an interesting idea recently when I was looking up a word in a dictionary. My 'reality control' is often turned down very low when I am working and in this state my concentration is apt to wander. On this occasion my eyes strayed to the running index at the top of each page and I was delighted to find wonderful associations that were sparked off by what I read there. I encountered an abusive accipitrine, an airworthy alevat, an anterior antigen, an apologetic appetiser and an avocet azimuth, all before I left the letter 'A'.

A great sense of play is evident in the works of the sixteenth-century Italian painter Arcimboldo, who created portraits from collections of unlikely objects. What appeared at close quarters to be a pile of fish, when viewed from a distance turns out to be a totally convincing and somewhat disturbing head of a man. He created similar portraits from groups of animals, trees, vegetables, books and all manner of other objects unconnected with the art of figure painting. The technique of combining or otherwise juxtaposing unlikely objects is a valuable way to enter into the spirit of imaginative art, but its secret lies in sensitivity, restraint and a finely tuned sense of incongruity. This element of perversity – deliberately setting out to stand the world on its head – is a priceless attitude for the artist to cultivate.

The Surrealists also practised automatic drawing, rather like the automatic writing of the spiritualist, where one moves one's hand without any aim in mind to create an image that is supposedly delivered straight from the unconscious. Dominguez developed the technique of 'decalcomania' described previously, where a non-absorbent sheet of paper or glass was covered with paint and, while still wet, a sheet of drawing paper was applied to it and immediately peeled away to leave a random pattern that served to set the imagination racing with the partially suggested images. These were then elaborated with conventional artistic techniques into often strange and wonderful pictures.

Allegories will utilise imaginative images to convey their message through a code of symbolism and this has been so throughout the history of art. Mankind's baser instincts have often been depicted as devils and demons and his higher ones as angels. I have already

discussed the more accessible symbolism attached to certain animals, plants and colours, and there are a wealth of additional symbols to be found in archetypal images such as the sun, moon, stars, keys, doorways, flames, eggs, chains, skulls, labyrinths, anchors, masks, hearts – the list is virtually endless.

There is also endless fun to be had playing visual games with scale. Making small things very big, as in the work of Oldenburg and Magritte, or big things very small, as in the work of Steinberg and Chagall. There is equal fun to be had by the use of visual 'puns' (for want of a better word). A verbal pun will create an extraordinary idea by the substitution of a homophone, while a visual pun will substitute a similarly shaped image in place of another to make us re-examine our notions of reality. A visual pun is harder to achieve than a verbal one and nowhere near as flippant.

Some artists have founded their reputation on the perfect melding of disturbing ideas in a single image such as Dali's soft watches, Ernst's bird-headed men or Oppenheim's magnificent fur cup and saucer. The only rule in art is success – all of the other rules are there to be broken. All of these techniques and any others that come to mind can be used in what has been called 'the pursuit of the marvellous'.

to symbolise the inspiration that I sought. The decision was made to leave the grid dividing the compartments white to exploit its pattern value and to save the drawing from becoming too sombre.

I eventually decided on an irregularly shaped and living image to complete the final compartment as a deliberate contrast to the hard, angular forms surrounding it. I drew this paler than the adjacent areas to attract the eye. This drawing took twenty-two hours to make over three days.

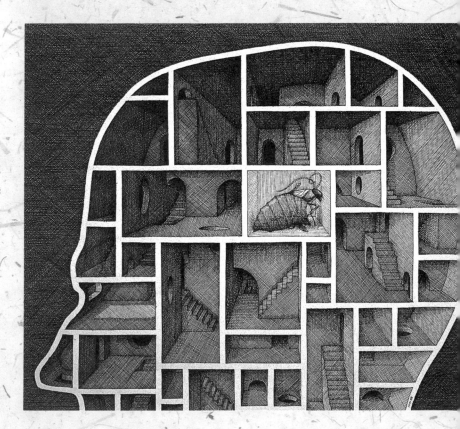

Estuary, *1977, by Mike Wilks.*
Whereas a pun is a play on words a
'visual pun' (for which no real
name exists) makes correspondence
between shapes and/or ideas. This
principle is used here to create an
ambiguous image.

COPYING

THIS PROJECT COMPLETES THE CYCLE OF EXERCISES IN THIS COURSE AND IN SOME WAYS HAS THE PARADOXICAL QUALITY OF BEING BOTH THE EASIEST AND MOST DIFFICULT FOR THE BEGINNER. I have awarded it last place, but it could equally well be the first. The idea behind copying is not the negative one of fakery or forgery or, worse still, plagiarism, but the positive one of catching a glimpse of the world, however fleetingly, through the eyes of a genius who has perceived some of its essence and who had the skills necessary to express a sense of wonder at it all.

Deliberately copying the work of great artists is perhaps the oldest academic technique for learning to draw. This was the way that all of the old masters would have acquired their skills in the early part of their careers. Part of my own early training included this and I can vouch for its efficacy as a method for learning to see. Art galleries were once full of young artists learning about art and acquiring their skills by making detailed copies of the works of the masters, and the National Gallery in London originally shared premises with the Royal Academy, whose students used the adjacent collection for just this purpose. Sadly, this approach is unfashionable today, and ironically, the last smell one would expect to encounter among any collection of great works of art is that of oil paint.

Unless you are unbelievably fortunate it is unlikely that you will have a great work of art in your home and you will therefore need to make your copy either from an original in a gallery or museum or, as is more likely, from a reproduction. The proliferation of reproductions of great works of art from the hands of many masters from many cultures is one advantage that we enjoy today and that would have been beyond the wildest dreams of earlier artists. The best reproductions will be the kind of high-quality gravure or lithograph commonly available in the shop attached to a major art gallery or museum. A print bought here has several advantages. Firstly, the picture is likely to be represented in the collection, so it will be possible to study the original at first hand if it is on display. If you can, compare the colour and definition of the print against the original, as even good-quality printing is bound to lack fidelity in some respect, most probably in the colour. Secondly, the picture may be reproduced in its original size. The size that an artist chooses to make an image is critically important and often the end result of much

This copy was to be of **The Condottiere** *by Leonardo da Vinci. A high-quality reproduction in an art book was overlaid with a sheet of transparent acetate and a grid of squares was drawn on it. A similar grid was faintly drawn in pencil at a larger size than the reproduction on to a sheet of beige Ingres paper and the general outline and main elements drawn in by copying them square by square from the book.*
A sheet of clean paper was placed under the drawing hand to prevent smudging of the image as it progressed and perspiration stains from marking the paper. The warrior's helmet was drawn in using three grades of pencil – 4B, 2B and HB.

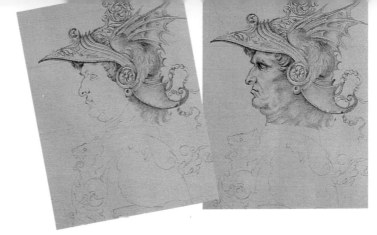

As the drawing progressed the initial pencil marks, which were at first rendered boldly, were refined and they began to be blended together with the aid of a torchon. Any excessive use of this was compensated for by removing unwanted areas of tone with a piece of putty rubber kneaded into a point.

The face was achieved with the same combination of pencils, torchon and putty rubber, always referring constantly to the reproduced image alongside. The original drawing was over 450 years old and exhibited a number of extraneous marks and stains, which were ignored in the copy. At this point the drawing was lightly sprayed with fixative to reduce the risk of smudging and the sheet of paper that was used to protect it was changed as it had acquired an amount of graphite dust.

thought and experimentation. If the image that you have chosen to copy is Leonardo's Mona Lisa or van Gogh's sunflowers this should be entirely possible, but if you have chosen Michelangelo's ceiling in the Sistine Chapel you will have to settle for a reduced-scale print. Thirdly, it will be possible to purchase two copies of the print, which will greatly aid you in this exercise. If this option is unavailable to you then a copy made from a reproduction in a high-quality art book that can be borrowed from a public library will suffice. It will in any event prove easier to find reproductions of drawings, as opposed to paintings, in this form.

How do you choose a subject from the vast treasure house of art? If you have decided to tackle this exercise towards the end of your course of study then in all likelihood you will have by now come to prefer one medium over another, and this will aid you in your choice. Similarly, your temperament will have asserted itself. If you are the kind of person who relishes fine detail or the kind who thrives on spontaneity your selection process will have been narrowed further. In any event your interests will play the major role in choosing a subject, be it portraiture, landscapes, still life or whatever.

All of the advice in the previous exercises is applicable to this one. Some people will find it a definite advantage to be working from a flat image, and there are several ways to arrive at your own drawing from this point. If you are especially skilful and confident, then this can be attempted freehand, but even a proficient draughtsman will make a great many mistakes although he or she will learn an enormous amount in the process.

Contrary to what the inexperienced might expect, the most difficult method will be to trace the image. Tracing paper is a particularly unsympathetic surface on which to draw as a pencil is inclined to skid easily, any complicated series of marks will inevitably deform the material rendering the copy inaccurate, there is a mental reluctance to alter any marks made in this way as one erroneously 'knows' they must be right and the triple act of tracing, transferring and redrawing any image will tax the skills of all but the most exacting of draughtsmen.

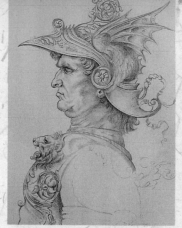

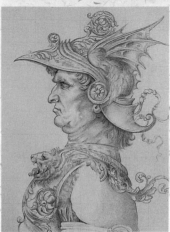

In my opinion the best approach is to copy the drawing with the aid of graticulation. This technique has been dealt with in the section on composition (see pages 22 and 23) and outlines how an image is 'squared up' by drawing a number of fine pencil lines over it and the corresponding number on the sheet that the final drawing is to be made on. The information in the squares is then copied on to the new sheet piece by piece until the entire image has been transferred. If you have a duplicate reproduction then these lines can be ruled directly on to it, but if you do not, or if you are using a library book, then such a grid drawn on to acetate (draw-film) can be attached to the image with 'low-tack' masking tape that will not damage it when it is later removed.

Some element of translation will be necessary in making your copy. For instance, many of the materials that were used to create the original works are probably not available today, and if they are, a modern, more practical alternative will prove easier to use. Therefore a silverpoint drawing can be copied using pencil, a sanguine

The copy began to near completion as the remainder of the image reached its final tonal values, which made it easier to assess the tonal quality of the drawing as a whole. This was adjusted and the darks made darker and the lights lighter.

When the balance was felt to be correct the completed drawing received a final liberal coat of fixative. The drawing was made in three sessions and took approximately twenty hours to complete.

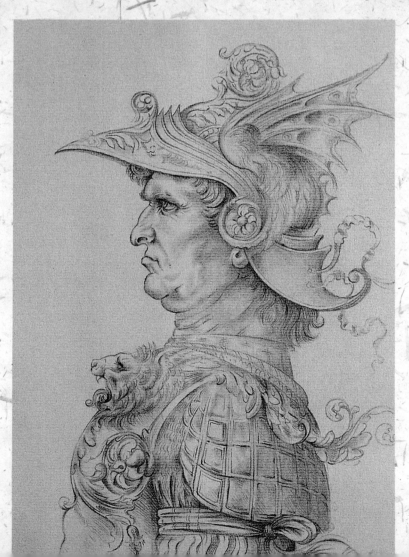

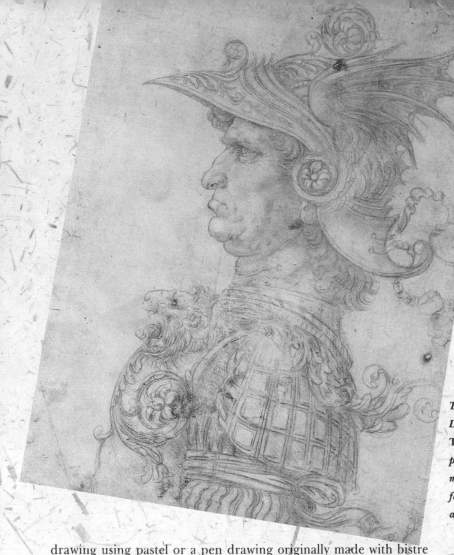

This silverpoint drawing by Leonardo da Vinci is known as **The Condottiere** *and depicts the profile of a warrior with a magnificently stern and expressive face wearing a suit of fanciful armour.*

drawing using pastel or a pen drawing originally made with bistre can be copied using a modern synthetic ink of a similar hue.

Just for fun you might care to age or 'distress' your finished drawing artificially. Easy ways of going about this are to give it a coat of mastic varnish and accelerate its drying by holding it in front of a strong heat source, which will have the effect of shrinking the varnish and causing the characteristic 'craquelure' often seen in antique works. Contrary to my previous advice, a drawing left for a period of time in the sun will degrade, giving it a phoney patina of age. A hilarious faking technique was practised by the late Tom Keating, who would toss a spoonful of instant coffee at a dampened drawing as a way of artificially creating the appearance of 'foxing', a kind of brownish mould that is often seen on old pictures.

When the drawing is complete you will have the most demanding criterion with which to assess its success by directly comparing it with the object from which you are copying. This will inevitably be a depressing experience, but the amount that you will have learnt in the process will make it all worthwhile.

THE WAY
FORWARD

Fall, *1963, by Bridget Riley (1931–). This quintessential 'Op Art' image exploits the inability of the eye to rest when confronted with the stimulus of closely spaced lines.*

OPTICAL ILLUSIONS

REMARKABLE THOUGH OUR FACULTY OF PERCEPTION IS IT IS NOT PERFECT AND IT IS RELATIVELY EASY TO FOOL IT BY PLAYING SIMPLE TRICKS. This is also fun. Optical illusions are not a phenomenon of our technological age and man has always had a tendency to see some things not quite as they really are. Ancient man would have looked at the moon and wondered why it seemed bigger when it was near the horizon than when it was overhead. In our technologically advanced era we know that it should in fact appear smaller as it is that much further away from the observer as it rises, but scientific measurement tells us that it is about the same apparent size in each position. This paradox has been explained as being due to an absence of comparison when it is at its zenith or to the atmosphere being thicker when viewed obliquely and acting as a lens. Neither explanation has been proved conclusively.

The artist has used this inability to perceive the truth in certain situations with a movement termed 'Op Art' that thrived in the 1950s and 1960s. The works of Riley perform dazzling effects by exploiting the inability of our eye to remain still when confronted with cunningly rendered achromatic lines and forms, and Vasarely has pursued much the same goals with the use of often beautiful colours. An offshoot of this movement called 'Kinetic Art' used moving phenomena, such as can be seen in the works of Soto and Cruz-Diez, to create its unsettling effects. The Dutch artist Escher had a profound understanding of the nature of our perception of perspective and used his considerable skills to create pictures that contradicted our accepted notions of reality such as staircases and

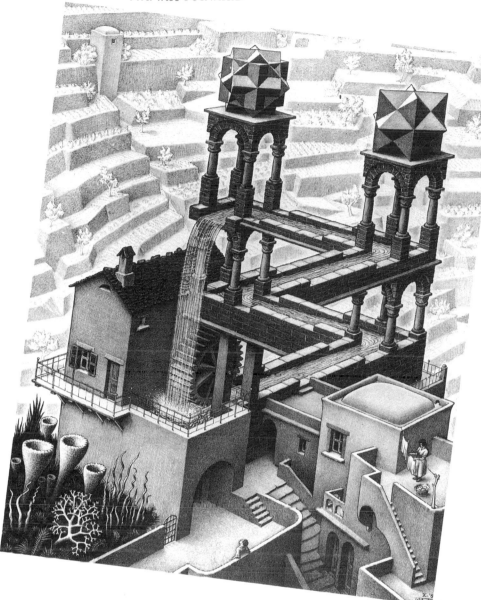

Waterfall, *1961, by M. C. Escher (1898–1972). This image confounds our sense of reality and throws into doubt our ability to perceive correctly. It is the result of a profound understanding and manipulation of linear perspective.*

rivers that forever travelled downhill (based on the Penrose illusion), buildings that occupied impossible spaces and images that blurred the boundary between reality and art.

Trompe-l'œil art is often employed in interior decoration to adorn wall panels with images of collections of objects rendered in such a way that they actually seem to be hanging from the surface in front of you. To achieve this effect everything is enhanced. The colours are brighter than normal, the images are highly defined and the shadows are more intense and painted in exactly the position that they would adopt from the ambient lighting. These pictures are wonderfully skilful visual games, but they can only ever depict shallow spaces and be used indoors in highly controlled conditions and are

vastly easier to render with the flexibility and chromatic range of paint. The use of this technique will therefore always be limited. The small-scale works are often very convincing when seen from certain angles. Grander examples of this specialised art form were less tricky and used in interiors to turn entire rooms into fantasies that sometimes even included a view of the gods looking down into the room from above. Perhaps the greatest exponents of this art were Tiepolo and Veronese.

Optical illusions are understandably of as much interest to the psychologist as they are to the artist and many of them bear the name of the scientific researcher who first isolated and recorded the particular phenomenon. Among the most common are those that fall into the general categories of either the field and ground illusions (the 'now you see it, now you don't' variety) or those that deal with our perceptual set and confound what we expect to see. All of them are highly interesting and some are actually worth considering when creating imaginative compositions. Dali exploited many of them – initially for legitimate artistic reasons rather than for their novelty – and their appeal obviously contributed to his enormous success.

Frontispiece to 'Dr Brook Taylors Method of Perspective Made Easy' *by Joshua Kirby, published in 1754. This image by William Hogarth (1697–1764) is a veritable catalogue of what not to do and thus plays wonderful games with the conventions of perspective. Ironically it makes the picture much more interesting than if he had obeyed all of the rules in making it.*

KEEPING A SKETCH BOOK

TURNER, CÉZANNE, DÜRER, LEONARDO, MATISSE, CONSTABLE, DELACROIX, REMBRANDT, PICASSO AND BONNARD ALL KEPT SKETCH BOOKS OF ONE KIND OR ANOTHER. Other artists have chosen not to. Once upon a time I kept a sketch book religiously, but now I feel that it should not be a compulsory activity and its usefulness will depend entirely on the type of artist that you are. You may care to carry one in your bag or pocket at all times to record ideas as they occur to you, or things, places and events that you encounter in your life. Such notes can be in the form of images or words and there is certainly nothing to stop you mixing the two together in the form of a visual diary. Indeed, the finest examples of sketch books that have survived from the past are often just this and provide a fascinating insight into the lives and creative processes of the artists who kept them.

Sketch books are widely available from artists' supply stores and come in a variety of styles and formats containing different kinds of paper. The type of binding that you select is also a personal matter. Some are bound along their long edge and some along their short one. There are books with stitched binding, others with spiral binding and some have the pages glued to the spine (perfect binding). The

paper can be cartridge, Ingres or water-colour, but unless you favour one particular medium for sketching then I suggest that you choose a smooth paper that will take many different kinds of media. Be sure that the backing board is sturdy so as to provide a firm support on which to draw. Some artists like to keep an elastic band with their sketch book which can be used to keep the page in place, especially if it is large, when sketching in a windy spot. You can also use your sketch book rather like a scrap book and paste things into it.

It is unlikely, but if you should find the commercially available sketch books inadequate for your particular needs then it is a relatively easy matter to make your own using your preferred type and size of paper. Simply cut a number of sheets or even a selection of different papers to the size that you require and either insert them into a loose-leaf binder or leave them as separate sheets which can be collected together into a folder of a sufficiently heavy material as to give you a firm support on which to draw. Otherwise you can trim a piece of stout card to the same size as your papers to keep tucked in with them for this purpose.

The range of drawing instruments that can be used for sketching will be limited by practicality. It is not normally possible to make rapid notes in odd places with wash or a range of pastels and all of the accompanying paraphernalia that this often entails. Pencil, felt- or fibre-tip pens or pen and ink applied with a fountain or stylograph pen are the least complicated and therefore the most useful media for carrying around.

Except for the dilettante, sketching is never an end in itself and you will certainly notice details and insights that you have recorded in your sketch books finding their way into your more elaborate drawings. It is another form of nourishment to help you grow to maturity as an artist, and, as they accumulate over the years, an insight into your artistic progress and achievements.

THE WAY FORWARD

HOWEVER MANY OF THE PRECEDING EXERCISES YOU CHOSE TO COMPLETE I HOPE THAT BY NOW YOU WILL HAVE ARRIVED AT A POINT WHERE YOU WISH TO IMPROVE YOUR SKILLS FURTHER. It takes a long time to learn any art form and, unlike rock singers or athletes, artists are usually considered young until they enter their fifties. Charlie Chaplin once said that nobody lives long enough to be anything but an amateur. I endorse this fully. I can, however, suggest several ways of thinking about your work which may provide

valuable insight and help to point the way forward for you.

By this stage you will doubtless have encountered numerous problems associated with your work. If your principal problem is an inability to draw well then the solution is simple if lengthy: practice. Every artist, amateur and professional alike, will encounter problems in the pursuit of their art. Those who are not prepared to meet and deal with them will not advance and their work will be full of the facile tricks that they have adopted to conceal this fact. One encounters their work every day. Rossetti offered ideal advice for anyone daunted by the prospect of the ever-receding nature of excellence. Dare to be bad. *This* is the way forward.

Another common problem is that of evaluation. You can show your work to friends and your family, but the quality of criticism that this is likely to elicit will almost certainly be unconstructive. Another artist would be more inclined to see and be honest about your shortcomings, but in the end you must be the final arbiter of what is good and bad, what must be kept and what destroyed and whether your general advancement as an artist is satisfactory. It is inordinately difficult, given the emotional commitment that went into it, to see your own work in an unbiased light, especially if you have invested a great deal of time in its creation. Faults are much easier to recognise in the work of others, but there are a number of ruses that can be used to distance yourself from your own work and see it in a different way. If you simply turn your drawing upside down all kinds of things that were previously invisible will become apparent. Just what these might be will depend on the particular inconsistencies in your work, but errors in composition and perspective will become especially evident. Another trick is to look at your work reflected in a mirror; this will tend to highlight errors of symmetry or a tendency (which I must confess to) for perpendiculars to lean in one direction. Once removed from the studio, a drawing will immediately look different, and if you put it somewhere where you can later come across it unexpectedly you will probably see in a flash just what needs to be changed to render a mundane work successful. Often the very fact of re-encountering your work after not seeing it for a while will enable you to see it in this new light.

Now there is a trap here. The real danger is that if you iron out all of the supposed faults in a work you are quite likely to iron out any character that it has as well and end up with just a bland record of the subject. It is impossible to offer concrete advice on how to avoid this without defining just what constitutes character in a work of art, and much more articulate people than I have made fools of themselves by attempting to do so. None has ever succeeded. If the personality of the artist is absent from the image then it merely becomes

Stairwell, *1989, by Mike Wilks. Pen and ink on paper. Sometimes our emotions can be expressed visually and this often has a therapeutic effect. Never ignore this as a source of inspiration.*

a stain on a piece of paper and a great waste of time and effort.

I have already written briefly about the ways in which the artist can mix media to create a drawing and I hope that you have taken an opportunity to play around with this idea. It is also possible, and sometimes good practice, to mix various techniques in one drawing. Wash might be applied with a brush, a sponge and an atomiser to create three entirely different qualities of mark within a single work. Ink is amenable to the same kind of treatment and felt- or fibre-tip pens can be used to draw simple lines, to stipple, to cross-hatch, to block in areas of solid colour, a wax resist can be used and, once made, the marks can be treated with water to create an extended vocabulary of marks within a single image.

The Hunting Party, *1986, by Mike Wilks. Pen and ink on paper. This drawing started out as an investigation into the work of other artists, but this was soon abandoned as it grew into this strange collection of creatures. Always follow where your fancy leads you.*

Large Drawing with Inscriptions, *circa 1970, by Vojislav Jakić. This splendid example of 'Art Brut' illustrates an altogether different way of perceiving the world around us.*

Not everyone wishes to draw in a realistic style, and the road to abstraction was paved by artists who felt this way. If this mode of expression attracts you then the key is simplicity. Begin by paring down the complex shapes that you observe in the world around you into ever-simpler ones. These can then either be reduced further to what you perceive as their very essence or elaborated from their basic forms in a different direction – at right angles to reality, if you like – to create something entirely new. The final goal of the abstract artist is to create a mark or set of marks in an image that has no reference to anything but itself. If this cerebral approach attracts you seek out examples of the works of Pollock, Kline, Mondrian, Rothko, de Kooning and Newman.

There are as many ways of creating art as there are artists. What has gone before in this book of necessity relates the ways in which artists of the past have gone about creating their pictures, but the artists of today are always seeking new ways of making images. 'Art Brut' (literally raw or unrefined art) is the name given to the work of (usually) untrained and often nameless artists who do not share the same psychological perspective as the rest of society and whose views of reality are therefore radically different. I am amazed, and humbled, by the inventiveness of the picture-making of these artists and if you, like me, are interested in seeing the world from altogether different points of view then I urge you to seek out examples of their work.

Probably the most common piece of advice given to anyone wishing to pursue the study of art further than can be encapsulated in the pages of any book is to enrol for a course of part-time study at an art school. This is not always necessarily sound advice as an art school is as capable of retarding the progress of some artists as it is of nurturing the progress of others. I profited immeasurably from my time spent there (particularly between the ages of 13 and 16), but other talents might be stillborn or otherwise hampered by such a training. Look at the work of artists of genius who never attended art schools and see if their work kindles a sympathetic spark in your soul before rushing off to sign up for a course of lessons. Rousseau, Bombois, Hicks, Hirshfield, Wallis and Wilson are usually termed 'naïve', van Gogh, Gauguin, Ernst and Bacon are unhampered by the description and all have made it into the history books with little or no formal training.

The pages of this book are littered with the names of many artists and we must all be aware of the art that is being made in the world around us as well as of that which has been made in the past. A close study of their work, and indeed of the work of any artists that you encounter, will provide much more inspiration and insight into techniques than this book, even at ten times its current length, could ever provide. If there is no easy formula for learning to draw then there most certainly is none for artistic success. This must always be measured on a personal scale. Comparisons with the works of the old masters are always dispiriting; comparisons with yourself are more productive. Look at your work and be honest. Discard that which is second rate and file away that which has ceased to inform your progress. Artistic advance is a never-ending journey of discovery, of redefining reality and of adjusting attitudes to acknowledge these new-found perceptions. Everyone is a potential artist and mankind has been described as an aperture through which the universe regards itself. Draw, dream, *see*. It is impossible not to be astounded by it all.

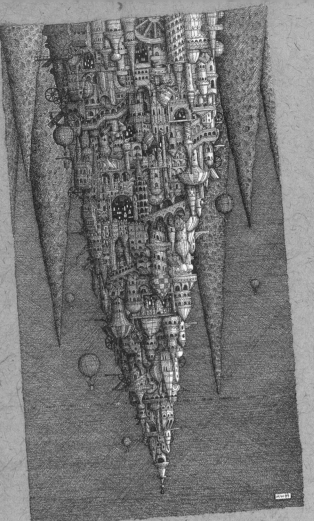

Stalactite, 1989, pen & ink on paper.

6 ARTISTS AT WORK

THIS SECTION FEATURES SIX CONTEMPORARY ARTISTS AT WORK ON A DRAWING OR PAINTING. The finished piece is shown together with some of the artist's thoughts and observations made during the course of the project.

MIKE WILKS

ONE OF THE GREAT VALUES OF ART IS TURNING THE WORLD ON ITS HEAD AND LOOKING AT THINGS FROM A COMPLETELY DIFFERENT POINT OF VIEW, SO YOU OFTEN SEE THINGS THAT YOU MIGHT NEVER EXPECT TO SEE.

99 OUT OF 100 ARTISTS WOULD SAY THAT THEY LIKE TO WORK ON LOTS OF BITS OF A DRAWING SIMULTANEOUSLY IN ORDER TO WEIGH ONE PIECE UP AGAINST ANOTHER AND ASSESS THE COMPOSITION AS IT GOES ALONG. WHAT I DO IS PROBABLY AN ODD WAY OF WORKING. HAVING DONE A PRELIMINARY, THUMB-NAIL SKETCH TO MY SATISFACTION, I WORK ON ONE SMALL AREA, MAYBE NOT MORE THAN A FEW CENTIMETRES SQUARE, AND FINISH THAT COMPLETELY. THEN I JUST MOVE ON TO THE NEXT BIT AND JOIN IT ON SO THE WHOLE THING WILL GROW RATHER LIKE AN AMOEBA DOUBLING ITSELF UNTIL IT COVERS THE WHOLE PAPER.

THE IMAGES THAT I DRAW ARE DIFFERENT FROM THOSE THAT I PAINT. THE DRAWINGS HAVE A DARKER FEEL ABOUT THEM, DARKER IN THE PSYCHOLOGICAL SENSE. WHEREAS MY PAINTINGS SEEM TO BE SUFFUSED WITH LIGHT, MY DRAWINGS ARE SUFFUSED WITH SHADOWS. MY SUBJECT MATTER IS OBVIOUSLY, AT ONE LEVEL, DEEPLY PERSONAL. SO DEEP THAT I CAN'T FATHOM IT — AND I DON'T WANT TO. IF I START ASKING MYSELF TOO MANY QUESTIONS AND BEGIN TO FIND OUT WHAT THIS THING IS, THEN IT'S GOING TO GO AWAY.

Maggie Hambling

A GOOD DRAWING CONSISTS OF THE RIGHT MARK IN THE RIGHT PLACE. IF YOU ARE DRAWING FROM LIFE, THAT MARK MUST BE DICTATED BY WHAT IS IN FRONT OF YOU: YOUR SUBJECT. THE IDEA IS TO GET SOME KIND OF ELECTRICITY INTO THESE MARKS THAT WILL GIVE BREATH AND LIFE TO THE PERSON TO WHOM YOU ARE RESPONDING.

DRAWING FROM LIFE IS IMPORTANT FOR ME BECAUSE IT KEEPS ME IN TUNE. IT'S LIKE A PIANIST PRACTISING SCALES OR A DANCER DOING EXERCISES. IT'S A SHOT IN THE ARM FOR WHEN ONE IS WORKING FROM IMAGINATION OR MEMORY.

Male Nude, 1989, graphite on paper.

ROY MARSDEN

PEOPLE TALK ABOUT BEING INTIMIDATED BY THE BLANK SHEET OF
PAPER, AND QUITE HONESTLY I USED TO BE, BUT NOWADAYS I FIND
SOMETHING ALMOST SEXY ABOUT A LARGE SHEET OF PAPER
THAT ONE'S GOING TO DO THINGS TO — AT THIS TIME EVERYTHING
IS POSSIBLE.

I START WITH AN IDEA THAT IS QUITE SIMPLE, QUITE DIRECT IF YOU
LIKE. THEN AS IT GETS EASIER TO HANDLE AS A VEHICLE OF
EXPRESSION, THAT IS I KNOW THE TECHNICAL PROBLEMS OF THE
DRAWING AND HOW I WILL DEAL WITH THEM, THEN THERE IS SPACE
FOR OTHER KINDS OF THINGS TO COME ALONG. SO I BEGIN TO INJECT
INTO THE PICTURE MUCH MORE OF MYSELF AND IN SOME DEGREE
ACTUALLY START TO LEAVE THE ORIGINAL IDEA BEHIND.

LEONARDO SAID THAT FOR HIM DRAWING WAS A WAY OF
UNDERSTANDING THE WORLD. AT THE BOTTOM LINE, I THINK
DRAWING IS ACTUALLY LIKE THAT FOR ME: IT'S A WAY INTO THE
WORLD, A ROUTE TO UNDERSTANDING WHAT I'M FEELING
ABOUT THINGS.

*Seeing and Being Seen, 1989,
mixed media on paper.*

CHARLOTTE FAWLEY

I LOOK A LOT BEFORE I START DOING ANYTHING. I KEEP ON LOOKING AND ABSORB IT ALL UNTIL I KNOW THE TIME IS RIGHT TO START. IT'S LIKE WHEN YOU SEE A DANCER IN THE WINGS JUMPING UP AND DOWN, JUST WAITING FOR THE MOMENT WHEN THEIR MUSIC STARTS. THAT'S REALLY ALMOST WHAT IT IS: IT'S WAITING FOR JUST THE RIGHT MOMENT, THEN YOU'RE AWAY AND YOU JUST KEEP ON GOING. IF A DRAWING'S GOING BADLY I WON'T LABOUR IT, I'LL JUST LEAVE IT, TURN THE PAGE AND START SOMETHING ELSE. I JUST HAVE TO KEEP ON GOING. THAT'S THE MAIN THING, KEEPING A CONTINUOUS FLOW OF WORKING.

MY DRAWINGS ARE ABOUT CONVEYING ON TO PAPER THE FEELING AND THE EMOTION OF WHAT I'M WATCHING, TRYING TO SHARE THAT WITH WHOEVER IS GOING TO LOOK AT MY PICTURES.

Janette Mulligan rehearsing Le Corsair, 1989, brush and ink with colour wash on paper.

135

*Canal at King's Cross, 1989,
pen & ink on paper with
water-colour wash.*

DAVID GENTLEMAN

❝THE POINT OF DOING A DRAWING IS TO TRY AND SET DOWN A MOMENT
OF ONE'S EXPERIENCE, WHICH IS ALL THAT LIFE HAS TO OFFER US. IT'S
A SUCCESSION OF EXPERIENCES WHICH, SOONER OR LATER, COME TO
AN END. IF YOU HAVE A MEANS OF GRABBING ONE OR TWO OF THESE
MOMENTS THAT WOULD OTHERWISE SLIP BY UNNOTICED, AND MAKING
SOMETHING RELATIVELY PERMANENT OF THEM, THEN THAT IS THE
INTEREST OF A DRAWING. WHEN YOU BEGIN TO DRAW IT CHANGES THE
WAY YOU LOOK AT THINGS. IT HEIGHTENS YOUR PERCEPTION OF THE
WORLD AROUND YOU, AND I THINK THAT IS A VERY STRANGE AND
EXCITING THING TO DO.

ALMOST EVERY DAY I BEGIN DRAWING I FIND THAT I AM SLIGHTLY
TENSE. MY FIRST LINES ARE OFTEN NERVOUS AND I FREQUENTLY TURN
THE PAPER OVER AND BEGIN AGAIN. I THINK THAT YOU GET A SECOND
WIND AND CAN DRAW NATURALLY AND WITH AUTOMATIC
CONFIDENCE, AND THAT'S THE HAPPY WAY TO DRAW. A GOOD
DRAWING ALMOST ALWAYS COMMUNICATES A SENSE OF EASE AND
RELAXATION.❞

SIR HUGH CASSON

"I LIKE MY LINE TO LOOK HESITANT, EVEN IF IT ISN'T, AND SO HAVE A
VIBRANCY OF ITS OWN. A LINE THAT HAS A TREMBLE IN IT LOOKS
URGENT, LOOKS INTERESTED, AND IS IN FACT A SYMPTOM OF WHAT
YOU'RE FEELING ABOUT THE VIEW YOU'RE DRAWING.

I'M A RATHER IMPRESSIONISTIC DRAWER – THIS IS LAZINESS REALLY!
I TRY TO GET A REASONABLE LIKENESS OF WHAT I SEE IN FRONT OF ME,
BUT WILL OCCASIONALLY SACRIFICE REALITY TO DRAMA: IF IT'S MORE
EXCITING TO MAKE THE COLUMNS TALLER, I DON'T MIND CHEATING.
ARTISTS ARE ALLOWED TO CHEAT.

KEEPING YOUR EYE ALERT IS THE SECRET OF ALL HAPPINESS IN LIFE.
I DON'T THINK THAT YOU HAVE TO BE AN ARTIST TO OBEY THAT RULE
BECAUSE I THINK CURIOSITY IS THE SECRET OF HAPPINESS."

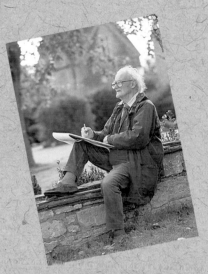

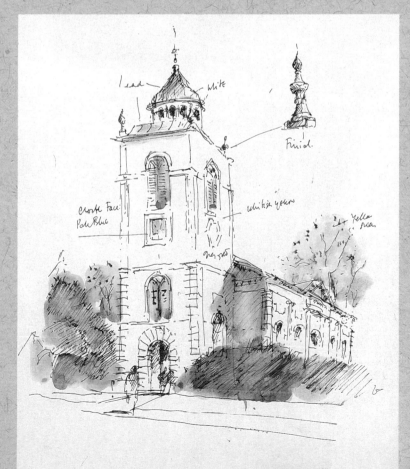

*Gayhurst Church, 1989, pen & ink
on paper.*

GLOSSARY OF DRAWING TERMS AND MATERIALS

'A' SIZES Standard international metric paper sizes.

ABSTRACTION Art unconnected with the depiction of concrete objects.

ACHROMATIC COLOURS Black, white and grey.

ACRYLIC COLOURS Colours with a synthetic resin base.

ADDITIVE METHOD The way in which colours of light are combined.

ADVANCING COLOUR Warm colours such as red, orange and yellow.

AERIAL PERSPECTIVE The rendering of distance by the progressive paling of colours.

AIRBRUSH A small, super-fine spray-gun.

AIRGUN A bigger form of airbrush for covering larger areas.

ALLA PRIMA To make a picture in one session.

ANTHROPOMETRIC SYSTEM System of anatomical measurement described by Albrecht Dürer.

AQUARELLE Water-colour.

ARCHES PAPER A brand of water-colour paper.

ART BRUT Art created by psychologically abnormal artists.

ART DECO Decorative art movement of the 1920s and 1930s.

ARTGUM ERASER Eraser used especially for cleaning drawings.

ARTISTIC LICENCE The freedom assumed by an artist to modify the subject.

ART NOUVEAU Art movement featuring natural forms dominant at the turn of the century.

ARTISTIC DEVICES Visual clichés repeatedly used in picture making.

ATMOSPHERIC PERSPECTIVE Aerial perspective.

B Designation of soft grades of pencil.

BALL-POINT PEN Writing instrument with a ball-shaped nib.

BAROQUE Ornate style of art dominant during the seventeenth century.

BEAM COMPASS Long compass for describing large circles.

BINDER Liquid medium mixed with pigment to form paint.

BISTRE Former type of ink made from wood soot.

BLEEDING The tendency of one colour to run into another.

BLEED-PROOF WHITE An opaque white paint for obliterating colours with a tendency to bleed.

BRIGHT A type of flat square-ended brush.

BRIGHTNESS The intensity of any given colour.

BRISTOL BOARD A type of thin, smooth board for drawing.

BROKEN COLOUR A method of visually mixing colour on the paper as in Pointillism.

BURNISHER Any tool used to smooth paper flat after abrasion.

CADAVRE EXQUIS A collective visual game used to create unusual images.

CAMEL HAIR Squirrel hair used in inexpensive brushes.

CAMERA OBSCURA Complex drawing aid where an image was projected on to a glass screen to be traced.

CARPENTER'S PENCIL Pencil with a rectangular section.

CARTOON Full-sized preparatory drawing.

CARTRIDGE PAPER Inexpensive and versatile white drawing paper.

CASEIN Paint binding agent derived from milk.

CHARCOAL Drawing material made from burnt wood.

CHIAROSCURO Bold depiction of light and shade in a drawing.

CHINESE INK Ink prepared with water from a solid stick.

CHINESE WHITE Opaque white water-colour.

CHROMA The purity of any given colour.

CHROMATIC COLOURS All colours except black, white and grey.

CLASSICAL PERIOD Period in ancient Greece between about 500–300 BC.

CLUTCH PENCIL Pencil with mechanical jaws for holding separate leads.

COLD-PRESSED PAPER Intermediate surfaced water-colour paper also called 'not' paper.

COLLAGE Picture formed from elements stuck on to it.

COLOUR WHEEL Disc demonstrating the relationships of colours.

CONCEPTUAL PERSPECTIVE Perspective used to describe objects as they are believed to exist.

COMPLEMENTARY COLOURS Colours diametrically opposite each other on a colour wheel.

COMPOSITION The underlying framework or structure of a picture.

CONCEPTUALISM Twentieth-century art movement dealing with ideas as distinct from images.

CONSONANCE The repeated use of a shape, colour or theme within a painting.

CONTÉ CRAYON A versatile type of compressed crayon.

COOL COLOURS Colours found at the blue, indigo and violet end of the spectrum.

COPAL A type of varnish made from natural resin.

COPPERPLATE NIB A variety of pen nib originally intended for writing.

CRAQUELURE Distinctive crazing that appears on old paint or varnish.

CROPPING Isolating a particular portion of a picture.

CROSS-HATCHING The repeated drawing of parallel lines in different directions.

CROW QUILL A type of fine steel pen nib.

CUBISM An early-twentieth-century art movement that investigated creative ways of depicting space.

CYAN Greenish-blue.

DADAISM An early-twentieth-century anti-art movement.

DAMAR A type of varnish made from natural resin.

DECALCOMANIA A technique for creating an area of random texture.

DEGRADED COLOURS Colours mixed with grey to reduce their intensity.

DIPTYCH A work on two sheets or panels.

DISTEMPER Egg- or glue-size-based paint.

DISTRESSING The artificial ageing of a picture.

DOUBLE ELEPHANT Paper size of 40 × 26½ inches (approx 1017 × 673 mm).

DOUBLE IMPERIAL Paper size of 45 × 30½ inches (approx 1143 × 775 mm).

DRAW FILM Transparent acetate made to accept ink lines.

DRY MOUNTING Method of lamination using heat and adhesive film.

EARTH COLOURS Ochres, siennas, umbers and other pigments made from natural minerals found in earth.

ÉCORCHÉ FIGURE Human figure without skin so as to display muscles.

EDO PERIOD Period of Japanese art flourishing in about the seventeenth and eighteenth centuries.

EIGHT-SHEET CARD Thick card made by laminating eight sheets of paper together.

ELEPHANT Paper size of 28 × 23 inches (711 × 584 mm).

ELLIPSOGRAPH Device for drawing ellipses.

EXPRESSIONISM Early-twentieth-century art movement featuring obsessional or dramatic themes.

EXTENDER Substance used to bulk up a pigment. Filler.

FABRIANO PAPER Brand of water-colour paper.

FAKE Imitation made without intent to pass it off as the work of another artist.

FAUVISM Early-twentieth-century art movement that celebrated the emotional use of colour.

FEATHERING Tendency of wet colours to run.

FELT-TIP PENS Drawing instruments with a nib made from felt.

FERRULE The metal part of a brush which attaches the hairs to the handle.

FIBONACCI NUMBERS Progression of numbers used to define harmonious visual intervals.

FIBRE-TIP PENS Drawing instruments with a nib made from fibreglass.

FIGURATIVE Non-abstract.

FILBERT A paintbrush with flat, tapering bristles.

FILLER Extender.

FITCH A paintbrush with chisel-shaped bristles.

FIXATIVE Sprayed-on varnish for protecting drawings.

FLAT A paintbrush with flat, square-ended bristles.

FLO-MASTER PEN A rechargeable type of felt-tip pen.

FORCING The exaggeration of the intensity of a shadow edge.

FORESHORTENING The rendering of something viewed from an oblique angle.

FORGERY Imitation made with intent to pass it off as the work of another artist.

FORM The suggested solidity of objects in a drawing.

FORMAT Shape and size of a drawing.

FOUR-SHEET CARD Medium-weight card made by laminating four sheets of paper together.

FOXING A type of mould on old pictures in the form of brown spots.

FRENCH CURVES Templates to assist in the drawing of irregular curves.

FRENCH MOUNT Mask with decorative lines applied around the aperture.

FROTTAGE Image created by rubbing over a texture.

FUGITIVE Pigments that fade when exposed to daylight.

FULL-FACE Portrait looking directly out of the drawing.

FUTURISM Early-twentieth-century art movement that celebrated machines, movement and energy.

GEOMETRIC PERSPECTIVE Perspective composed with the use of vanishing-points. Linear perspective.

GILLOT NIB Type of fine steel drawing nib.

GLAIR Medium made from egg-white.

GLAZE Transparent film of paint.

GOLDEN SECTION A method of dividing a whole into two harmoniously related parts.

GOUACHE Opaque water-colour.

GRAPHITE A type of mineral carbon used in the manufacture of lead pencils.

GRAPHOS PEN Technical pen with a refillable reservoir.

GRATICULATION The 'squaring up' of an image to facilitate its copying elsewhere.

GRISAILLE Painting or drawing in tones of grey.

GROUND Coating applied to a surface to be drawn or painted upon subsequently.

GUM ARABIC Natural gum used as a binder in water-colours.

H Designation of hard grades of pencil.

HACHURE LINES Shading lines that follow the form that they are describing.

HALF-PAN Small square-shaped block of water-colour.

HALF-TONE Photographic image rendered as tiny dots for reproduction.

HALOING Technique for suggesting distance between drawn objects.

HARMONY Visually pleasing combinations of form or colour.

HATCHING Shading formed by repeated parallel lines.

HB A medium grade of pencil.

HIEROGLYPHICS Ancient Egyptian writing system using symbols to represent words.

HOG'S HAIR High-quality bristles used in stiff brushes.

HOT-PRESSED (HP) PAPER Smooth-surfaced water-colour paper.

HUE The proportion of another colour present in any given colour.

ILLUMINATION Decorative embellishment to a manuscript

IMPASTO Paint applied thickly.

IMPERIAL (STANDARD) Paper size of 30½ × 22½ inches (approx 775 × 571 mm).

IMPRESSIONISM Late-nineteenth-century art movement specialising in the recording of light and natural phenomena.

INDIAN INK Dense black carbon-based ink.

INGRES PAPER A range of versatile white and coloured papers.

ITALIC NIB Writing nib with a square end.

JUXTAPOSITION Placing drawn elements side by side.

KEY The roughness of a surface that retains the drawing medium.

KINETIC ART Mid-twentieth-century art movement that employed moving elements.

KOLINSKI Finest-quality red sable.

KOZO Type of Japanese rice paper used for wash drawing.

KRAFT PAPER High-quality laid brown wrapping paper.

LAID PAPER Paper with raised lines evident.

LANDSCAPE FORMAT Rectangular format with long edge used horizontally.

LAPIS LAZULI A blue mineral formerly used to make ultramarine pigment.

LAY FIGURE Small wooden figure with movable limbs used as a substitute for the human form when drawing.

LAYOUT PAPER Thin translucent paper.

LETRASET Instant lettering system.

LIGHT BOX Shallow illuminated box used to trace through drawings on to another sheet of paper.

LIGHTFASTNESS Ability to resist fading when exposed to daylight.

LIMNING Outmoded word for painting.

LINEAR PERSPECTIVE Conventional geometric perspective using vanishing points.

LINE BOARD Board with a durable surface.

LINSEED OIL Oil made from flax seeds.

LOCAL COLOUR The inherent, unmodified colour of an object.

MAPPING PEN Dip pen for making very fine lines.

MARKER Drawing instrument with a fat felt or fibre tip.

MARKER PAPER Paper specially made for taking marker inks.

MASK Cardboard surround to a framed drawing. Also shaped protection used when applying colour.

MASKING FILM Transparent self-adhesive film used to mask out areas of a drawing prior to applying colour.

MASKING FLUID Liquid latex applied with a brush to mask out areas of a drawing.

MASKING TAPE Low-tack paper tape used to stick things temporarily.

MASTIC Varnish made from natural resin.

MEDIUM Materials and technique used to make a drawing. Also substance mixed with pigment to make it fluid.

METAPHYSICAL ART Early-twentieth-century art movement that depicted dream images and was the precursor of Surrealism.

MING DYNASTY Period in ancient China between about the mid-fourteenth to mid-seventeenth centuries.

MINIMALISM Mid-twentieth-century art movement that advocated extreme simplicity and minimal involvement of the artist.

MIXED MEDIA Two or more media used to create a single image.

MODERNISM Over-all title for progressive art produced since the end of the nineteenth century that broke with previous modes of expression.

MODULAR SYSTEM A system of colour classification.

MOGUL PERIOD Period under the Mogul rulers of India from about the sixteenth to nineteenth centuries.

MOMOYAMA PERIOD Period in Japanese history corresponding to the late sixteenth century.

MONOCHROME The use of a single colour.

MONOPRINT A one-off print.

MOTTLING The depiction of spots or blotches.

MUCILAGE Natural gum.

MUNSELL SYSTEM A system of colour classification.

NAÏVE ART Detailed figurative art by untrained artists.

NEO-IMPRESSIONISM Pointillism.

NEUTRAL Grey or other colour without a strong hue.

NOCTURNE Night scene.

NOT PAPER Cold-pressed paper with a slightly rough surface between smooth (hot-pressed) and rough paper.

NUANCE A subtle variation in colour or tone.

OBJETS TROUVÉS Found objects used in art.

OCHRE A natural earth pigment.

ONE-POINT PERSPECTIVE Linear perspective using one vanishing point.

OPACITY The covering power of a pigment.

OPALINE PAPER A hard-surfaced paper for pen-and-ink work.

OP ART A mid-twentieth-century art movement that utilised optical illusions.

OSTWALD SYSTEM A system of colour classification.

OUTLINE A drawn line representing the boundary of an object, tone or colour.

OVAL A type of brush with the bristles in the form of an oval.

PALETTE The surface on which paint is mixed. Also the range of colours used.

PALIMPSEST A drawing that has been erased and drawn over.

PAN A rectangular block of water-colour twice the size of a half-pan.

PANTOGRAPH An instrument for plotting the enlargement or reduction of a drawing.

PAPYRUS Early paper-like material made from certain reeds.

PARALLEL MOTION Draughting machine that remains parallel however it is moved.

PARALLEL PERSPECTIVE System of perspective where parallel lines are drawn as such.

PARALLEL RULERS Device for drawing repeated parallel lines.

PASTICHE Work of art in the style of another artist.

PASTEL Drawing medium made from pigment bound together with gum.

PEN Early name for a nib. Now applied to a steel drawing instrument.

PENCIL Early name for a paintbrush. Now applied to a rod of graphite (usually) retained by a wooden barrel.

PERCEPTUAL PERSPECTIVE Perspective system in which parallel lines converge towards a vanishing point. Linear perspective.

PERMANENCE The light-fast quality of a pigment.

PERSPECTIVE An artistic convention for rendering three-dimensional objects on a flat surface.

PHOTON A quantum of light.

PHOTOPIC VISION Colour vision.

PICTURE GLASS Thin glass used in framing pictures.

PICTURE-PLANE The surface of a drawing representing a 'window' through which a scene is depicted.

PIGMENT Natural or synthetic colouring matter.

PLANS CHEST A chest with shallow drawers for storing flat sheets of paper.

PLEIN-AIR Drawing or painting out of doors.

POCHADE A rough sketch of a landscape executed in situ.

POINTILLISM Late-nineteenth-century art movement that used the juxtaposition of points of pure colour.

POLYMER Synthetic base for certain paints.

POLYPTYCH A painting or drawing consisting of more than three sheets or panels.

POP ART Mid-twentieth-century art movement that depicted commercial products and popular culture.

PORTE-CRAYON Device for extending the length of a pencil.

PORTFOLIO Portable folder for transporting flat drawings.

PORTRAIT FORMAT Rectangular format with the long edge vertical.

POST-IMPRESSIONISM Late-nineteenth-century art movement that succeeded Impressionism.

POST-MODERNISM Late-twentieth-century art movement that re-examines modernism in the light of its predecessors.

PRE-RAPHAELITES Mid-nineteenth-century art movement that drew inspiration from early Renaissance art.

PRIMARY COLOURS Red, yellow and blue (pigments). Red, green and blue (light).

PRISM Transparent triangular optical device for refracting light.

PROPORTION The relationship of one part to another and of these to the whole.

PROPORTIONAL DIVIDERS Adjustable device for translating proportions.

PROTRACTOR Device for measuring angles.

PSYCHOLOGICAL PROPORTION Subjective assessment of proportion.

PUMP COMPASS Compass for making circles with tiny radii.

PUTTY RUBBER Kneadable eraser.

QUARTER-FACE Representation of a face looking slightly to one side.

QUILL A pen made from a feather.

QUIRE 24 sheets of paper.

REAM 480 sheets of paper.

RECEDING COLOURS Colours from the cool end of the spectrum. Blue, indigo and violet.

RELIEF Raised surface.

RENAISSANCE Period of artistic activity in Europe between about fourteenth and sixteenth centuries.

RENDER To make the marks that constitute a drawing.

RESINS Natural and synthetic substances much used as a base for paints and varnishes.

REVERSE PERSPECTIVE Form of perspective that takes into account the movement of the observer around an object.

ROCOCO Highly decorative style of art from the mid-eighteenth century.

ROMANTICISM Early-nineteenth-century art movement that eulogised nature.

ROUGE PAPER Paper used for transferring drawings. Tracing-down paper.

ROUGH PAPER Water-colour paper with a rough surface.

ROUND Type of paintbrush with cylindrical tapering bristles.

RULING PEN Pen with adjustable jaws for ruling ink lines.

SABLE The finest-quality hair used in paintbrushes.

SANGUINE A form of red chalk.

SATURATION The purity of a given colour.

SAUNDERS PAPER A make of water-colour paper.

SCENE PAINTER'S CHARCOAL Large-sized sticks of charcoal.

SCOTOPIC VISION Light-sensitive vision.

SCRAPER BOARD A drawing medium that is scratched away to expose a contrasting surface beneath.

SCRATCH BOARD Scraper board.

SCRIPT NIB A dip-pen nib that makes a uniform thickness of line.

SCUMBLE A thin, broken layer of colour laid over a darker one.

SEASCAPE A scene featuring the sea.

SECONDARY COLOURS Any colour made by mixing two primary colours.

SEPIA Brown ink originally derived from cuttlefish ink.

SET-SQUARE Triangular drawing aid.

SFUMATO Subtle hazy gradations of tone.

SGRAFFITO Scratching a colour to reveal another beneath.

SHADE A colour modified by the addition of black.

SHELLAC Natural resin used in varnish.

SIENNA Natural pigment derived from earth.

SILVERPOINT Outmoded drawing instrument originally made from a silver rod.

SIX-SHEET CARD Heavy card made by laminating together six sheets of paper.

SIZE Thin liquid glue used to prime a surface.

SLIP A type of versatile pen nib.

SPATTERING The random application of globules of paint or ink.

SPECTRUM The entire range of visible light.

SQUARING UP Graticulation.

STEREOSCOPIC VISION The ability to perceive depth.

STIPPLE To create areas of tone with repeated dots.

STRETCHING The preparation of paper to take a liquid medium.

STUDIO An artist's place of work.

STYLOGRAPH PEN A refillable reservoir pen for drawing lines of uniform width.

STYLUS A pointed instrument for incising.

SUBTRACTIVE METHOD The way in which colours made with pigments are combined.

SUNG DYNASTY Era of artistic activity in China between about mid-tenth to mid-thirteenth centuries.

SURREALISM Early-twentieth-century artistic movement that aimed to liberate the unconscious mind through art.

SWATCH A small sample of a colour.

SYMBOLISM Late-nineteenth-century art movement that used symbolic allusion to express itself.

TECHNICAL PENCIL A mechanical pencil with thin leads made for drawing uniform lines.

TEMPERA Paint made with an egg emulsion.

TEMPLATE Any object used to draw around as a drawing aid.

TENEBROSO The use of pronounced dark and light in a drawing.

TERTIARY COLOURS Colours made from a primary and a secondary colour or two secondary colours.

THREE-POINT PERSPECTIVE Linear perspective that uses three vanishing points.

THUMBNAIL SKETCH Small casual sketch used to try out an idea.

TINT A colour modified by the addition of white.

TONDO A circular drawing or painting.

TONE The reflectance of any given colour.

TOOTH The degree of roughness of a paper surface.

TORCHON A paper stub used to blend together tones of pencil, charcoal or pastel.

TORTILLON Torchon.

TOXICITY The poisonous quality of certain pigments.

TRACING-DOWN PAPER Transfer paper.

TRAGACANTH A natural water-soluble gum.

TRANSFER PAPER Paper coated with graphite or oxide used to transfer drawings.

TRIPTYCH Drawing or painting consisting of three sheets or panels.

TROMPE-L'ŒIL Highly illusionistic style of representation.

T-SQUARE Drawing aid for creating repeated parallel horizontal lines.

TWO-POINT PERSPECTIVE Linear perspective that uses two vanishing points.

TWO-SHEET CARD Thin card formed by laminating two sheets of paper together.

UMBER Natural pigment derived from earth.

VALUE Tonal quality of a given colour.

VANISHING POINT Imaginary point where parallel lines meet in the depiction of linear perspective.

VEHICLE The substance in which a pigment is suspended.

VELLUM Fine-quality calf-skin parchment.

VIEWING MASK A drawing aid made to isolate a view.

VIGNETTE A drawing without definite edges.

VINE CHARCOAL The finest-quality charcoal.

VISCOSITY The stiffness of a liquid such as paint.

WARM COLOURS Colours found at the red, orange and yellow end of the spectrum.

WASH Dilute paint or ink applied with a brush.

WASH BRUSH A large, flat, soft-haired brush.

WATER-COLOUR Transparent water-soluble paint.

WAVERLEY NIB A fine drawing nib for dip pens.

WHOLE PAN Rectangular block of water-colour twice the size of a half-pan.

WILLOW CHARCOAL Inexpensive form of charcoal.

INDEX